Kids and
Health
Care

**Using Insurance,
Cash and Government
Programs to Make
Sure Your Children
Get the Best Doctors,
Hospitals and
Treatments Possible**

**SILVER LAKE PUBLISHING
LOS ANGELES, CALIFORNIA**

Kids and Health Care

Using Insurance, Cash and Government Programs to Make Sure Your Children Get the Best Doctors, Hospitals and Treatments Possible

First edition, 2004
Copyright © 2004 by Silver Lake Publishing

Silver Lake Publishing
3501 W. Sunset Blvd.
Los Angeles, California 90026

For a list of other publications or for more information from Silver Lake Publishing, please call 1.888.663.3091. Outside the United States and in Alaska and Hawaii, please call 1.323.663.3082. Find our Web site at **www.silverlakepub.com**.

The Silver Lake Editors
Identity Theft
Includes index.
Pages: 306
ISBN: 1-56343-780-5.
Printed in the United States of America.

ACKNOWLEDGMENTS

The Silver Lake Editors who have contributed to this book are Daniela Cendron, Kristin Loberg, Megan Thorpe Rust and James Walsh. We'd like to thank Sander Alvarez and Christina B. Schlank for research and other assistance.

This is the 13th title in Silver Lake Publishing's series of books dealing with risk and insurance issues.

The Silver Lake Editors welcome any feedback. Please call us at 1.888.663.3091 during regular business hours, Pacific time. Or, if you prefer, you can fax us at 1.323.663.3084. Finally, you can e-mail us at TheEditors@silverlakepub.com.

James Walsh, Publisher
Los Angeles, California

CONTENTS

TABLE OF

THE MECHANICS OF
THE MEDICAL
INDUSTRY

You're reading this book because you have a child or children and you want to make sure they get good medical care.

If you're concerned...a little worried...you're right to be. The United States has one of the most complex medical services systems in the world. This complexity results in the world's highest quality health care. But it doesn't always distribute that care evenly. People who either have lots of money or know how to work the system get good care; others lose their way.

Don't get discouraged. Once you get a basic understanding of how the U.S. medical industry works (and how health insurance works), you'll be able to get the best coverage for your kids.

Even if the best health insurance is too expensive for your family, there are inexpensive plans that work well. Also, there are government programs run at the state and federal levels that make high-quality health care available to people under 18.

We'll consider all of these options in the course of this book.

But the best place to start is with a quick survey of how the U.S. medical industry—doctors, medical groups, hospitals and drug companies—works.

THE NUTS AND BOLTS

Most American families get their health insurance through a family member's job.

Health insurance first became an employee benefit in the U.S. during World War II. Companies found that offering health care coverage was an effective way to attract scarce workers without violating the wartime freeze on salaries. After the war, full health care coverage became an expected benefit of big-business jobs.

Through most of the decades after WWII, people could go to any doctor they wanted. If your general practitioner decided you needed to see a specialist, you could see one. If you needed medicine, you'd go to any pharmacy and get exactly what the doctor prescribed. If you had insurance, you'd bill the doctor's fees to the insurance company. If you didn't, you'd simply pay the bills yourself. Just about everyone paid for prescription drugs on his or her own.

Once large companies started making health insurance a standard benefit, a significant de-linking started. Most of the people who used medical care and prescription drugs no longer paid for them directly. So, over the course of several decades, they became blissfully unaware of what medical care cost.

Third parties (either their employers or their insurance companies) took care of the costs, including the cost of prescription drugs, in most cases. The end-users just focused on the quality of the care they got.

As a result, medical costs rocketed.

According to the Washington Insurance Council, the average annual per capita expenditure for health care in the U.S. was $268 in 1969; by 1990, the figure had increased to $2,567. During the same 20-year period, health expenditures grew from 5.3 percent of the Gross National Product (GNP) to 12.2 percent.

As a percentage of Gross Domestic Product (GDP), health care spending was 15.3 percent in 2003, up from 14.9 percent in 2002, according to a report published by the journal *Health Affairs*.

> **By 2013, health care spending in the United States is projected to reach $3.4 trillion and 18.4 percent of GDP. From 2002 to 2013, health care spending is projected to grow 7.3 percent per year on average.**

These costs grew faster than inflation, interest rates, the Dow Jones Industrial Average and just about any other economic indicator. The job security and potential to make good money as a doctor resulted in flourishing medical schools. But from an economics perspective, the surging costs had to cut into how medical care was delivered—and how doctors got paid. And they did.

MANAGING COSTS

Health insurance companies had to pay for much of the rocketing costs; they had to contend with increasing fees for doctors, lab tests, prescription drugs and hospitals. These growing costs meant insurers either needed to keep increasing their premiums, or they needed to find another way. To some degree, they did both.

> The important thing to remember about these companies is that their market has almost never been individual people or families—their market has been employers offering fringe benefits as a cheap alternative to higher salaries. Many people, faced with long lines in the ER and daunting paperwork when they take their kids for checkups, forget this.

Through the 1960s, 1970s and 1980s, health insurance companies managed the rising costs of medical care (which they were also enabling) by passing along the increases in the form of higher premiums to their customers. Most of the time, the companies simply absorbed these higher costs.

But no economic system can simply absorb higher costs forever. In the 1980s, the companies that were the main market for health insurance companies started to react to the increasing premiums. Some cut back on the benefits they offered employees. Some left their well-known insurance companies for lesser-known, cheaper start-ups. Some laid off employees to keep salaries and benefits higher for those who remained.

None of these options was good. American insurance companies realized they couldn't pass along rocketing costs any longer. They had to do something else to remain competitive; they had to cut the costs themselves.

What did insurance companies do to cut costs? They moved toward managed care. This meant they set up agreements with doctors and hospitals that enabled them to standardize fees for various services. They limited their coverage to doctors and hospitals that would accept the standard fees. They started paying for services of low-cost alternative therapies like acupuncture and chiropractic treatment—which they used to dismiss as quackery. They stopped paying for prescription drugs.

By the late 1990s, the delivery of medical services had changed dramatically for most Americans. A growing number no longer had traditional indemnity health insurance; they had managed care plans—things like health maintenance organizations (HMOs) and preferred-provider organizations (PPOs). Even those who had traditional health insurance felt the influence of HMOs and PPOs. Seeing any doctor or any specialist was no longer easy. All programs were full of limits—lists of doctors you can't see and treatments you're not allowed unless two or three doctors and a review board agree they're necessary.

RESPONSIBILITY CREEPS BACK TO CONSUMERS

Today, many small employers can't afford to offer health insurance to their workers. And a growing

number of mid-size and even large firms can do so only if the employees pay part of the cost.

If you have at least some health coverage through your employer, you're in pretty good shape—even if you have to pay part of the price. You also may have the option of paying your share with pre-tax dollars, which reduces your taxable income for the year and shrinks the bite Uncle Sam takes out of your paycheck. Sometimes, the tax benefits wind up making your health insurance virtually free—for you, anyway.

But there are still lots of questions: *If your employer offers you a choice of health plans, do you have enough knowledge to make the right choice for your children? If they allow pre-tax payments for your share of the costs, how do you know whether—or how much—to participate?*

If you're confused about the types of health coverage available and what coverage is best for you and your family, you're not alone. Many of the insurance agents and brokers who used to explain the details to people are gone. Companies that sell medical insurance rely on a shrinking number of experts to explain coverages to people—and most of these experts focus their pitch on the start of a new plan with a client. When questions come up later...and they usually do...people often get some brochures and a shrug of the shoulders.

WHAT IS "HEALTH COVERAGE"

The term *health coverage* refers to a collection of insurance policies and government programs that pay for a range of costs—from doctors and hospitals to

more particular needs, such as preventive medicine, alternative medicine and specialties like dental care, vision care and mental health care.

> When people refer to health insurance, they usually mean group insurance offered by employers—insurance that covers such things as medical bills, surgery and hospital expenses. Insurance companies call this *comprehensive* or *major medical* coverage, because of the broad protection it offers.

Health coverage includes insurance policies and government-provided benefits. Most consumers are familiar with some of these. The terms *fee-for-service* and *managed care* appear just about everywhere. The specific kinds of managed care plans—health maintenance organizations (HMOs), preferred provider organizations (PPOs) and point-of-service (POS) plans—are also fairly common. But what do these terms mean?

Both fee-for-service and managed care plans cover an array of medical, surgical and hospital expenses. Most offer some coverage for prescription drugs; and some even include coverage for dentists and other providers. But because there are differences that will make one or another plan right for you, it is important to know how each plan works.

FEE-FOR-SERVICE COVERAGE

Fee-for-service coverage simply means that *someone* will pay a medical-care provider (usually a doctor

or hospital) for services rendered. Paying cash—that is, unreimbursed out-of-pocket expenses—for medical care is a fee-for-service arrangement. Traditional health insurance—what insurers call *indemnity coverage*—is also a fee-for-service arrangement.

With fee-for-service coverage, you choose the doctor you want to see; and you can choose a different doctor for any reason, any time you feel like it.

This flexibility is something that most people value highly. And it's the reason that fee-for-service plans are more expensive than other kinds of health care.

PAYING CASH

If you pay cash, there's not much to the mechanics of seeing a doctor. You simply hand over the money or write a check after each visit. In some cases, the doctor or (more often) hospital will require partial payment in advance of treatment; on the other hand, either may give you 30 days or so to pay.

If you pay cash: Make sure to ask for the cash prices for time and treatments. Most doctors and hospitals offer discounted rates to patients who pay in cash. This is called the *professional discount.*

Some health care providers are more accustomed to being paid in cash than others. Dentists, eye doctors, many general practitioners and most alternative-medicine specialists usually aren't covered by insurance. They are thus better prepared to take cash payments.

Most hospitals and certain medical specialists—heart doctors, cancer specialists, anesthesiologists and even pediatricians—are almost always paid by insurance companies or government programs. They may not be set up to accept cash payments, at least not conveniently.

One of the many ironies of the medical industry is the fact that providers who serve the highest and lowest ends of the socio-economic spectrum are used to being paid in cash. Marginal outfits and clinics in seedy neighborhoods accept cash readily—and, often, so do plastic surgeons and general practitioners in the wealthiest. Among other reasons, rich people often pay cash for their medical care for privacy, to avoid the paper trail caused by insurance.

Don't assume because you're paying cash that means you have to settle for the low-end. Call a few doctors in swank locations, if only to find out how far your cash will go with them.

TRADITIONAL, INDEMNITY INSURANCE

If you have indemnity insurance (the "old-fashioned," non-HMO kind), the mechanics of paying for medical care aren't so different than paying cash. Essentially, you pay the insurance premiums every month, so that the company takes over paying most of your medical bills when you go to the doctor or a hospital.

That *most* is a critical word.

After you've been treated, you or your doctor sub-mits a claim to your insurance company for reim-bursement. You will only receive reimbursement for the covered medical expenses listed in your plan.

Services that are covered under your policy are gen-erally reimbursed for some—but not all—of the cost. Many policies pay 80 percent of the costs; you are responsible for paying the rest. In most circum-stances, the doctor's office or hospital will bill you for the balance.

The portion of the covered medical expenses that you pay, the other 20 percent, is called *co-insur-ance*. It's different than (and usually exists in addi-tion to) the *deductible*, which is a small amount that you pay directly to the doctor or hospital in advance of the insurance indemnity coverage.

A key caveat to indemnity coverage: Insurance com-panies usually limit their 80 percent coverage to *usual, customary and reasonable (UCR) fees*. These fees—which vary slightly by geographic location and medical specialty—are standards kept by the insur-ance industry as a way to limit particular doctors from overcharging patients with insurance.

Many fee-for-service plans pay hospital expenses in full, so be sure to check with your plan provider.

While indemnity policies allow for maximum flexibility, they leave you on the hook for out-of-pocket expenses. To compensate for this, most indemnity policies have an *annual out-of-pocket maximum*. When out-of-pocket expenses reach a pre-set amount in a given calendar year, the UCR fees for benefits covered by the plan will be paid in full by the insurance company and you no longer pay the co-insurance. (However, you still have to pay deductibles and, if your doctor bills more than the UCR fees, you may have to pick up that part of the tab.)

Many policies place lifetime limits on benefits. When shopping for a plan, it's smart to look for a policy whose lifetime limit is at least $1 million. If the limit is lower than this, you or your kids could run through the coverage if you have major health problems for several years.

MANAGED CARE

Old-fashioned indemnity insurance is old-fashioned because the group of alternative health care payment systems known collectively as *managed care* has taken over a large part of the medical marketplace.

A managed care plan provides comprehensive health services to its members and offers financial incentives for members to use doctors and hospitals under contract with the plan. Different managed care plans limit your options to different degrees; some allow some choice among doctors while others set rigid controls.

Managed care plans keep their costs low by putting particular doctors and hospitals under contract in advance. Instead of paying for each service that you receive separately, the plans pay providers in advance. That's why insurance professionals call these plans *prepaid care.*

HMOs have been in existence for many years. However, their popularity increased dramatically after the U.S. Congress passed the Health Maintenance Organization Act in the late 1970s.

If you join an HMO, you pay a monthly or quarterly premium. The plan requires you to make *copayments* for certain services.

For example: In an HMO, you may have to pay a $10 copayment for a regular doctor's office visit and $5 for each prescription you need filled. These copayments are like the deductibles in indemnity insurance—designed to balance the financial impact of those who use a lot of medical services and those who don't.

> Aside from the copayments, you should have no (or very few) out-of-pocket expenses for medical care in a managed care plan—as long as you use doctors or hospitals that are contracted with the plan. If you use providers that haven't contracted with the plan, coverage will be limited...or non-existent—and expensive.

HOW DO YOU GET HEALTH INSURANCE?

Health insurance is generally available on an *individual* or *group basis*. Premiums tend to be lower for group coverage—and this is how most people get their health insurance.

Group coverage is typically offered through your employer, but unions, professional associations and other organizations also offer this type of insurance. When you receive group insurance at work, the premium usually is paid through your employer. In some cases, the employer pays some or all of the premium as a benefit; in others, the premium is deducted from your pay.

Group coverage has distinct advantages:

- First, and simplest, groups have more buying power than individuals.

- Second, groups allow for what actuaries call *risk pooling*. This means that groups tend to be less risky because all members pay premiums—but only a few (if any) members need medical care in any given month.

- Third, administrative and brokerage costs are usually paid by the employer. These costs can be larger for health insurance than other kinds of coverage (life, auto, home, etc.).

For all of these reasons, eligibility for group coverage is usually open when you start a job—you won't

have to undergo a physical exam to prove you're insurable.

> Individual insurance is a main option if you are self-employed or work for a small company that doesn't offer health insurance. An individual policy works in the same way that a group policy does; the main difference is that the premiums are usually higher because the administrative costs are, too.

Federal law makes it easier for you to get individual insurance under certain situations. If you aren't covered under a group plan and can't get insurance on your own, check with your state insurance department to see if it has a medical coverage risk pool. Like risk pools that group health plans create, these state-run pools can provide health insurance if you can't get it elsewhere. But their coverage can get expensive.

One advantage of individual insurance: You can tailor a plan to fit your needs. However, shop carefully. Coverage and costs vary widely, so be sure to evaluate the medical services covered, benefits paid, what you must pay in deductibles and co-insurance—for each kind of coverage.

OTHER PLANS

If you don't get health insurance at work and insurance companies consider you or your kids uninsurable—because of your age, pre-existing conditions or other reasons—you can usually find some form

of state-sponsored health coverage...at least for your kids.

These programs should be used as a last resort, because they typically offer limited benefits, are expensive and usually include a waiting period before the benefits kick in and you are covered. But at least they're there, if you need them. You can find out about these plans by calling your state insurance department.[1]

If money is the problem, you may qualify for Medicaid. This federally-funded network of state-run programs provides medical assistance to low-income families and individuals of all ages. Your county's Social Services Department or—again—the state insurance department can fill you in on the eligibility requirements.

But don't give up on getting health coverage through work. Get up your courage and ask your employer to check out state-subsidized health insurance. If your employer can't afford to offer health coverage through normal channels, it may be able to get some help from the state government.

For example: In California, companies with three to 50 full-time employees are eligible for the Health Insurance Plan of California (HIPC), a state-sponsored pool. It guarantees coverage to workers in any one of 20 different health plans offered through

[1] We've included a list of state insurance departments and their contact information in Appendix A.

insurance companies or HMOs at more favorable rates. Most small employers can't be refused coverage because of the medical history of one or more of their employees; this is known as a *guaranteed issue* policy.

These state-run programs are designed particularly to provide coverage for families with children.

SELF-FUNDED PLANS

If you get health coverage through your work (and you work for a larger company), your employer may have set up a system by which it pays directly for employee health care expenses.

A self-funded plan is a program that allows a financially-secure employer to assume the risk for health care costs instead of transferring the risk to an insurance company. Instead of paying policy premiums, the employer places money into a secured account that pays for health care services itself.

A self-funded plan may be an indemnity program that reimburses covered employees for medical care they have received. Or, the employer may provide benefits through the service plan offered under an HMO, or through a PPO network.

Self-funded plans aren't always easy to recognize. Some employers self-insure but pay an insurer to administer the plan and process claims. In these cases, the employees may think that the insurance company is actually funding coverage. It's not.

Not all self-funded plans use outside administrators. If your employer self-funds, it may just have a department set up to handle medical claims.

> A self-insured plan is a less expensive way for an employer to provide health care benefits, provided the claims experience is favorable and the employer can realize a good rate of return on the money deposited in the trust account.

Many large employers use self-funded plans to cover their employees' dental expenses, because dental insurance is relatively expensive and difficult to get.

Self-funded plans can work well for all parties. The one caveat to keep in mind, if your employer self-funds health coverage: Although there are federal benefits laws that regulate these plans, they are inevitably subject to the employer's own fiscal stability. If the employer goes bankrupt, the health coverage can evaporate.

WHAT IS NOT COVERED?

While HMO benefits are generally more comprehensive than those of traditional fee-for-service plans, no health plan will cover every medical expense.

Most plans won't cover eyeglasses or hearing aids because these are considered *budgetable expenses* (in other words, you should be able to plan for them). Very few cover elective cosmetic surgery, except to correct damage caused by a covered injury.

Some indemnity insurance won't cover checkups or preventive care; and some plans cover complications arising from pregnancy but not normal pregnancy or childbirth.

Both fee-for-service plans and managed care plans limit coverage for experimental procedures—and they retain the right to define *experimental*. But recent government regulations have tightened the experimental procedure loophole.

Also, insurers won't pay duplicate benefits. Your children may be covered under health insurance plans that both you and your spouse get at work; but, under what insurance companies call *coordination of benefits provisions*, the total they can receive under both plans for a covered medical expense can't exceed 100 percent of the UCR fee. And, if neither of your plans covers 100 percent of a procedure, your kids will only be covered for the percentage of coverage (for example, 80 percent) that the more generous plan covers.

USING YOUR DOCTOR AS A TOOL

If you understand the relationship that your doctor and your insurance coverage play in the delivery of health care, you can use each to maximize the effectiveness of the other.

Your doctor should be familiar with your insurance coverage, so he or she can provide you with covered care. However, there are so many different insur-

ance plans that few doctors can keep up with the details of all of them. By knowing your insurance coverage, you can encourage—perhaps even prod— your doctor to recommend medical care that is covered in your plan.

> **Remember that your insurance company, not your doctor, makes decisions about what will be paid for and what will not.**

Don't hesitate to write, e-mail or call your insurance company with questions about coverage for specific conditions, *before* going to the doctor. Finding the right person to e-mail can take time. And calling may mean some time spent on hold...but it's better to know what your insurance company will pay for before you receive a service, get tested or fill a prescription. Some kinds of care may have to be approved by your insurance company before your doctor can provide them.

Most of the things your doctor recommends will be covered by your plan, but some may not. And, in many cases, you won't find out coverage was denied until weeks...or months...later, when you get a bill. This is the worst way to find out about a coverage issue, because you've already received the service or therapy. You can try to get the insurer to pay after the fact, but it's better to have an idea of what will happen in advance.

If your insurance company denies your claim, you have the right to appeal (challenge) the decision.

Before you decide to appeal, know your insurance company's appeal process. Also, ask your doctor for his or her opinion. If your doctor thinks it's right to make an appeal, he or she may be able to help you through the process.

TRICKS OF THE TRADE

For some readers, this chapter may have been a review of things they already knew about health care in the U.S. But we're usually surprised by how many people—including smart, rich ones—don't know the nuts and bolts of how doctors, hospitals and insurance companies work.

If you're on your own, you can afford this obliviousness. If you have kids, you can't.

To conclude this chapter, we'll consider a few of the tricks, traps and sharp moves that make medicine in the U.S. so complicated. And we'll make some suggestions for how to deal with them.

Trick 1: Insurance companies—and some providers—don't really want you to understand how health coverage works. Most group health insurance policyholders have no idea of their exact coverage limits or rules of their plans until after the open enrollment period when they receive their benefit booklets. And, even then, benefit booklets don't fully describe policy terms. The actual master policies are usually kept at the insurance company, with the broker who arranged the policy or with the HR department of the insured entity.

Solution: Every member of a health insurance group has the legal right to review the master policy. How-

ever, the policy owner (the employer or organization) can put various limits on how a member can see the master policy. Most people never ask to read the master policy. If you have kids—and if the policy is reasonably close—ask to read the policy. When you do, look for two things: the Declarations Page, which describes the parties to the insurance contract; and, even more importantly, the Exclusions and Exceptions. These say what's *not* covered. Understand both.

Trick 2: Managed care plans often pad their provider lists—and providers don't mind. Have you ever tried to switch primary care physicians within a managed care plan's provider network, only to find out with each phone call that many of the doctors named on the provider list are not accepting new patients? Insurance professionals call these listings "phantom networks." They make plans seem larger and easier to use than they actually are.

Solution: Technology can help here. Instead of relying on printed materials, visit your plan's Web site; these usually have more up-to-date listings. Also, work backwards from providers in your area or that you like to plans in which they are active members.

If the providers aren't part of plans available to you, take them plan information and ask them to join.

Trick 3: Cash-flow management 101. Insurance companies and managed care plans intentionally delay

paying claims in order to hang on to cash and maximize profits (insurers keep their cash in interest-bearing accounts). Although most states have laws that require prompt payment of claims, those laws usually apply only to claims that don't have any missing or wrong information. Virtually all claims have some sort of technical error.

Solution: Identify a customer-service representative or claims manager—even before you make a claim—and keep that person on your speed dial throughout the claims process. If you or your employer used a broker to set up the coverage, that broker can either be the claims point-man...or find you one in the insurance company.

Trick 4: Your doctor may be all too ready to admit he or she isn't calling the shots. When it comes to things like diagnostic tools and the length of a hospital stay, doctors rarely make decisions anymore. Some may act like the call is theirs...but more will usually admit the decisions are out of their hands. They'd rather blame faceless actuaries.

Solution: Hold your provider responsible for the quality of the care he or she provides. Emphasize that you and the doctor are on the same side of the equation. Offer to press any contacts you have at the insurance company or managed care plan to get additional care, if you believe you need it.

Convince the doctor that you're willing to fight for the services you need; he or she will be more inclined to press your kids' case.

Trick 5: Sometimes, managed care plans will try to get members to pay out-of-network charges that aren't the members' fault.

Solution: Question every out-of-network charge you get in the mail. It's not your responsibility to pay the doctor's fee for an out-of-network radiologist who read your hospital x-ray because no network radiologist was available. As a patient, all you can do is select an network primary care physician and network hospital. Other than that, you have no control of who else gets involved with your care within the hospital setting.

> **If the plan tries to force an out-of-network fee on you, file an official complaint with your state insurance department, and then ask the department to investigate the plan's billing history.**

Trick 6: Insurance companies, managed care plans and some providers hide behind UCR fee schedules. The groups will argue—sometimes within the same claim cycle—that UCR fees are both too high...and not high enough. And then, if you challenge the settlement, you find out that the details of UCR fees are usually kept secret (as "proprietary" business information).

Solution: Fight a two-front battle. If your providers charge more than UCR fees, pressure them to accept the UCR fees as full payment. Many will—even if they start out billing more. At the same time, use the threat of a complaint to the state in-

surance regulators to pressure the insurance company or managed care plan to reconsider its UCR fees. This last step is a long shot...but it plays off of the last trick.

Trick 7: Insurance companies and managed care plans will do everything they can to keep complaints and grievances within their internal review and appeals processes. They don't like to admit—as they are required by law in many states—that external complaint channels exist. These external complaint channels usually involve the state insurance department.

Solution: See Appendix **A**. And let your contact at the insurance company or managed care plan know that you have the insurance department's number. In most cases, insurance regulators are bound by law to investigate all consumer complaints that fall under their jurisdiction.

CONCLUSION

Some of these solutions may take more effort, energy and argument than you're inclined to take when your child is hurt or sick. But that's exactly the time to hit hard anyone or anything that will delay or obscure the best possible health care.

The bureaucrats who hide within the complex machinery of the U.S. health care system aren't evil. They're just lazy...institutionally lazy. Your best strategy for assuring the best medical care for your children is to learn a few basic facts about how these bureaucrats operate and hammer those facts hard.

2

KEY HEALTH INSURANCE TERMS & DEFINITIONS

In the last chapter, we considered the nuts and bolts of how medical care is financed and delivered. Here, we'll build on that primer by defining some of the key terms that are used in the health care industry. A working knowledge of these terms will help you find good coverage for your children—and fight for the best services, once you have coverage.

We've discussed some of these terms already...and will discuss others in the coming chapters...but they appear here in one central place.

ACCIDENTAL

In a health insurance policy, *accidental* means unexpected or an undesigned cause of bodily injury. A related term—*accidental means*—means the mishap itself must be accidental...not just the resulting injury. An example: Your son Bo is chopping wood when the ax slips from his hand and cuts his foot; this is accidental means. However, if Bo's finger gets in the way of the ax, it may not count as accidental means.

ACCIDENTAL DEATH AND DISMEMBERMENT

AD&D coverage is a policy or a provision of a policy that pays either a specific amount or a multiple of a weekly disability benefit. The full coverage takes effect if your child loses his or her sight—or two limbs—in an accident. (A lower amount is payable if he or she loses one eye or one limb.)

ACUTE CARE

Acute care means skilled, medically necessary care provided by medical and nursing professionals in order to restore the person to health or the ability to function. For example, acute care would be rendered to persons recovering from major surgery.

ADDITIONAL INSURED

A person other than the named insured who is covered by the terms of a policy. Usually, additional insureds are added by endorsement or are described in the definition of insured in the policy. Your children would be additional insureds under your policy.

AGE CHANGE

The date on which a person's age—for insurance purposes—changes is an important coverage point. In most policies, health insurers use the age at the previous birthday for rate determinations. This can be of special importance as your children near adulthood; most standard health plans will require them to get their own coverage by the time they turn 25.

BASIC PREMIUM

This is a fixed cost charged in a retrospective rating plan. The basic plan is a kind of starting point—a percentage of the standard premium, designed to give the insurance company enough money to cover administrative expenses and commissions.

BENEFIT PERIOD

The *benefit period* defines the period during which you are eligible for benefits. Usually, a 90-day benefit period starts with each illness and commences the day you are admitted to a hospital and ends when you haven't been hospitalized for a period of 60 consecutive days. There is no limit to the number of 90-day benefit periods you can have.

CAPITATION

Capitation (CAP) is the fixed amount of money paid on a monthly basis to an HMO or an individual health provider for the full medical care of an individual.

CASE MANAGEMENT

Case management means the assessment of a person's LTC needs and the appropriate recommendations for care, monitoring and follow-up as to the extent and quality of the services provided. Your *case manager* is the health professional (e.g. nurse, doctor, social worker) affiliated with a health plan who is responsible for coordinating and approving the medical care that you and your family receive.

CLOSED PANEL

This is a system in which insured people must select one primary care physician who will refer patients to other health care providers within the plan. This is also called a *closed access* or *gatekeeper system*.

CO-INSURANCE

Co-insurance is the percentage of your medical bills that you are expected to pay. Co-insurance payments usually constitute a fixed percentage of the total cost of a medical service covered by the plan.

> **If a health plan pays 80 percent of a physician's bill, the remaining 20 percent that the member pays is referred to as co-insurance.**

COPAYMENT

A *copayment* is the fee paid by a plan member for medical services. A copayment would be the out-of-pocket expenses you are expected to pay, such as $10 for an office visit or $5 for a prescription.

COVERED SERVICES

Most policies list medical benefits such as tests, procedures, treatment services and drugs that they will pay for. These lists are usually based on industry-standard lists called *taxonomies*. In most cases, the covered services on the list are also coded according to how much and under what special limits the services are covered.

Most policies also list the services that the insurance company *will not* cover. You have to pay for these services. This is an easy concept to describe in the abstract—but it can be complicated in a dispute.

DEDUCTIBLE

The sum of money that an individual must pay out of pocket for medical expenses before a health plan reimburses a percentage of additional covered medical expenses is called the *deductible*. Deductibles for family coverage are often $200 to $500 per year.

ELIMINATION PERIOD

Elimination period (EP) means the period of time, usually expressed in days or months, at the beginning of a confinement in a long-term care facility, during which no benefits are payable. The EP could be defined as a "time deductible."

FEE-FOR-SERVICE

Health insurance plans that reimburse physicians and hospitals for each individual service they provide are called *fee-for-service* plans. These plans allow insureds to chose any physician or hospital.

FORMULARY

This is a health plan's list of approved prescription medications for which it will reimburse members or pay for directly. Additional medications are usually not available to plan members.

GATEKEEPER PHYSICIAN

The primary care physician who directs the medical care of HMO members is the *gatekeeper physician*. The primary care physician determines if patients should be referred for specialty care.

THE HCFA

The *Health Care Financing Administration (HCFA)*, part of the Department of Health and Human Services, administers Medicare and Medicaid with the assistance of Social Security Administration offices throughout the country. The HCFA establishes standards for medical providers and organizations if they are to satisfy the requirements to be certified as a qualified Medicare provider.

HEALTH MAINTENANCE ORGANIZATIONS (HMOs)

These are health plans that contract with medical groups to provide a full range of health services for their enrollees for a fixed pre-paid, per-member fee. There are three different kinds of HMOs: *open* or *group model HMOs*; *closed* or *staff model HMOs*; and *individual practice associations (IPA)*.

- Open or group model HMOs contract with independent groups of physicians that provide coordinated care for large numbers of HMO patients for a fixed, per-member fee. These groups will often care for the members of several HMOs.

- Closed or staff model HMOs employ salaried physicians and other health professionals who provide care solely for members of one HMO.

- Individual practice associations (IPA) contract with groups of independent physicians who work in their own offices. These independent practitioners receive a per-member payment or capitation from the HMO to provide a full range of health services for HMO members. These providers often care for members of many HMOs.

A growing number of HMOs now offer a *point-of-service (POS)* option. These "escape hatch" plans allow HMO members to seek care from non-HMO physicians, but the premiums for POS plans are more costly than those for traditional HMOs. For more on these and other types of HMOs, see Chapter 4.

HOSPICE CARE

Hospice care refers to nursing services provided to the terminally ill. It's offered in a hospice, a nursing home or in the patient's home—where nurses and social workers can visit on a regular basis. The purpose of the care is to keep the patient comfortable and to enable the patient to die with dignity.

INDEMNITY CONTRACTS

Indemnity contracts are policies that provide a daily benefit—$50, $60 or $70 per day—for each day of confinement in a hospital or LTC facility. This

method of payment can be contrasted with an expense incurred contract that reimburses for actual expenses incurred while confined. (See Chapter 3.)

INTERMEDIARY

A private insurance company contracted by the Department of Health and Human Services for the purpose of processing payments to patients and health care providers.

LIMITED HEALTH INSURANCE

These special health insurance policies provide limited coverage for specific injuries or illnesses—such as travel accidents, particular diseases and hospital income.

LONG-TERM CARE

Long-term care (LTC) is care that is provided for persons with chronic disease or disabilities. The term includes a wide range of health and social services, which may involve adult day care, custodial care, home health care, hospice care, intermediate care, respite care and skilled nursing care.

LTC does not include hospital care.

MANAGED CARE

Managed care refers to a broad and constantly changing array of health plans that attempt to control the cost and quality of care by coordinating medi-

cal and other health-related services. The vast majority of Americans with private health insurance are currently enrolled in managed care plans.

Proposals currently being considered by the U.S. Congress would, if enacted, guarantee that millions of Americans who are covered by Medicare and Medicaid will soon join managed health care plans.

MEDICAID

Medicaid is the federal-state health insurance program for low income Americans. (Medicaid also foots the bill for nursing-home care for the indigent elderly and mentally disabled.)

MEDICAL NECESSITY

A *medical necessity* is something that your doctor has decided is necessary. But a medical necessity is not always the same as a *medical benefit*—something that your insurance policy has agreed to cover. In some cases, your doctor might decide that you need care that is not covered by your insurance policy.

Your insurance company may have some discretion over whether or not it will pay for medical necessities. The company's decisions are supposed to be based on its understanding of the medical care that most patients need and state-of-the-art practices at the time; but political and regulatory pressure weighs heavily in favor of coverage, in disputed cases.

MEDICARE

Medicare is a federal health insurance program for persons age 65 or older, individuals with perma-

nent kidney failure and certain persons who are to-
tally disabled. The program was implemented in
1965 as part of the amendments to the Social Secu-
rity Act of 1935.

PEER REVIEW

Groups of doctors who are paid by the federal gov-
ernment to conduct pre-admission, continued stay
and reviews of services provided to Medicare pa-
tients by Medicare-approved hospitals are referred
to as *peer review organizations (PROs)*.

PRE-EXISTING CONDITIONS

An important concept in health coverage is the *pre-
existing condition*, or a physical condition that ex-
isted *prior to* the effective date of a policy. This is a
hot-potato liability issue among insurers.

In short, what happens if your kids have health
problems before you change jobs and get new health
insurance at your new work?

Until the 1990s, the new insurance company could
refuse to pay for medical care related to the health
issues your children had before switching coverage.
This caused a number of high-profile lawsuits dur-
ing the 1980s and 1990s. Finally, in 1997, the
Health Insurance Portability and Accountability Act
or HIPAA (also known as the Kennedy-Kassebaum
Act) quashed pre-existing condition limits.

As of July 1997, insurance companies can impose
only one 12-month waiting period for any pre-ex-
isting condition treated or diagnosed in the previ-
ous six months. As long as you have maintained

coverage without a break for more than 62 days, your prior health coverage will be credited toward the pre-existing condition exclusion period.

> One exception: Pregnancy *can* be excluded as a pre-existing condition. So, try not to change jobs if you or your spouse is expecting.

An exception to the exclusion: The 12-month waiting period is waived for any newborn or adopted child who's covered within 30 days.

If you've had group coverage for two years, switch jobs and move to another plan, the new health plan can't impose another pre-existing condition exclusion period.

PREFERRED PROVIDER ORGANIZATION (PPO)

A health plan that encourages savings by establishing a network of *preferred providers*—health professionals who agree to provide medical services to plan members for discounted rates. Plan members may go "out of network" to seek medical services from non-affiliated medical professionals. Members are charged higher copayments for this option.

PRIMARY CARE PHYSICIAN

These physicians provide basic health services to their patients. General practitioners, pediatricians, family practice physicians and internists are recognized by health plans as *primary care physicians*.

HMOs require that members be assigned to a primary care physician who functions as a gatekeeper.

PROSPECTIVE PAYMENT

A system of Medicare reimbursement, which bases most hospital payments on the patient's diagnosis at the time of hospital admission rather than the costs the hospital actually incurs prior to discharging the patient is called a *prospective payment system*.

RISK CONTRACT

This is an arrangement through which a health provider agrees to provide a range of medical services to a population of patients for a pre-paid sum of money. The physician is responsible for managing the care of these patients and risks losing money if expenses exceed the pre-determined amount.

SKILLED NURSING CARE

Skilled nursing care is daily nursing and rehabilitative care that is performed only by, or under the supervision of, a skilled professional or technical personnel. The care is based on a physician's orders and performed directly by or under the supervision of a registered nurse. This care would include administering prescription drugs, medical diagnosis, minor surgery, etc.

A *skilled nursing facility* is a facility, licensed by the state, which provides 24-hour nursing services under the supervision of a physician or RN.

UTILIZATION REVIEW

This includes the various methods used by health plans to measure the amount and appropriateness of health services used by its members. These checks can occur before, during and after services have been sought or received from health professionals.

CONCLUSION

These are a few of the basic definitions and terms that apply to insuring your health. You will see these definitions—and others—throughout the book. Where needed, we will reiterate and expand definitions to provide you with the tools necessary to understand the language of health care financing.

HOW HEALTH
INSURANCE WORKS

In Chapter 1, we considered how doctors and hospitals function...and how they expect to be paid for caring for someone who's injured or sick. In the United Sates, the main mechanism for making these payments is health insurance. For adults under age 62, health insurance is a necessity—the only real option to it is government-run programs for the indigent, which operate under the umbrella program named "Medicaid."

Working-age adults who can't afford health insurance often go without coverage. And, in some cases, that can be a rational decision.

For children, going without coverage doesn't make as much sense.

First, many injuries, illnesses and medical conditions that occur in childhood can affect a person's health for his or her whole life. The high fever associated with as simple an illness as strep throat can cause blindness or deafness. A blow to the head from a fall at a soccer game can trigger epilepsy. Providing quality health care to children can minimize or eliminate these long-term effects.

Second (and as a result), there are more options available for paying for childrens' health care. Various programs—run by both the private sector and the government—offer medical coverage or the means for paying for medical coverage for kids. In fact, there are so many of these programs that even health care industry experts usually don't know them all.

When it comes to medical coverage for your child, you usually have a few basic choices: Do you want to join a managed care program like a *health maintenance organization (HMO)* or a *preferred provider organization (PPO)*? Or do you want to pay more for an *indemnity policy*?

There's not much expert consensus about which coverage is the best for families with children. The closest thing to conventional advice is that an HMO or PPO usually has lower premiums and keeps out-of-pocket expenses to a minimum.

However, some parents feel strongly that the limits that managed care put on which doctor you can see or which hospital you can visit are particularly bad for kids, whose conditions are sometimes difficult even to diagnose.

In this chapter, we'll consider how indemnity insurance works for families with children in more detail.

WHAT "INDEMNITY" MEANS

Indemnity plans are the standard by which most health care plans are measured, even though managed care plans have become more common. In-

demnity plans remain the choice of larger corpora-
tions and wealthier individuals—including many
people who work in the health care industry.

When insurance people talk about indemnity in-
surance, the thing that's being indemnified is...you,
the policyholder. An indemnity insurance contract
states that the insurance company will pay some or
all of the medical bills for you and your family mem-
bers. In some cases, it will reimburse you for bills
paid out-of-pocket; in other cases, it will pay bills
directly to the doctor or hospital providing services.
In either case, it pays fees for medical services *after*
they are provided.

This structure puts most of the decisions about
health care and treatment on the shoulders of the
insured people, who usually defer to the sugges-
tions that their doctors make.

With the doctor strongly influencing the decisions
about how much and what kind of service should
be provided, at least one truth emerges about in-
demnity coverage: It's not very effective for con-
taining costs.

With increasing health costs, insurance companies
started to put limits on how much an indemnifica-
tion contract would indemnify.

The first limit is the *deductible*. The deductible works
this way: The insurance company will pay the doc-
tors and hospitals bills—after you pay a small amount
first. This small fee is defined at the start of the
policy period; and it's usually structured to spread
over the whole period.

For example, the insurance company might indemnify you for 80 percent of all of the costs related to your child's medical care, after the first $500 each year...or the first $50 each month. The point isn't so much to get you to pay part of the cost as it is to make sure you only take your kid to the doctor when he's really sick. The company figures that, if you have to pay $50, you're less likely to rush your child to the emergency room with a low-grade fever or a simple cut.

In health coverage, as in other kinds of insurance, these up-front fees are very effective at reducing bills generated by policyholders.

Another limit is *co-insurance*. This limit *is* designed to get you to bear part of the cost.

In a contract with a co-insurance clause, the insurance company agrees to pay a certain portion (80 percent is common) of the medical bills you incur. This shared burden applies from the first dollar of coverage to the policy's limit. The rest—the other 20 percent—you have to pay out-of-pocket.

This is a major compromise on the concept of full indemnification. Insurance companies usually make it financially appealing to take the lesser coverage.

It's easy to calculate how much the insurance company wants you to pay. Compare the annual premium for full indemnity coverage with the annual premium for indemnity with an 80/20 split. (Many companies sell both kinds of insurance.)

The full indemnity coverage should be about 25 percent more expensive. If it's that much more or

less, the company won't mind the risk—and you should buy the full coverage. If it's more than 25 percent more—and most will be—you may be better off with the cheaper coverage.

> Many indemnity policies have both a deductible and a co-insurance clause. In these cases, focus your negotiating efforts on lowering your portion of the co-insurance. The deductible doesn't usually impact the value of the policy as much.

If you choose a reimbursement insurance plan, you will have to pay for medical services up front, then fill out a claim form and send it to the insurance company. Between deductibles and co-insurance, indemnity coverage can seem like it doesn't pay for very much—especially if you have more than one child. Because kids usually need more health care than working-age adults, a standard indemnity policy can easily require as much as $1,000 per month per child (this is in addition to the premium).

Another limit is that some indemnity policies don't cover specifically-named medical services. These may not cover prescription drugs or routine visits.

The final limit is the category of exclusions the indemnity contract includes. Many companies will agree to pay medical bills—except for those related to a list of specific illnesses or conditions.

Many individual indemnity policies exclude coverage for pregnancy and childbirth. The companies look at this as an optional condition that has more

complexities—and hidden costs—than most people realize.

VARIATIONS ON INDEMNITY

The most common form of indemnity health coverage is *Medical Expense* insurance, designed to insure you and your children against sickness and accidental bodily injury. Medical Expense policies are of two types: *Basic Medical Expense* and *Major Medical Expense*.

Basic Medical Expense policies cover one of three expenses and include: hospital, physician and surgical expenses. You can purchase only one, or a combination of expense coverages.

The *hospital expense coverage* includes room and board, including intensive care, operating room and lab fees and other necessary services and supplies. *Surgical expense coverage* includes doctor's fees related to surgery and coverage for various types of procedures based on the company's surgical schedule (the maximum amount payable for particular operations). Finally, *physicians expense coverage* pays for treatment by a physician not related to surgery. Basic Medical Expense policies are usually written with deductibles ranging from $100 to $500 per calendar year. Once the deductible is met, the insurer pays the remaining costs in full, up to the policy limits.

Major Medical Expense insurance, on the other hand, is aimed at catastrophic medical expenses (in fact, the policies are often called *catastrophic coverage*).

This coverage was introduced in the 1950s by a small group of insurance companies; today virtually every health insurer offers some form of it. Major Medical is intended to cover serious illnesses and accidents that end up costing thousands of dollars. As a result, they come with very high deductibles and limits. A $10,000 deductible seems like a huge amount, if you and your kids are basically healthy; but it's a reasonable part of the six- or seven-figure costs that can pile up if your child needs a bone marrow transplant or cancer treatments over an extended period of time.

Major Medical policies will often have a co-insurance clause, meaning you must pay a portion of the covered expenses—usually 20 percent—and the insurance company pays the remaining 80. Major Medical also limits coverage for such things as mental illness and drug or alcohol treatment programs.

Because it covers costs related to hospitalization and has high deductibles, Major Medical is usually an insurance company's favorite kind of indemnity policy. It's almost always the cheapest and easiest for which to qualify. It can work well for you— even if you have kids—especially if you've had health problems in the past. But you have to look at this coverage as one part of a larger approach to buying health insurance. There are a lot of expenses that the plans don't cover; you're going to have to fund those expenses somehow—out-of-pocket or with some kind of supplemental insurance. These plans are often used in conjunction with *Medical Savings Accounts (MSAs)* and other non-traditional health care financing programs.

In short, Major Medical is the most stripped-down form of indemnity coverage. It assumes that you will be willing—and able—to pay considerable amounts of money out-of-pocket for the high deductibles and co-insurance. Frankly, this scenario doesn't fit for most families with young children.

With regard to the cost, the premium for a Major Medical plan will cost less—usually a lot less—than the premium for a Basic Medical Expense plan. But these cost advantages often fade as you have more dependents. So, again, Major Medical plans aren't really the best option for families with kids.

COMPREHENSIVE MEDICAL EXPENSE POLICIES

Major Medical coverage is considered *hospitalization insurance*. It doesn't cover all medical expenses—the way that traditional indemnity coverage does. What do you do about these other expenses? Paying for them out-of-pocket is the simplest option. But you need to be cash-rich to do this. So, most people will look for some kind of insurance to add on to their Major Medical.

In these situations, you may be faced with the prospect of buying a *comprehensive medical expense plan*. This kind of insurance adds separate coverage for basic—and not necessarily hospital-related—medical expenses to the Major Medical coverage.

This may seem like a long way to walk around the insurance block in order to get back to something like the traditional indemnity coverage we considered earlier. It is. The long walk is a testament to how convoluted insurance coverage can be.

The comprehensive plan consists of a block of first dollar benefits followed by a deductible and a typical Major Medical plan. This plan might specify that 100 percent of the first $5,000 or $10,000 of UCR expenses will be covered. Once this bundle of first dollar benefits is exhausted, you must satisfy a deductible (usually referred to as a *corridor deductible*) and then the Major Medical benefits kick in.

All of the provisions common to a basic plan as well as the provisions and concepts related to Major Medical plans, i.e., deductibles, co-insurance, stop loss, etc., are found in this type of plan.

The question raised by the comprehensive plan is whether or not you and your kids would be better off with this multi-part coverage or simply a "straight" Major Medical plan. More specifically: Does the block of first dollar benefits really enhance your overall protection?

To answer these questions, let's assume your son falls from a second-floor window of your house and has to have surgery for a ruptured spleen and spend a week in the hospital. The result is a $20,000 hospital bill—that includes the surgery and related fees. Everything in the total is an undisputed UCR fee.

A straight Major Medical policy that includes a $1,000 deductible and 20 percent co-insurance will require you to pay $4,800 (the $1,000 deductible plus $3,800 in co-insurance). The policy will pay the hospital $15,200.

If you combine the Major Medical policy with basic medical coverage to create a comprehensive pack-

age, the basic coverage will cover all of the first $5,000 due the hospital. Then, you have to pay the $1,000 corridor deductible on the Major Medical plan, plus 20 percent of the balance: This means $3,800. The Major Medical policy pays the rest.

You've saved $1,000 by combining the coverages (and you've also saved $5,000 against the lifetime maximum benefit on your Major Medical policy). Following our logic from earlier in this chapter, if the comprehensive policy costs $1,250 or less, it's probably worth having.

In small claims situations, the extra premium for the comprehensive plan has to be weighed against the likelihood of a small claim of a few thousand dollars. Generally, this kind of calculation will make the comprehensive coverage look like a bad deal. But, with today's health care costs, it is difficult to spend a few days in a hospital, have surgery and not incur expenses exceeding $10,000.

Comprehensive plans vary, but generally cover the same kinds of services. Some of these include:

- professional services of doctors of medicine and osteopathy and other recognized medical practitioners;

- hospital charges for semiprivate room and board and other necessary services and supplies;

- surgical charges;

- services of registered nurses and, in some cases, licensed practical nurses;

- home health care;

- physical therapy;

- anesthetics and their administration;

- x-rays and diagnostic lab procedures;

- x-ray or radium treatment;

- oxygen and other gases and their administration;

- blood transfusions, including the cost of blood when charged;

- medicine requiring a prescription;

- specified ambulance services;

- rental of durable mechanical equipment required for therapeutic use;

- artificial limbs and other prosthetic appliances, except replacement of such appliances;

- casts, splints, braces and crutches; and

- rental of a wheelchair or hospital bed.

MORE ON DEDUCTIBLES

Most Major Medical plans will offer a variety of deductibles from $500 to $5,000...or even higher. Some high-risk policyholders—usually people with histories of health problems—pay closer to $10,000 deductibles. *That* is truly catastrophic coverage.

The deductible may be expressed as a *calendar year deductible* or as a *per cause deductible*.

A calendar year deductible means that you satisfy the deductible once in a calendar year. A per cause

deductible is similar to the deductible found in an auto policy. Each time you ding a fender, you are responsible for a deductible. A per cause deductible basically states that each medical claim you incur will have a deductible requirement. Thus, if you had three claims, three deductibles would need to be satisfied before your insurance company would begin to pay benefits.

Example: If your son Elroy has three separate medical claims in a given year and your family's indemnity policy contains a $250 per cause deductible, then you must satisfy three separate deductibles before the insurance company will pay. If your policy contains a calendar year deductible, you only have to pay one deductible to cover the entire year.

Another version of the calendar year deductible is the *family deductible*. Most plans will specify an individual deductible such as $250 and a family deductible equal to two or three times the individual deductible.

So, if the plan had an individual deductible of $250 and a family deductible of $750, after the family incurred expenses totaling $750, there would be no further deductibles for the balance of that year.

Most of the Major Medical plans contain a *deductible carryover provision*. If you haven't incurred any claims or received any benefits from the plan, expenses incurred in the last three months of a calendar year may be applied toward the new year's calendar deductible.

In this case, if Elroy has no claims in most of 2005 but does incur $100 of covered medical expenses

in November 2005, he can apply that $100 toward the annual deductible for 2006.

Deductibles do have a large effect on the cost of Major Medical plans. A plan with a $100 deductible will cost considerably more than a plan with a $1,000 deductible. So, if you want to save premium dollars, select a plan with a higher deductible—it will reduce the cost of the premium. But you'll need to have some cash on hand if a health crisis strikes.

STOP-LOSS PROVISION

As we've noted, *co-insurance* is the other cost that affects the price of insurance. The normal co-insurance formula is that you have to pay 20 percent of UCR fees, after deductibles and other adjustments are applied. But your portion can be higher—30 or even 40 percent. In some cases, you might choose to absorb more in order to make your monthly premiums lower; in others, the insurance company may only be willing to write the policy if you agree to take a larger portion of any expenses.

You can cap your liability by adding a *stop-loss provision* to your policy. The stop-loss is the point at which the insurance company begins to pay 100 percent of a claim. Without a stop-loss, you would be responsible for 20 percent of an indefinite amount such as $100,000 or even $1 million.

Stop-loss limits vary. They usually range from $5,000 to $20,000...though some policies have higher ones. For example, a plan with a $500 deductible and an 80/20 percent co-insurance split on the next $5,000 of covered expenses would re-

sult in a total out-of-pocket expense to you of $1,400—the $500 deductible plus 20 percent of the remaining $4,500.

> The out-of-pocket maximum is a major consider-ation when shopping for a policy. Regardless of the size of a potential claim, the most that you will have to pay out of your own pocket is the deductible and the co-insurance amount up to the stop-loss.

The stop-loss point is also a contributing factor in the policy's premium. The higher the stop-loss-the lower the premium. A stop-loss at $2,500 will cost more than a stop-loss at $10,000.

ANNUAL RESTORATION PROVISION

One way to think of a Major Medical (or any medi-cal) policy is as a big bag of money—holding $1 million, $2 million or more. This money is the maximum amount available to pay for covered health care expenses. You incur a claim subject to the plan's deductible and co-insurance requirements (including the stop-loss point). Whatever the total claim amount, it will be deducted from the bag of money leaving a smaller sum for future claims.

Example: Your son Elroy has a $1 million dollar Major Medical plan with a $500 deductible, 80/20 percent co-insurance split up to $5,000 and 100 percent coverage thereafter. He's hit by a meteorite and incurs $300,000 in hospital costs. After the deductible and co-insurance are paid, $294,100 is

withdrawn from the bag of money—leaving $705,900 for future claims. If Elroy has no large claims for the rest of his life, he has nothing to worry about. But, if he's struck by lightning two months later, the money in the bag would dwindle to $411,800. If he breaks his back in a skiing accident a year after that, the money in the bag would be down to $117,700. And then he starts having trouble with his kidneys....

The annual restoration provision puts back a certain amount of Major Medical dollars used each year. These amounts are generally small, such as $2,000, $3,000 or $5,000 per year.

If your family's plan contained a $5,000 restoration provision, one year after Elroy's first claim (and, assuming he doesn't have such a hard-luck existence) the total amount available for future claims would be increased to $710,900. After two years it would be $715,900—and so forth.

The size of a claim is usually several times larger than the amount restored. Many view this as a token reassurance that some sum of money will be in the plan for claims. If the plan only has a $1 million lifetime maximum, it is possible to exhaust this sum with a major illness such as a prolonged battle with cancer. To offset this disadvantage, many insurers provide major medical plans with $2 million lifetime maximums or unlimited maximums.

OTHER MEDICAL EXPENSES

Basic medical expense policies usually provide benefits for inpatient services such as hospital room and

board costs, surgical expenses and miscellaneous charges. Outpatient (out of the hospital) expenses are usually not covered.

Basic group plans have limitations. Usually, benefits are limited to a specified amount. Room and board charges may be limited to $300 or $400 per day for example. Surgical benefits are usually factors of a surgical schedule, which specifies the maximum surgical benefit to be paid. Miscellaneous benefits (private duty nurses, bandages, medication, in-hospital x-rays, lab work, etc.) are usually limited by an amount equal to 10 or 20 times the daily room and board rate.

> **Basic plans are also limited in terms of time. Most plans will specify that policy benefits will be paid for 30 days or possibly up to 365 days.**

Because of these limitations, basic medical expense plans usually do not cover your medical expenses in full. As a result, you will be responsible for certain out-of-pocket expenses.

In contrast to basic group medical plans, group major medical policies provide more comprehensive benefits. Group major medical will "limit" benefits normally to what is reasonable and customary as opposed to a specific dollar amount. In essence, you are provided with a sum of money to cover medical expenses. Most insurers require 75 percent or more of the eligible members to participate. Under a non-contributory plan, the employer pays

the entire premium. The insurance companies in this case require 100 percent participation.

The minimum participation requirement is to help guard against adverse selection. If a free choice were given, many people in good health might not choose the insurance, whereas many in poor health would.

> Group medical coverage may cost less than individual policies depending on the ages and dependent status of the participants. If you are single, you can usually purchase individual coverage for less premium than if comparable coverage was obtained under a group policy.

When a group policy is rated, the premium may be higher or lower than individual coverage because everyone in the group is paying for every other group member. If the ages of the participants are relatively high, the premiums will be high. A single person, age 21, will consequently pay a relatively higher premium (due to the age of the group) than he or she might pay on an individual policy basis. An individual policy is rated on the age and insurability of the applicant, not an entire group.

On the other hand, a married person with several children would probably find that the group premium would be less than an individual family premium. On an individual basis, this person must "pay by the head"—a separate premium for each covered family member. Usually, a group policy will charge a family rate regardless of the number of

dependents the participant may have. This is a good deal if you have kids.

UCR FEES DISPUTES

Usual, customary and reasonable fees have caught on with indemnity companies, which is why the distinctions between indemnity insurance and managed care are beginning to blur.

If your indemnity insurance company uses a UCR fee schedule—and if you don't use a participating provider—you may be responsible for the difference between the UCR fee and what the provider charges for a service.

The UCR amounts are determined by insurance companies; they establish UCR charges for specific services in a specific geographical area.

Example: Your daughter Julie has a tonsillectomy performed in a small farm community in central Nebraska. She is charged $1,500 for the procedure. By coincidence, your niece Suzy has the same procedure performed at a New York City hospital and her charge is $2,000. It's possible that Julie's incurred expense of $1,500 for the tonsillectomy would be considered reasonable and customary by her insurance company. It is also conceivable that Suzy's $2,000 charge would be reasonable and customary for New York. If so, their claims would be paid in full by their respective insurers.

On the other hand, assume that Julie incurs a $2,000 charge for her tonsillectomy. She hasn't reached the stop-loss point but has satisfied her

deductible. Julie's insurance company will pay 80 percent of $1,500—the UCR charge—or $1,200. Julie is responsible for 20 percent ($300) and now she must contend with a $500 excess charge. Her insurance company views the $500 as excess or unreasonable for that part of Nebraska. Julie has to pay $800 out-of-pocket to cover the expense. The excess is an additional out-of-pocket expense for Julie that is not counted by the insurer towards the stop-loss point or any other provision of the policy.

What can someone dealing with a UCR dispute do? One option—the one that insurance companies and health care providers hope you will choose—is simply to pay the difference and forget it. Another option is to appeal the decision with the insurance company's internal review structure. A third is to file a complaint with state regulatory authorities, though major medical insurance companies are usually allowed wide discretion in setting UCR fee schedules.

But there's a less contentious approach that often works. Explain to your health care provider that your insurance company uses a UCR limit that's lower than the fee you've been charged. If you back this argument up with the insurance company's paperwork, you may be able to convince the provider to bring the bill in line with the UCR fee schedule.

Often, doctors and hospitals would rather coordinate their fees with an insurance company's UCR schedule than fight it. They don't want to be identified with difficult claims...this sometimes brings scrutiny and slower payments.

In Julie's case, she could tell her doctor that her insurance company considers $1,500 to be a UCR fee for her tonsillectomy and will only reimburse that amount. The doctor may agree to accept the insurance company's reimbursement and Julie will only owe the $300 co-insurance. If the doctor insists that the full amount be paid, Julie could simply ignore the bill—and the doctor's collection efforts. There is always a chance that the doctor will give up. But that's a risky approach that most people should avoid to protect their credit ratings.

> The problem with UCR disputes is that a doctor may not consider a high fee to be unreasonable; only the insurance company does. And you are caught in the middle. Unfortunately, there is no simple answer when the insurance company deems a charge to be unreasonable.

One obvious preventive measure is to find out the cost of a procedure before it becomes a claim and then check with the insurance company to determine how much of this charge will be paid. This gives you the chance to discuss the fee with your doctor before incurring any expense. And your doctor will probably be more inclined to reduce the fee before it becomes a claims matter.

Another alternative is to find a pediatrician who will perform services for the UCR fees as determined by the insurance company. Some people are resistant to "shopping for doctors" this way—but they shouldn't be. As a group, pediatricians tend to be

willing to work with families to make sure their insurance covers as much as possible. There are exceptions to this rule, of course; but most good child specialists know that their patients will generate plenty of fees on their way to adulthood.

So—as difficult as it may be—make sure your kids' doctor will accept, or at least work close to, your insurance company's UCR fee schedule.

APPLYING FOR INSURANCE

Finding a good pediatrician—who will work with your insurance company—is one of the great challenges of raising children. Some parents feel strongly enough about their kids' doctor that they would rather change insurance companies than change pediatricians. That's high praise. And it may mean changing insurance companies several times over.

At this point, it may be worth discussing exactly what happens when you change insurance policies.

The main challenge here is actually applying for the new coverage. If you're simply changing policies within a menu offered by your employer or industry group, the application isn't quite so difficult; but, if you're buying insurance on your own, it can be daunting.

We'll consider the daunting version.

To get an accurate quote for health insurance, you'll have to fill out an application. It's very important that you do this completely and correctly. If you lie on the application, the company can not only deny

you coverage for a problem down the road, it can rescind the policy entirely. And, most companies can get your medical information anyway through a non-profit association called the Medical Information Bureau (MIB).[1]

Before you apply for insurance, it might be a good idea to check if there's a report on file for you, it's at no charge. And, if there is one and it's wrong, you can correct it. Just telephone them at (617) 426-3660 and ask for your free report.

The application for health insurance also will ask for your age and health history. Most insurance companies will ask your doctor for your medical records, and they may require you—and, on rare occasions, your kids—to undergo a physical with one of their doctors or even get additional blood tests. (However, they can't conduct an HIV test.)

You will have to let the insurance company know about pre-existing conditions. The company will want to know what illnesses and health problems you have had during the last couple of years (possibly longer). Most insurance companies would prefer not to pay you for treatment for a pre-existing condition, such as an ulcer or a gallstone. However, they are usually required by law to cover pre-existing conditions eventually—usually after six months to a year.

[1] The MIB was formed in 1902 by a group doctors who were also medical directors at several, large insurance companies, to centralize health related information on individual applicants and reduce the potential for fraud. Today, the MIB maintains medical information on approximately two out of every 10 applicants for health, life or disability insurance.

An insurance company also may restrict certain benefits for a set period of time. For instance, it may not cover expenses related to a pregnancy until the coverage has been in effect for one year. If you're already pregnant, this would be treated as a pre-existing condition. So, if you're planning on becoming pregnant, you'll want to get your health coverage sorted out as far in advance as possible.

If you've had a serious pre-existing condition, such as cancer or a heart attack, an insurance company may not want to cover you at all. Or it may require you to sign a waiver. This is a rider or amendment to a policy that restricts benefits by excluding certain medical conditions from coverage. (However, some states have begun to prohibit this practice.)

Your age also is an important factor in pricing and obtaining insurance. Many insurance companies have age "bands," when it comes to costs for coverage. For instance, everyone age 21 to 25 may fall into one price range, and everyone 26 to 30 would cost a bit more to insure. Family policies are based on multiples of the primary insured person's band.

> Insurance companies prefer to write policies for young, healthy people—and they prefer to stay away from older, less healthy people. So, it pays to pick a good plan when you're relatively young and stay with it, if you can.

Some companies allow you to change your mind and get your money back after you purchase health

insurance—but only if the policy has a "free look" or review period, which typically ranges from 10 to 30 days. So, you'll want to read your policy as soon as you get it.

You may even want to ask your pharmacist and your doctor how different plans are handled before you sign up. They should be more than happy to tell you which companies and which plans are easy to work with, and which ones make life difficult for them and for their patients.

BUYING INDIVIDUAL COVERAGE

If your employer does not provide health insurance—or if you're self-employed—you can purchase insurance on your own. Unfortunately, you'll wind up paying more for your own insurance than an employer or other group would—since insurance, like most other things, is cheaper by the dozen.

Another option: Health insurance through a group. By becoming a member of a trade association, labor union, alumni association, church group, etc., you'll be eligible for any member benefits provided that often include health insurance at reduced costs.

If you do have to seek coverage on your own, you'll want to shop around for the best coverage at the best price. Speak with your colleagues or peers about their experience and how they've obtained coverage—especially if they're not getting it from work or through a spouse. You can contact an insurance company directly, or you can go through an agent. This will help you find the best overall deal. You also will want to check with your state insurance

department to see if there have been any complaints about the insurance companies you're considering.

You can even check out the insurance companies' financial stability ratings. A.M. Best Co. rates each company on a letter scale from A to F, in order to provide an overall indication of the company's ability to meet its policyholder obligations. Their ratings are based on financial strength, the company's market profile and operating performance. For instance, A++ and A+ indicate Superior while F indicates the company is in liquidation. These ratings can be found at your local library or online.

CONCLUSION

This chapter has discussed traditional indemnity health insurance—and its several variations—in detail. It's also explained how this kind of health coverage works for children and families.

To sum up, indemnity insurance is not usually the most cost-effective form of health coverage. And its higher costs often increase geometrically for a larger family. In addition to having higher monthly premiums than managed care plans, indemnity insurance requires a variety of out-of-pocket expenses of people covered. The combination of these factors means that a family with two or three children may need $3,000 to $5,000 a month in cash on hand to cover medical costs.

This is a steep price to pay for indemnity insurance's undeniable pluses—flexibility and broad acceptance.

If you manage the insurance carefully and insist on stop-loss provisions and other expense caps, the costs can be controlled. But this will require a hard focus on your part, every time the policy comes up for renewal.

HOW MANAGED
CARE WORKS

Managed care programs are usually the most cost-effective form of medical coverage—and this cost advantage grows substantially when a family has more than one child. The bad reputation that managed care programs have for limited options and bureaucratic paperwork is often exaggerated. Starting in the 1980s, rising health care costs forced insurers and providers to reorganize the medical delivery system in the U.S. To accomplish this, they turned to managed care.

> Managed care imposes controls on the use of health care services, the providers of health care services, usually through health maintenance organizations (HMOs) or preferred provider organizations (PPOs).

Managed care plans can be organized as for-profit (commercial) corporations or non-profit corporations. In most scenarios, however, a managed care plan is a for-profit corporation with responsibilities to stockholders that take precedence over responsibilities to you.

Managed care got a bad reputation in the late 1980s and early 1990s because of some highly-publicized abuses related to HMO cost-saving measures. Among these abuses: plans that refused to let members see medical specialists; paperwork so confusing that one doctor couldn't refer a member to another doctor; financial bonuses paid to doctors who denied legitimate care; "gag" clauses in employment contracts that prohibited doctors from discussing expensive treatments; and, most infamously, so-called "drive-through" baby deliveries and mastectomies—in which women were sent home before they had recovered.

In short, under managed care, doctors' compensation is often directly proportionate to how little they do. Bonus plans reward doctors who order fewer expensive services. So, critics say, doctors in managed care are more likely to advise against costly interventions that might benefit the patient.

Beginning in the 1990s, political groups in Washington, D.C. started lobbying for various versions of a so-called "Patients' Bill of Rights" to be passed into law. While the different plans included specific details of their own, they tended to share some basic points.

The proposals tended to eliminate many of the cost-control mechanisms that managed care plans use to keep their coverage less expensive than traditional indemnity insurance. Among the common targets: gatekeeper referral systems, appeals boards made up of administrators (rather than doctors) and restrictive lists of approved providers. These proposals created enough concern in managed care circles that most plans voluntarily made the changes.

Indeed, some HMOs did place strict limits on the amount of time a mother could stay in the hospital after giving birth. Rage over these limits resulted in a 1995 federal law mandating that new mothers have the option to stay in the hospital for 48 hours after delivery.

In the mid-1990s, the American Medical Association called on all managed care plans to cancel "gag" clauses in their contracts or policies with physicians. A few months later, the American Association of Health Plans (AAHP), a national trade group based in Washington, D.C., that represents roughly 1,000 managed care plans, announced its adoption of a similar program to urge the strengthening of the patient-physician relationship.

The so-called "gag" rules are a way for managed care organizations to discourage discussion between physicians and patients regarding treatment options that managed care organizations do not want to cover (usually more expensive and non-traditional methods of treatment). The rules initially were intended to prevent the physician from criticizing the managed care organization.

The 1997 HIPAA, more commonly known as the Kennedy-Kassebaum Act, formalized some reforms.

The net effect: Managed care plans offer more flexibility—and, generally, aren't so restrictive—as they were in the 1980s and early 1990s.

SWITCHING TO MANAGED CARE

If you switch your coverage from traditional insurance to a managed care plan—and your personal

physician isn't in the managed care plan's network—
you probably can't continue to go to the same doc-
tor. And, even if he or she is a member, your office
visits still may be restricted, especially if your doc-
tor is a specialist.

Most managed care plans require you to choose a
primary care doctor from their list of doctors. This
doctor, also called a *gatekeeper*, controls your access
to medical care. And unless your primary care doc-
tor decides your medical problem is outside his own
realm of expertise, you cannot see a specialist.

The principal objective of managed care is cost con-
trol. The plans control costs by:

- stressing preventive medicine—physi-
 cal exams and diagnostic procedures;

- reducing the number of unnecessary
 hospital admissions;

- reducing the average number of days
 per hospital visit;

- reducing duplication of benefits; and

- saving on administrative costs.

A federal employee benefit law passed during the
1970s requires employers who offer health care ben-
efits to offer enrollment in a managed care plan as
an alternative to indemnity insurance. Employers
falling under this Act are those that:

- have 25 or more employees and are
 within the service area of a federally
 qualified HMO;

- are paying at least minimum wage; and

- offer a health plan to their employees.

HMOs

A *health maintenance organization* is a form of managed care and consists of a network of doctors and hospitals that provide comprehensive health care services to their members for a fixed periodic payment, usually monthly. As a result, the HMO is both the insurance company and the health care provider.

HMOs were formed to control skyrocketing medical costs and provide preventative health care *before* members got sick. (It's a lot less expensive to pay for hypertension medication than a heart transplant, after all.) They keep costs down by getting hospitals, doctors and other medical personnel to join the HMO. These providers offer health care to the HMO members in return for a pre-paid monthly charge. So, you can go to the provider as often as you want for the same monthly premium—plus an additional small fee (or copayment) per office visit or per prescription. Most other medical services are fully covered by an HMO, such as hospital stays.

However, in exchange for lower premiums, you give up your freedom of choice (unless, of course, your doctor is part of the HMO and listed as your primary physician). If you see a doctor who's not part of the plan, you'll usually have to pay the whole bill yourself. This is a strong incentive to see only providers within the HMO.

(Some HMOs have added options to their plans that allow you to see a doctor of your choice who is out of network—and get some coverage. But this coverage is still very limited.)

A key point with regard to gatekeeper physicians: In most cases, specialists are not allowed to be gatekeepers; but pediatricians are one of the few regular exceptions to this rule. In most plans, you can use any participating physician as your children's primary provider. (The most common alternatives: *general practitioners* and *family-medicine specialists*.) In most cases, this exception is something you should take full advantage of. While it requires some paperwork to change your kids' primary physician, you can usually do this with a standard form that you send by e-mail or fax.

> **In most cases, the managed care plan doesn't limit the number of times you can change primary providers—so, take your kids to every pediatrician in the plan until you decide which you like best.**

Many HMOs and other managed care plans require members to make a copayment when they get treatment. A *copayment* is a specific dollar amount, or percentage of the cost of a service that you must pay in order to receive a basic health care service.

> **Copayments are rarely more than $10—but they are due every time you visit a health care provider.**

EXCLUSIONS AND LIMITATIONS

HMO exclusions or limitations are used to either limit a benefit provided or specifically exclude a type of coverage, benefit, medical procedure, etc. HMOs may not exclude and limit benefits as readily as commercial insurance companies. This is usually because the rationale of an HMO is to provide comprehensive health care coverage.

Benefits that your HMO may exclude from coverage include: eye exams and refractions for persons over age 17, glasses or contact lenses resulting from an eye examination, dental services, prescription drugs (other than those administered in a hospital), long-term physical therapy (over 90 days) and out-of-area benefits (other than emergency services).

Your HMO is required to have a complaint system, often called a *grievance procedure*, to resolve any complaints that you may have. They provide forms for written complaints, including the address and telephone number of where complaints should be directed. Additionally, your HMO must notify you of any time limits applying to a complaint.

Complaints must be resolved within 180 days of being filed with the HMO (with a few exceptions). They may be resolved through binding arbitration if so specified by the HMO.

ENROLLMENT

Your HMO must provide you with evidence of coverage within 60 days of enrollment.

Evidence of coverage is equivalent to a Certificate of Insurance for standard insurance policies.

The evidence of coverage should include your coverages and benefits (including your required copayments), benefit limits, exclusions and specified conversion privileges. It should also include:

- the name, address and telephone number of the HMO;

- the effective date and term of coverage;

- a list of providers and a description of the service area;

- terms and conditions for termination;

- a complaint system;

- a 31-day grace period for premium payment provision;

- a coordination of benefits provision;

- incontestability clause; and

- a provision on eligibility requirements for membership in the HMO.

Other provisions may be found in the evidence of coverage, but those listed above must be included.

HMO BENEFITS

HMO benefits are not limited to treatment resulting from illness or injury, but include preventative measures like routine physical examinations and programs for quitting smoking, losing weight and managing blood pressure. HMO members pay a set fee, usually on a monthly basis, which entitles them to a broad definition of "necessary health care."

HMOs provide a wide range of health care services. These required services are referred to as *basic health care services*. And any services or benefits provided by your HMO in excess of the basic services are referred to as *supplemental health care services*. Your HMO must provide you with a list of the basic services that are covered under the plan. For example:

- inpatient hospital and physician services for at least 90 days per calendar year for treatment of injury and illness;

- if inpatient treatment is for mental, emotional or nervous disorders—including alcohol and drug rehabilitation treatment—services may be limited to 30 days per calendar year. Treatment for alcohol and drug rehabilitation may be restricted to a 90-day lifetime limit;

- outpatient medical services when pre-scribed by a physician and rendered in a non-hospital health care facility (i.e. physician's office, member's home, etc.) including diagnostic services, treatment services, short-term physical therapy and rehabilitation services, lab and x-ray services and outpatient surgery;

- preventative health services, including well child care from birth, eye and ear examinations for children under age 18 and periodic health evaluations and immunizations; and

- in- and out-of-area emergency services, including medically necessary ambu-lance services, available on an inpatient or an outpatient basis 24/7.

Supplemental health care services may take the form of additional coverages over and above those provided as basic, or additional amounts of the basic benefits already provided.

Because an HMO provides service benefits rather than reimbursement benefits, they are required to follow guidelines prescribed by the Insurance Department to assure quality service to members.

These guidelines specify the requirements for reasonable hours of operation and after-hours emergency care and standards to insure that sufficient personnel will be available to attend to your needs. The guidelines also require adequate arrangements to provide inpatient hospital services for basic health care and a requirement that the services of specialists be provided as a basic health care service.

IPAs OFFER A GOOD SOLUTION

Consumer advocates made much during the late 1980s and early 1990s about the harsh treatment HMOs give members. They told stories—many factual, some exaggerated—about so-called "drive-through deliveries," assembly-line surgeries and miserly gatekeepers.

One of the legitimate issues raised by this muck-raking: Some plans put business-oriented administrators—rather than doctors—in decision-making positions with regard to the delivery of care.

An impersonal approach has been the source of many problems for HMOs in the public mind. So, most of the plans have begun using networks of so-

called "individual practitioners." In these *individual practice associations (IPAs)*, you will get your care in a specific doctor's office. More than half the people enrolled in managed care plans are in IPAs.

IPAs are especially well suited for kids seeing pediatricians. Because so much of the health care that kids need is preventive, they seldom need more than visits to "their doctor's office." Using an IPA, you can be enrolled in an HMO but get the kind of service that indemnity insurance would provide—once you've found a participating pediatrician that you like.

PREFERRED PROVIDER ORGANIZATIONS (PPOs)

Unlike HMOs, PPOs do not utilize primary care gatekeepers. A single physician does not manage an individual's health care services. PPOs—which combine some elements of *fee-for-service plans* and the cost controls of HMOs—are designed to provide you with increased benefits if you use doctors and hospitals within its network.

Here's how a PPO works: An insurance company contracts with certain physicians to join a "preferred provider" network of doctors and specialists who will treat plan members for pre-arranged fees.

As a PPO member, you're given a list of participating providers. If you use these doctors and facilities, you only have to pay a small HMO-like copayment. However, unlike an HMO, you don't have to go to the doctors in the preferred provider

network. But, if you go to a doctor outside of the network, you have to pay larger deductibles and substantial co-insurance (often 30 percent of all fees).

> A PPO allows you to choose between cost savings and freedom of choice in selecting a health care professional. It counts on the coverage differences to encourage you to use participating doctors and hospitals.

PPOs are a better choice than fee-for-service plans if you have a big family but you want to have some flexibility in your choice of a doctor. They are also good if you have built a relationship with a physician not in the network and want to continue that relationship. You can still use preferred providers for other services and keep seeing your specialist.

One caveat: PPOs make financial sense when you know you will exceed the deductible amount. Most people with kids will do so, easily. However, if you don't exceed the deductible, you will basically be getting no value out of your insurance because the deductible amount must come out of your pocket before your insurance company starts paying.

BEFORE YOU JOIN A MANAGED CARE PLAN

You should ask a few questions before you join a managed care plan. Here's a list of the most important:

- *What exactly does the plan cover?* Some services, such as mental health treatment, drug rehabilitation or dental care, may not be included at all. While you can't possibly predict all of your health care needs, find out if the treatments you think you'll need are covered. Also, find out if treatments that are considered experimental or non-traditional, are permissible under your plan and, if you're interested, if alternative or holistic treatments are covered.

- *What will it really cost?* Don't just look at the monthly premiums. Consider the overall costs, including copayments and deductibles. Some plans offer a reasonable limit on the total you will pay each year. Others place a lifetime limit on what the company will pay, which you can reach if you have one major health problem.

- *Do you have a choice of doctors?* Be sure you have some flexibility. Also be sure at least a few local hospitals and pharmacies are covered under the plan.

- *Is there a utilization review?* In some plans, you cannot switch doctors or see a specialist without authorization. What happens if you don't like the doctor you choose? This can delay—or deny—care.

- *Who decides what is considered "medically necessary"?* Is it the insurance company or the doctor who decides?

- *What about pre-existing conditions?* If you have a pre-existing condition, such as high blood pressure, you may be liable for all costs relating to the illness. Know when and if your insurance pays for illnesses you may have.

- *What is the relationship between your doctor and the health care company?* If your doctor receives a set fee per patient (capitation) or receives a bonus for minimizing costs (incentives), your health care could get shortchanged. The physician may be reluctant to order tests or referrals under these situations. Gag clauses can prevent doctors from revealing their compensation or discussing treatment options not covered by the plan.

- *Does the plan you're considering have a grievance procedure? What if something goes wrong? Can you appeal?* Talk with someone who is authorized to answer your questions, like the plan administrator— and keep good records. Who regulates HMOs in your state and what's the procedure to lodge a complaint if you think you're being treated unfairly?

CONCLUSION

Some industry experts suggest that what's disturbing about managed care isn't that the health care is worse—it's that the plans shine a light on what a highly variable, random approach doctors and managed care companies take toward medicine. In fact, some researchers suggest that there is little evidence

that managed care has nudged doctors toward pro-
ducing the most cost-effective outcomes.

In the early 2000s, with various proposed "patients'
Bill of Rights" proposals circulating around Wash-
ington, D.C., the Feds began drafting laws that
would limit the limits—reducing the discretion
HMOs can use in delivery of health care services.

Ultimately, the biggest issue facing managed care
in the United States is whether all the talk of a
patient's bill of rights will lead federal regulators or
the court system (federal or state) to erode HMOs
and PPOs so much that they cease to have any cost-
saving advantage over other health coverage plans.

An example of this erosion came up in early 1999,
when a California jury ordered Aetna/U.S.Health
Care to pay $116 million in punitive damages for
refusing to cover experimental treatment for a can-
cer patient—who eventually died.

In 1992, David Goodrich was diagnosed with a rare
form of stomach cancer. Doctors in the Aetna HMO
recommended that Goodrich undergo high-dose
chemotherapy and a bone-marrow transplant. But
the system's administrators denied the coverage.

However, nothing in the plan's handbook—the main
document about coverage issues that members re-
ceived—said that the treatments recommended by
its own doctors were excluded.

One California-based managed care expert summed
up the issues wrapped in the big verdict: "This
shows the issue that is driving the consumer debate
is the fear that plans are looking over the shoulders

of doctors and are denying what a doctor perceives to be medically necessary."

Managed care advocates would argue that the problems reflected in the Aetna/U.S.Health Care case had been resolved years before. But the tide of public opinion was continuing to flow against managed care cost controls.

In another case that involved a managed care plan's coverage for prescription drugs, NYLCare Health Plans of the Mid-Atlantic Inc. was accused of noncompliance with a law that entitled certain patients to a 90-day supply of prescription medication.

In 1997, the Maryland Insurance Administration brought a sanction against the company after it received complaints between April and September that NYLCare denied members covered by its prescription drug rider the 90-day supply, according to the order signed by Maryland Insurance Commissioner Steven Larsen.

Under the Maryland law, health plan members who require maintenance medication for chronic conditions are entitled to a 90-day supply each time a prescription is refilled. The 90-day supply cannot be limited to purchase through a mail-order program.

NYLCare contended that it had complied with the law by making 90-day supplies available exclusively through its mail-order service. The HMO said administrative problems prevented it from providing wider access to members whose plans were effective prior to July 1998.

It didn't prevail.

Most states have passed laws that give people who join managed care plans specific legal rights demanding medical coverage. One good example: Beginning in July 2002, North Carolina passed one such set of guidelines. The state required "external review" of managed care disputes: This meant an independent review done by independent medical professionals. The review was binding on managed care plans.

If the external review determined that the plan was wrong in denying coverage, it must reverse its decision and pay for the requested service.

According to the North Carolina Department of Insurance (NCDOI), the law does not cover self-funded employee health plans covered under ERISA (the Employee Retirement Income Security Act), Medicare or Medicaid. And it doesn't cover denials for reason other than medical necessity.

However, members had to exhaust all internal appeals procedures with the plan before being eligible for the external review—and that could take some time.

State laws like the North Carolina appeals process have had their intended effect on managed care plans. Most are careful about denying needed medical care. With this liberalization of benefits, and with the understanding that all health care in the U.S. requires a more aggressive approach than it did before the 1980s, managed care plans usually make the most sense for families with children.

MEDICAID & OTHER GOVERNMENT PROGRAMS

In the United States, about 8.1 million children don't have any kind of health coverage, according to 2003 numbers from the Department of Health and Human Services. However, given the various government programs in place at the federal and state levels, the number of children without health coverage should be zero.

Most of those uninsured children live in homes where at least one parent works—but the household income is less than two times the poverty rate. This means families that are working are poor. According to social services experts, the reason these kids don't have health coverage is that their parents and guardians either don't know that health care programs exist for children...or they don't have time to file the necessary paperwork. These barriers can be overcome.

In this chapter, we'll describe the government programs that provide health care for children and explain what families have to do to get their kids enrolled in these programs.

MEDICAID

If you don't make enough money to pay for health insurance for a managed care program for your kids—and you live in the U.S.— you can get coverage for them through Medicaid or related government programs.

Title XIX of the Social Security Act, also known as Medicaid, provides medical assistance for low-income individuals and families. The Act became law in 1965. Title XIX provides both mandatory and optional requirements states must follow in terms of establishing eligibility standards; the amount, duration and scope of services; and program administration.

Medicaid is a jointly funded, federal/state health insurance program that covers approximately 36 million low-income individuals, including families with children and people with specific illnesses or disabilities. It is the largest program providing medical and health-related services to America's poorest families and individuals.

The program offers a minimum set of services including hospital and doctor services. Additionally, state agencies have the option of adding any or all of 31 services—including prescription drugs, hospice care and personal care services.

The federal government and the states share the costs of financing Medicaid through tax revenue. In 1995, Medicaid expenditures for health care amounted to $152 billion; the Feds paid $86 billion and states paid $66 billion. The details of Med-

icaid vary from state to state because each state: ad-
ministers its own program; establishes its own eli-
gibility standards; decides the type, amount, scope
and duration of services; and sets the rates of pay-
ment for services. States may also require recipients
to pay nominal deductibles, co-insurance or
copayments for certain services.

> State Medicaid programs must provide a broad
> range of services, including inpatient and outpa-
> tient hospital services, physician services, nursing
> facility coverage and more. Both fee-for-service ar-
> rangements and managed care plans are used to
> deliver Medicaid services.

Within federal guidelines, each state sets its own
income and asset (or resource) eligibility criteria.
For example, a person who is eligible for Medicaid
in one state is not necessarily eligible in another.
Some states also have a "medically needy" program,
in which Medicaid eligibility is extended to higher-
income people who have high medical costs.

Medicaid is *means tested*: eligibility is based on the
ability to pay for health care. That ability is mea-
sured by income and assets (or resources). In deter-
mining a family's eligibility for Medicaid, its finances
(all income and assets) are scrutinized. The eligibil-
ity question is: *Does this person have the means to pay
for health care on his or her own?*

At one time, Medicaid required you to liquidate
virtually all of your assets—including savings, in-

vestments, bank accounts, real estate and even some forms of cash-value life insurance—in order to qualify for coverage. In 1993, Congress relaxed those requirements to allow surviving spouses and children with certain illnesses or disabilities to keep more of the family's assets. Now, in some cases, a family can keep a home, a car, up to about $75,000 in assets and $1,900 in monthly income...and still qualify for Medicaid coverage.

(Each application is reviewed to make sure an applicant family genuinely qualifies; and, if your family has more money, it will be reviewed more closely. Playing legal games to "hide" assets isn't a good idea. Federal law sets criminal penalties for transferring assets for the sole purpose of qualifying for Medicaid; the penalties include fines of up to $25,000 and imprisonment for up to five years.)

MEDICAID FOLLOWS A MANAGED CARE MODEL

The Medicaid Act and regulations include separate protections for individuals enrolled in managed care. The Act requires all participating managed care organizations (MCOs) to have an *internal grievance process* through which an enrollee may challenge a denial of coverage or payment. Each MCO must provide access to an appeals process and to the state's fair hearing process.

The MCO must resolve grievances and appeals "as expeditiously as the enrollee's health condition requires" within certain time frames established by the state. For disposition of a grievance, that time frame cannot exceed 90 days from the date the MCO

receives a grievance and for resolution of an appeal, time cannot exceed 45 days. Enrollees must also have access to an expedited hearing process.

These internal procedures must satisfy constitutional standards of due process. MCOs must provide: 1) written notice of actions; 2) notice of grievance and appeal rights; 3) assistance in completing forms and filing grievances and requests for appeals; 4) information about rights to continued benefits; 5) hearing rights, such as the right to present evidence, to be represented, to examine the case file and access to an impartial decision maker; and 6) interpreter services. States may require enrollees to exhaust the MCO's internal procedures; however, it must also permit them to request a fair hearing within a reasonable time, no fewer than 20 days and no more than 90 days of the date of the MCO's resolution of the grievance or appeal. If the state does not require exhaustion, the enrollee must be allowed to request a hearing no fewer than 20 days and no more than 90 days of the date of the MCO's action.

MEDICAID LAUNCHES CHIP

In the U.S., uninsured children are at greater risk for preventable health problems because they're likely to go without needed medical care. For this reason, the government created the Children's Health Insurance Program (CHIP). CHIP gives federal money to states so that they can create coverage programs for kids whose families have or earn too much to qualify for Medicaid but can't afford private health insurance.

The U.S. Congress created CHIP in 1997, in a bit of deal-making, as part of the Balanced Budget Act.

The program gives states the flexibility to create their own programs; they can use CHIP money to:

- expand traditional Medicaid coverage;

- create new and separate programs aimed at children; or

- create a combination of both a separate program and an expanded Medicaid program.

This flexibility has allowed a broad range of program designs involving eligibility requirements, scope of benefits and administrative rules.

States that implement a CHIP Medicaid Expansion program simply extend medical assistance under Medicaid to cover children who are not otherwise eligible for Medicaid. Medicaid can be expanded to include kids in what government types call "targeted low-income" families; this usually means families whose incomes are below 200 percent of the federal poverty level—though some states choose different percentages.

This type of program offers CHIP enrollees the same benefits and applies the same rules that are offered or applied to traditional Medicaid enrollees under the Title XIX of the Social Security Act.

As of January 2004, 20 states and territories were operating Medicaid expansion programs with CHIP money.

States that implement a separate CHIP operate directly under the authority of the federal CHIP statute. These states usually provide benefits by charg-

ing participants different premiums based on household income levels (the higher the income, the higher the premium). States are free, within the boundaries of the federal statute and regulations, to design whatever processes they choose and to develop their own plans for determining eligibility. For example, a separate program may cover children whose parents have incomes higher than the state's Medicaid eligibility levels. However, states under the separate state plan may choose not to provide due process protections as extensive as those required by Medicaid.

> **As of January 2004, 18 states were operating separate CHIPs.**

States that use the combination plan approach generally extend Medicaid coverage to children whose families fall within a low-income bracket and—at the same time—create an entirely separate program to cover other children in a somewhat higher income bracket. For example, a state may choose to extend Medicaid coverage to children with family incomes that fall below 150 percent of the federal poverty level (FPL) while creating a separate CHIP that covers children who fall between 150 and 200 percent of the FPL. The federal poverty level for a family of four was $18,850 for 2004.

As of March 2003, 19 states were operating combination programs.

Unlike Medicaid, the CHIP statute contains language stating that it is not an entitlement program.

Also, statutes and case law have established extensive and detailed rules for how Medicaid is operated. The result: The rules for operating a CHIP program are more flexible than for operating a Medicaid program. In many cases, this means CHIP programs can work with a family to make sure its children qualify for coverage.

On the other hand, the rules for appealing adverse decisions (about whether your kids qualify or are denied coverage) are also less-clearly defined. The CHIP legislation does provide for "an external review" of issues related to services:

- delay, denial, reduction, suspension or termination of health services; and

- failure to provide payment for health services in a timely manner.

There are minimal standards prescribed for this "external review": states need only ensure that the review offered be conducted by the state or a contractor other than the contractor involved in the matter under review. States must also ensure that reviews be completed within 90 days, unless "the medical needs of the patient...dictate a shorter time frame." If a physician says it's urgent, the review must be completed within 72 hours. Still, this is all more vaguely stated than Medicaid's extension rules for review and appeal.

If you think your kids might qualify for a CHIP program, you can get more information by calling the nationwide toll-free hotline: (877) KIDS-NOW. You can also find out more on the Insure Kids Now Web site, which offers information about eligibility in your state and applying for coverage.

If you live in Rhode Island or Wisconsin and are the parent of a CHIP-eligible child, you may also qualify for health insurance under the program. Those two states have special permission to use money from CHIP to cover parents as well as children.

THE VARIOUS STATE PROGRAMS

The details of how various states run their CHIP programs can be instructive about how these benefits work, generally.

California's program, called Healthy Families, is a program separate from traditional Medicaid (which itself is called Medi-Cal in California). It offers medical coverage to children from birth to 19 years old.

For a child to be eligible for Healthy Families, at least one parent must be working and household income must be between $11,000 and $21,000 a year for a family of two or $32,000 a year for a family of four. Households with incomes below this range are eligible for Medi-Cal.

Parents don't have to work to qualify for Healthy Families; a family can get income from sources other than employment—such as alimony, unemployment or interest income. These types of income can keep a child off Medi-Cal.

However, children must not have been covered by an employer-sponsored plan for the three months

prior to the time of application, and must be either legal immigrants or U.S. citizens.

Healthy Families benefits are essentially the same as those given to state employees—and include medical, dental and vision care. To enroll a child in Healthy Families, parents or guardians must complete an application that includes personal financial information; once eligibility is determined, the family receives a letter asking it to choose from a list of certified health plans. The child's name is then forwarded to the chosen health plan. Monthly premiums range from $4 to $9 per child, depending on family income and the plan selected.

> **Families can get applications and assistance through the county Social Services offices or designated community centers, such as Head Start programs, public health clinics and other certified agencies.**

Some child-welfare advocacy groups in California complain that Healthy Families doesn't do enough. They point to state estimates of 1.8 million uninsured children and sneer at fewer than 200,000 kids enrolled in the program (as of early 2004). The advocacy groups say that numerous problems—including an application that's long and complicated, insufficient outreach efforts and fears of illegal immigrant parents about enrolling their eligible children—keep the numbers down. But, most emphatically, the groups complain that Healthy Families should include more families—including those with household income of up to 300 percent of the FPL.

State administrators counter that 300 percent of the FPL is a household income of nearly $56,550 for a family of four. It's hard to characterize such a family as "poor."

The advocacy groups counter by pointing to New Jersey's KidCare Program (its combined Medicaid and CHIP) that is available to children in families with incomes up to 350 percent of the FPL.

Arizona's CHIP program, called KidsCare, is separate of its Medicaid program. But the state administers both its CHIP and Medicaid programs through a managed care system, the Arizona Health Care Cost Containment System (AHCCCS).

In Massachusetts, the state combines its CHIP and Medicaid programs into one entity called MassHealth, which is run through the Massachusetts Division of Medical Assistance (DMA). MassHealth operates a managed care plan with participating MDs and hospitals throughout the state.

From an administrative perspective, there is some distinction within MassHealth between standard Medicaid recipients and CHIP families; ordinary Medicaid recipients are administered by one department (MassHealth Standard) and CHIP applicants and enrollees by another (MassHealth Family Assistance). Because the CHIP law allows somewhat more flexible rules, its administrators can respond accordingly.

MassHealth is aggressive about reaching as many potential members as it can. It has enrollment centers in hard-to-reach communities and organizes

outreach campaigns to homeless and immigrant populations. It focuses its application assistance efforts during evenings and weekends, so that working parents can more easily seek out the help.

MassHealth—like CHIPs in a number of states with combination programs—extends important Medicaid protections to CHIP families. Most importantly, it provides for presumptive eligibility, which means that applicants are treated as though they're eligible for CHIP coverage once they apply for the program. (CHIPs in Michigan, New York and New Jersey do the same.)

LINKING CHIPS TO WIC

Still, most child welfare advocacy groups remain critical of the CHIP system as offering too little and making applications too difficult. They want children covered automatically.

The 100 Percent Campaign, a California group, has proposed that the state's Medicaid and Healthy Families programs be linked automatically with the state's Women, Infants and Children (WIC), school lunch programs and Head Start. A key characteristic that these other programs share: They don't ask any questions about immigration status.

WIC is a federally funded food and nutrition education program for low-income and nutritionally at-risk pregnant, breastfeeding and post-partum women, and children under age 5. Eligible households must have annual incomes at or below 185 percent of the federal poverty level (FPL); this meant an income of $33,930 for a four-person family in 2004.

> Nutritional risk is indicated by such factors as low
> weight, obesity, anemia or an inadequate dietary
> pattern.

The purpose of WIC is to improve the health of participants during critical times of growth and development. WIC provides participants with nutrition screening and counseling, breastfeeding support and referrals for health care, social and community services.

Families also receive a check or voucher for nutritious food items that can be obtained at local grocery stores. The value of the vouchers depends on the participant but averages $32 per person per month.

The U.S. Department of Agriculture administers WIC through seven regional Food and Nutrition Service offices and 88 state and tribal WIC agencies, including the Department of Health Services in California.

> California has the largest number of WIC recipients
> in the nation, with 81 local WIC agencies providing
> services to 1.21 million participants in all 58 California counties.

WIC does not have citizenship or permanent residency requirements.

In fact, California has tried periodically to link WIC and Healthy Families. The most ambitious effort took place in December 1998, when a letter was sent to all WIC participants in California—who were not on Medi-Cal—informing them that they could enroll in Medi-Cal or Healthy Families at their local WIC site.

The response and enrollment results were unexpectedly low. One reason: Lack of coordination. Families arrived at some sites with the state's letter in hand but WIC program staff members were unfamiliar with it and were unable to assist them.

Also, immigration status remained a problem. WIC program staff members reported that fear of retaliation from the Immigration and Naturalization Service was a prevalent problem among immigrant families. Many immigrant families eligible for Healthy Families feared repercussions on their immigration status or their ability to sponsor an immediate relative. This fear remains—even though WIC programs have stated repeatedly that they don't share information with the INS.

Vermont has done more than any other state in coordinating its WIC and health programs by establishing a joint application for WIC and Medicaid/Dr. Dynasaur—its CHIP program serving children with family incomes up to 300 percent of the FPL. An applicant using the joint application can submit it to either WIC or Medicaid/Dr. Dynasaur. As a result, 97 percent of Vermont's kids on WIC had health insurance at the time of their most recent WIC visit.

When a joint application is received at a WIC clinic, it is reviewed for WIC eligibility and then forwarded, with an income determination worksheet, to Medicaid/Dr. Dynasaur. Since the income eligibility guidelines are lower for WIC than for Medicaid/Dr. Dynasaur, virtually all pregnant women and children found eligible for WIC are income-eligible for health coverage.

Each state handles its Healthy Family program in its own way; some are better at making access available than others. The main thing to keep in mind if you apply for Healthy Family coverage: Don't assume that the first person you talk to knows everything about the program. In many states, program staffers simply don't know all of the details about the programs.

EFFECTS OF STATE BUDGET CUTS

The early 2000s have been tough for many state governments. Budget pressures starting from the federal level have made various hard financial choices necessary. And there's been some cutting back of state-funded health care programs for children.

Most of the kids who lost state-funded health coverage live in low-income working families with incomes too high to qualify for Medicaid and the group of benefits programs loosely known as welfare. Some examples:

- In California, several proposals were submitted to eliminate Medicaid coverage for nearly 300,000 low-income families with incomes between 61 per-

cent and 100 percent of the poverty line ($9,160 to $15,000 for a family of three) and close to 200,000 parents with even lower incomes.

- Changes were implemented in Tennessee's Medicaid program, too. Its TennCare program eliminated health care coverage for between 160,000 and 250,000 adults and children. Here, too, those affected overwhelmingly are people in working families.

- Deep cuts in Oklahoma's health care programs were also approved, including near-elimination of the state's CHIP program.

Other states that made cutbacks affecting lower income families included: Connecticut, Nebraska, New Jersey, Missouri, Montana, Massachusetts, Oklahoma, Tennessee and Washington.

> These losses point to an upward trend in the number of people who are uninsured. From 2000 to 2001, the number of individuals lacking health insurance rose by 1.4 million, mainly because millions of individuals lost their private health insurance in the economic downturn.

Growth in the number of people enrolled in Medicaid and CHIP helped to offset some of these losses. Far fewer people became uninsured than would have, if the public programs weren't able to pick up many of the low-income unemployed. But these people

are the ones most susceptible to being thrown out of state programs because of budget cuts.

In December 2002, the National Conference of State Legislatures released a survey of state legislators and legislative staff that found that, in 2003 and 2004, 44 states expect to consider proposals to limit Medicaid eligibility, cut the health services that Medicaid covers, and/or freeze or cut back payments to health care providers. The findings were similar to those of a survey of state Medicaid directors conducted the previous summer, which reported that most states had already adopted Medicaid reductions—and had plans for more.

The following state actions and governors' proposals are examples of the types of proposals that states make when faced with budget issues:

- *Connecticut.* In December 2003, Governor John G. Rowland proposed a deficit reduction plan that would eliminate health care coverage for thousands of parents and children in low-income working families. The plan also proposed to freeze enrollment in the state's CHIP program and eliminate presumptive eligibility and continuous eligibility, which enabled uninsured children and families to gain and maintain health care coverage. The plan aimed to reduce the Medicaid income limit for parents and other eligible adults from 150 percent of the poverty line to no more than 100 percent of the poverty line, and possibly to a lower level than that.

- *Massachusetts*. In the fall of 2002, the Massachusetts legislature voted to eliminate Medicaid for about 50,000 unemployed adults with very low incomes. In October 2002, its governor also took administrative actions to eliminate coverage for health services such as dentures and prosthetic devices for about 600,000 low-income beneficiaries.

- *Missouri*. In the summer of 2002, Missouri legislature passed a large package of Medicaid cuts. The changes reduced coverage for low-income parents from 100 percent of the poverty line ($15,020 for a family of three) to 77 percent of the poverty line ($11,565 for a family of three), curtailed coverage for about 160,000 new mothers and eliminated dental coverage for about 300,000.

A Kaiser Commission survey found that in fiscal year 2002, some 40 states imposed cost controls on prescription drugs, 22 states froze or reduced provider payment rates and nine states reduced the scope of Medicaid benefits for fiscal year 2003. The survey found states planned much more extensive Medicaid cuts in fiscal year 2003. Some 40 states reported they would impose drug benefit cost controls in 2003, while 29 states said they would reduce provider reimbursements, and 15 states said they would require Medicaid beneficiaries to pay more out of pocket.

CONCLUSION

It's worth noting that most of these cuts focus on standard Medicaid programs—most leave CHIP

programs alone. So, a smart parent should look to the CHIP program first. Not only are its financial qualifications easier to meet (meaning you can make more and still get your kids in the plan), but the plans are usually safer from budget cuts than straight Medicaid.

When CHIP programs do face budget cuts, the cuts usually focus on the types of care covered. For example, dental and vision care might be eliminated, but hospital and physician coverage maintained. From a system-wide perspective, this approach makes sense. The CHIPs are designed to get at least a minimal level of health care coverage to as many families as they can.

6

COBRAs, CAFETERIAs, MSAs & OTHER JOB-RELATED ISSUES

The most common issue for family health care in America is what happens when the family's main earner changes jobs. Because most Americans get their health coverage through their breadwinner's work, changing jobs can be as much about benefits as career-track, money, location or other considerations.

If you have kids, you know how important these benefits are.

The main U.S. law related to job changes and health care is the Consolidated Omnibus Budget Reconciliation Act of 1985—commonly known as CO-BRA—which provides health coverage for qualified people, their spouses and dependent children when people are between jobs. Under COBRA, if you voluntarily resign from a job or are terminated for any reason other than gross misconduct, you're guaranteed the right to continue in your former employer's group plan for individual or family health insurance for up to 18 months, at your own expense.

And, in some cases, non-working spouses and dependent children can buy COBRA coverage for longer periods...sometimes as long as three years.

Your spouse or any of your children may enroll in COBRA independent of your COBRA decision. So, even if you don't use COBRA coverage, your family members may elect to continue *their* health insurance benefits under your former employer's plan. Newborn and newly adopted children of people who have COBRA coverage automatically qualify for the coverage, as long as you enroll them within 30 days of the adoption or birth.

Another point: You don't have to stay on COBRA the whole time—nor will you always be able to—if different health insurance becomes available to you.

Your former employer will not keep paying for your health insurance. You'll have to start picking up the tab. The company can charge you 102 percent of what the coverage under the group plan actually costs (the extra 2 percent is to cover administrative costs). But you can be pretty sure that this amount is substantially less than what you'd pay if you bought your own individual family coverage.

By law, your employer is required to let you know about COBRA and what steps you must take to retain your health insurance coverage.

A caveat: Not every employer has to offer COBRA benefits. The law grants exemptions to the federal government, certain church-related organizations

and firms employing fewer than 20 people. But, even if you worked at a small company that's exempt from the federal law, you might still be able to keep some coverage for your kids. Many states have adopted their own laws, sometimes known as "mini-COBRAs" that grant broader rights in determining eligibility for coverage.

The coverage you receive under COBRA must be identical to the coverage you had before. But, if your former employer changes its health insurance plan for current employees, you may receive benefits under the new plan, even though the benefits may change. In other words, if your former employer switches plans, you cannot keep the old plan.

If your former employer offers an *open enrollment period* to active employees and you're on COBRA, you must also be given the option to switch plans during that time. You may also add new dependents (a newborn, newly adopted child or new spouse) if your employer offers this option.

Your former employer can—but isn't required to— give you the option of dropping such "noncore" benefits as dental and vision care. Since you'll be footing the bill each month for the coverage, dropping these coverages sometimes makes sense.

COBRA coverage ends when:

- you reach the last day of maximum coverage;
- you don't pay the COBRA premiums on a timely basis (usually within 30 days of each month's due date);

- the employer ceases to maintain its group plan for current employees;

- the employer goes out of business;

- you get coverage through another employer plan that doesn't contain any exclusion or limitation with respect to pre-existing conditions;

- you relocate out of your COBRA health plan's coverage area (your former employer is not required to offer you a plan in your new area); or

- a beneficiary is entitled to Medicare benefits (in this case, family members can stay on the COBRA coverage).

Although COBRA sets specific time limits on coverage, there is nothing stopping the health plan from extending your benefits beyond the mandated coverage period. So, it's usually a good idea to ask whether your former employer is willing to extend COBRA coverage longer than the 18- to 36-month terms required by law.

QUALIFYING FOR COBRA

Both you and your former employer need to follow proper procedure to initiate COBRA, or else you could forfeit your rights to coverage.

The employer must notify its health plan administrator within 30 days after an employee—or the employee's family—becomes eligible for COBRA coverage. A "qualifying event" can be any of the following:

- resignation;

- termination;

- death (of the employee);

- reduced hours of employment; or

- eligibility for Medicare.

> **In cases of divorce, legal marital separation or a child's loss of dependent status, it is you or your family's responsibility to notify the health plan administrator within 60 days of the event.**

Once notified, the plan administrator then has 14 days to alert you and your family members—in person or by first-class mail—about your right to elect COBRA. The Feds get tough here: If the plan administrator fails to act, he or she can be held personally liable for breaching the duties. However, the plan administrator must have your correct mailing address. If you move, it's your (or your family's) responsibility to tell the health plan administrator.

You and your family members then have 60 days to decide whether to buy COBRA coverage. This election period is counted from the date your eligibility notification is sent to you or the date that you lost your health coverage, whichever is later. Your COBRA coverage will be retroactive to the date that you lost your benefits (as long as you pay the relevant premiums).

During the election period when you have to choose whether to buy COBRA, you might initially de-

cide not to...and then change your mind. As long as the election period hasn't expired, you can change your mind and choose the coverage—and the CO-BRA coverage would start on the day you notified the plan administrator that you wanted in.

In insurance and human resources jargon, choosing not to use COBRA coverage is called "waiving coverage" and changing your mind is called "revoking the waiver."

If you first say you don't want COBRA coverage, then decide that you do, you may be liable for any medical costs that your family incurred in the interim. On the other hand, if you say nothing and then choose to take the coverage on the last day you can, you'll usually have coverage retroactive to the first day you were eligible. So, there's no reason to rush your decision.

PAYING FOR COBRA

If you choose COBRA coverage, you have to pay the first premium within 45 days. And that first premium is likely to be high because it covers the period retroactive to the date your standard job-related coverage ended. Monthly payments are due according to health plan requirements, but COBRA rules allow for a 30-day grace period after each due date for payment.

COBRA also includes a controversial "short payment" rule. If your COBRA payment is short by an "insignificant amount"—either 10 percent or $50, whichever is the less—your former employer must accept the short payment as payment in full, or notify you of the deficiency and allow you another

30 days from the date that you receive the notification to correct the deficiency.

Regardless of how it pays its premiums, the plan must also allow you to pay premiums on a monthly basis if you want.

Your COBRA premiums can be increased if the costs of the health plan increase for everyone at the workplace—but, generally, they will be set in advance of each 12-month coverage cycle.

> **Neither the health plan nor your former employer are required to send you monthly premium notices, so make sure you pay attention to due dates.**

If the health plan offers former employees the option of converting from a group plan to an individual policy under COBRA coverage, you must be given that option and allowed to switch within 180 days of your COBRA coverage's end. But you'll pay individual—not group—rates, which are almost always more expensive. The advantage of doing this: You will usually be able to keep the individual coverage beyond the COBRA time limits.

THE KENNEDY-KASSEBAUM ACT

In addition to COBRA, there's one other major U.S. law that affects how you can keep health benefits when you change jobs: The Health Insurance Portability and Accountability Act of 1996 (HIPAA), also known as the Kennedy-Kassembaum Act—after the two senators who first promoted it.

HIPAA is designed to ease "job lock," which is the reluctance that many people feel to changing jobs for fear of losing their family's high-quality health coverage. The law limits the extent to which some group health plans can exclude coverage for pre-existing conditions. For instance, if your family has had creditable health insurance for 12 straight months, with no lapse in coverage of 63 days or more, a new group health plan cannot invoke the pre-existing condition exclusion. It must cover your medical problems as soon as you enroll in the plan.

What is "creditable" coverage? It includes prior coverage you had under any of the following:

- a group health plan;
- Medicare;
- Medicaid;
- a military-sponsored health care program;
- health plans offered by the Indian Health Service;
- a state high-risk pool;
- the federal Employees Health Benefit Program;
- a public health plan established or maintained by a state or local government; or
- a health benefit plan provided for Peace Corps members.

On the other hand, if you are not switching from a "creditable" health policy when you enroll in a new

group plan, your new insurer can refuse to pay for any existing medical problems—except pregnancy. And maternity restrictions are only legal for a maximum of 12 months. (That said, there's no U.S. federal law that *requires* health plans to provide maternity coverage, although some states have such laws.)

Basically, HIPAA says that a new health plan has to recognize the time your family was covered under your previous plan—and deduct that from any preexisting condition limits or exclusion periods. If you had 12 or more months of continuous coverage, it can't make you accept any exclusion period; if you had coverage for eight months, you can only be required to have a four-month exclusion period; etc.

Under HIPAA, group health plans can't deny your application for coverage based solely on your health status. And they can't deny coverage because of mental illness, genetic information, disability or claims your family members have filed in the past.

HIPAA's rules apply to any employer group health plan that has at least two participants who are current employees; and the law also applies to larger companies that are self-insured.

There is one major exception to HIPAA: It provides no protection if you switch from one individual health plan to another individual plan.

And, even though HIPAA makes it easier to get coverage from your new employer if you switch jobs, it doesn't guarantee the same level of benefits, deductibles and claim limits you might have had with a former employer's plan. And, as we noted above, the law does allow some waiting periods before coverage kicks in. So, you may need to keep your COBRA coverage from the old job while waiting for the new coverage to take effect.

To comply with HIPAA rules, whenever you leave a job with health benefits get a "certificate of creditable coverage" in writing. This will simplify matters when it comes time to join the group plan at your next job. A certificate should list the following:

- coverage dates;
- policy ID number;
- the insurer's name and address; and
- any children or family members covered by the policy.

This is the easiest way to ensure maximum protection under HIPAA. But, if you can't or don't get a certificate, you can use other evidence to prove creditable coverage, including:

- pay stubs that reflect a health insurance premium deduction;
- explanation-of-benefit forms;
- a benefit-termination notice from Medicare or Medicaid; or
- a verification letter from a doctor or former health insurance provider.

IF YOUR EMPLOYER CUTS BACK ON HEALTH BENEFITS

HIPAA also helps if your employer drops group health coverage. In short, the law can make it easier to get an individual health policy for your family.

Under HIPAA, you might be able to buy an individual health plan without the threat of exclusions for pre-existing conditions. In order to do so, you have to qualify as an "eligible individual." To be eligible as an individual under HIPAA, you must:

- have had at least 18 months of continuous creditable coverage;

- have been covered under a group health plan, a governmental plan or church plan (or health insurance offered in connection with such plans, such as COBRA) during the most recent period of creditable coverage;

- not be eligible for coverage under a group health plan (including a spouse's plan), Medicare or Medicaid;

- not have other health coverage;

- not have lost your most recent health coverage due to non-payment of premiums or fraud (unless your employer failed to pay premiums); and

- have elected and exhausted any option for continuation of coverage (under COBRA or a similar state laws) that was available under your prior plan.

In some states, if you qualify for individual health coverage under HIPAA, any company offering individual health plans in that state must sell you coverage. In these situations, the HIPAA individual coverage works much like a state-sponsored risk pool—though the HIPAA will usually have fewer exceptions and exclusions.

HIPAA does not limit the premiums health plans can charge for individual family coverage. So, while your application won't be rejected because of past health problems in your family, the premiums for individual coverage can be much higher than for group plans. Also, the benefits available under individual family coverage can change dramatically from plan to plan. So, comparing plans—both for cost and benefits—is more important when you're buying individual family coverage. Even if you can count on HIPAA protections.

OTHER OPTIONS

If your COBRA coverage is about to expire and you expect to start another job that provides health insurance soon, a *temporary insurance policy* might be a good choice for filling in the gap.

This sort of coverage is expensive and has lots of limits; but it will protect you and your family from catastrophic medical expenses. Simply said, a temporary health policy is a form of individual family coverage. It usually will have a deductible, then will reimburse you for a percentage of your costs. Most temp plans will reimburse you on a percentage basis up to a set amount (sometimes $5,000), then pay 100 percent of costs above that threshold.

But, following the peculiar logic of insurance, the coverage will usually be less expensive because it's short-term.

A temporary medical policy will pay typical hospitalization costs—but only for procedures that are medically necessary, at rates that are usual and customary—as well as recovery costs, including time in a nursing home or in-home visits from a registered nurse. It often will not pay for any condition you had during the 24 months prior to the start date of the policy, or for any self-inflicted injuries or job-related injuries or illnesses that might be covered by worker's compensation insurance.

Also excluded, coverage for:

- dental treatment;
- routine physicals and immunizations;
- routine pediatric care of a newborn;
- normal pregnancy or childbirth;
- sterilization (or the reversal of sterilization);
- mental illness, alcoholism or drug abuse;
- prescription drugs and medications that you get when you are not confined to a hospital; and
- treatment outside the United States.

Also, temporary health insurance tends to come with rigid time requirements. If you purchase 120 days' worth of temporary coverage and get a job in 30 days, the temporary insurance usually can't be can-

celled. (With standard individual family coverage, if you change to some other sort of medical insurance, you could get a refund—less administrative expenses—for the unused portion.)

> Another relatively new option is the tax-free medical savings account (MSA), which combines a long-term savings account and a high-deductible health insurance policy.

MSAs began as part of a pilot program that was put in motion by HIPAA. The pilot program allowed no more than 750,000 policies to be distributed—and those early policies were marketed primarily to high-net-worth individuals and the self-employed.

An MSA includes the actual savings account, which—like an IRA—is funded with pre-tax dollars. These contributions lower your taxable income. Then, you can use the money in the MSA to pay a variety of medical expenses.

You also use the pre-tax dollars to buy some form of high-deductible, catastrophic health insurance policy (usually offered in tandem with the MSA by the same company). The annual deductible for a single person must be between $1,500 and $2,250; for families, between $3,000 and $4,500.

A family can contribute up to 75 percent of the deductible into the MSA each year.

MSAs also allow you to use money for a broader range of services than are covered by most health

plans. The funds in an MSA can cover small, every-day medical or drug expenses—as well as dental care, eyeglasses, psychotherapy or home health care.

Money that you put into an MSA grows tax-free, like an IRA or a 401(k) retirement plan and accumulates over time. If the annual premium is not exhausted at the end of the year, this amount will roll over into the next year; when you turn 59½, the money in the account becomes your property and is no longer restricted to use for health care.

This is why MSA policies are being marketed as investment tools—since the leftover money can be rolled over year after year and collect interest.

CAFETERIA PLANS

MSAs are a variation on the more common, tax-advantaged cafeteria plans. The phrase "cafeteria plan" refers to the way in which you can spend proceeds from the account on specific needs that may arise, like choosing dishes in a cafeteria line. Some insurance professionals prefer the more technical descriptions "flexible-spending accounts" or "Section 125 plans" for the plans. (They're regulated by Section 125 of the Internal Revenue Code.)

Cafeteria plan money is placed into an escrow account. Whenever you have a medical cost that is not covered by your insurance, you submit a claim to the company that manages your employer's cafeteria plan, and that firm debits your account and sends you a check.

Any company can set up a cafeteria plan for its employees; this allows the employees to pay for a full menu of medical expenses with pre-tax dollars. This not only reduces taxable income for employees—making the benefits virtually free—it also reduces taxable payroll for the employer.

You can use the money from a cafeteria plan to pay for various deductible expenses. These can include:

- health insurance premiums;
- unreimbursed medical expenses (including copayments for doctor visits or prescription drugs);
- dependent care and child care expenses,
- alternative medical treatments (including acupuncture and chiropractic);
- treatment of alcoholism;
- programs to lose weight or quit smoking;
- vision care (eye doctor visits, glasses, contacts, etc.);
- birth control pills (which some health plans don't cover);
- dental fees, dentures and orthodontia;
- psychiatric care; and
- hearing aids.

If your employer offers a cafeteria plan, you choose the amount you would like to have withheld from each paycheck. If you typically spend $200 a month on child care and another $50 on prescription

copayments, for example, you might elect to have $250 a month withheld from your paycheck. If you also have annual expenses for glasses, copayments for checkups, dental visits and so on, you can have an additional amount deducted each month to cover these costs, as well.

A cafeteria plan can be a very good way to save money on health care costs. However, the key is to avoid having too much money deducted from your paycheck. The money you put into a cafeteria plan each year *must* be used for health care costs. If there is money left over, it can't be rolled over into the account for the next year or returned to you. For all practical purposes, it's gone.

Cafeteria plans do tend to be somewhat complex and expensive to administer—so, they usually make sense for larger employers.

CHANGING FAMILIES INSTEAD OF JOBS

When it comes to your children's health coverage, there are many similarities between changing jobs and changing spouses. In fact, the various U.S. benefits laws apply many of the same programs to people changing jobs and families split by divorce.

If you and your children are on a group health plan through your spouse's job and you get divorced, you and your children might be eligible for CO-BRA coverage, allowing you to keep the same exact health benefits for as long as 36 months.

A better strategy might be for you to take COBRA and keep the children on your ex-spouse's plan. This approach will work, as long as you and the children stay in the health plan's service area and you can afford the premiums. It's a concrete reason for staying in the same area...and maintaining cordial relations with your ex—for the kids' sake.

If you move, the chances are greater that you'll be out of the service area of your spouse's plan—especially, if it's a managed care plan. In this case, you'll need to pay attention to the shopping protections offered by COBRA and HIPAA for people moving between jobs.

And, if your kids split time between you and your ex-spouse, you should look for a managed care plan that offers national coverage. For example, Blue Cross has an HMO plan called "Away From Home Care" that offers coverage nationwide. If your child is enrolled in that HMO, the child is covered even if you and your ex-spouse live in different states. Unfortunately, these plans aren't sold in every state.

Otherwise, an individual indemnity policy for each child might be the best solution. With an indemnity policy, your kids can see virtually any doctor—no matter where they're staying when they're injured or ill. But these policies are expensive and difficult.

In most states, individual health plans (that aren't part of state-sponsored insurance pools) can turn down your child due to medical conditions, such as asthma or a history of ear infections. The plans can also accept your child but refuse to cover certain

existing medical problems, which means you'll have to pay for a lot of things out-of-pocket And the plans often exclude coverage for wellness or preventive care—important matters for kids.

If money is a problem, you can apply for state-sponsored children's health coverage—which we considered in detail in a previous chapter.

CONCLUSION

If you have kids, you probably need to work in order to provide health coverage almost as much as to earn money. So, changing jobs can be a nervous process for families with children.

Since the mid-1980s, U.S. health care laws have made changing jobs easier. COBRA and HIPAA assure consistent health coverage that provides steady benefits. The laws don't give you coverage for free; you'll still have to pay—and sometimes pay a lot—for your kids' health insurance. But they do assure reliable levels of medical services and care.

And, the more often you change jobs, the more important this steady and reliable coverage becomes.

7

CHAPTER

SCHOOL
PROGRAMS, ETC.

In earlier chapters, we took a look at the various programs—traditional insurance companies, managed care plans and government agencies—that help provide health coverage for kids. But one of the most important health care programs for many children is related to the place that they spend most of their waking hours: School.

School health programs involve everything from physical hygiene and sex education to public health programs, diet and nutrition and medical care far beyond the "nurse's office" that most adults remember from their own school days. Parents or guardians of school-aged children should be aware of how much health care service is delivered at school...and what this can mean for their kids.

SCHOOLS AND DIETS...AND OBESITY

When it comes to diet and nutrition matters, the middle school years (fourth through sixth grades) are often a bigger crisis point than junior high or high school. In these years, kids often develop poor

nutrition habits. For the first time, they're making their own choices at cafeterias and snack bars in school. While some schools are careful about the foods they make available to kids, others are not.

According to a 2003 study co-authored by Baylor College of Medicine nutritionist Karen Weber Cullen, consumption of healthy foods—fruits, non-fried vegetables and non-processed dairy products—dropped by at least a third among children in one Texas school district when they made the transition from primary to middle school. Perhaps more importantly, the students ate almost 70 percent more junk food—things like french fries and sweetened beverages—than they did the year before.

Cullen pointed out that most school diet studies focused on cafeteria menus, which don't always reflect what kids are actually eating. For example: Diet studies rarely consider the food and drinks offered at school snack bars. These items lean heavily toward junk food. Few elementary schools have snack bars, but middle and high schools often do—giving students as young as 10 years old the chance to buy food ranging from fruit and salads to soft drinks and candy.

Cullen's study surveyed nearly 600 fourth- and fifth-graders in a southeast Texas school district from 1998 to 2000. Offered three options—bringing food from home, buying a hot lunch or choosing items at a snack bar—35 percent of the students told Cullen that they chose to "graze" entirely at the snack bar.

Many students even went to the snack bar after receiving a subsidized hot lunch for free.

The study concluded that part of the problem was that the snack bars didn't offer fruit. And, even when a snack bar did stock healthier food, it seemed not to appeal to the students.

Cullen's suggestion: Better presentation of healthy foods. Oranges require peeling and can make a mess for students pressed for time between classes. School districts could make fruit more appealing by cutting and slicing it. And fruit juices or bottled water could become a bigger seller, if offered at the same price as smaller bottles of soft drinks.

JUNK FOOD MONEY

Sadly, junk food is often a financial matter for schools and school districts.

Schools often put soda and candy machines in their hallways because they need the money that the machines generate to fund extra-curricular activities and other expenses that are often the first things cut by tight-fisted state politicians.

Cash-strapped districts can make money—millions, in some cases—by signing exclusive contracts with Pepsi or Coca-Cola to stock vending machines in schools. In 2003, Hillsborough County, Florida (which includes Tampa), signed a 12-year contract with Pepsi expected to bring in $50 million.

Traditionally, vending machines on public school campuses were restricted in the U.S. by federal and state regulations; but many of these rules were relaxed during the 1990s. For example, in 1999, the state of Florida allowed its high schools to make

their own decisions about candy and soda machines—and keep the proceeds of machines, if they chose to have them. Most decided to take the money.

But a strong backlash has followed in the 2000s.

Groups like the American Academy of Pediatrics, alarmed by rising rates of child obesity in the United States, have started opposing these business deals. The AAP has issued public statements that soft drinks don't belong in schools and called on pediatricians to help get rid of them. The Center for Science in the Public Interest, a Washington, D.C.-based consumer group, has been making soft drinks sound like obesity-in-a-can for years. The group labels soft drinks "liquid candy" in its reports about rising soda consumption.

> **Legislation to restrict school vending machine sales has been filed in more than 15 states, including Florida.**

From California to New York, individual school districts and schools have kicked out soda.

The soaring numbers of childhood obesity in the U.S. has forced school administrators' hands. In 2003 and 2004, school districts around the U.S. started to reconsider their snack policies and cafeteria menus. About 20 states restricted student access to junk food until after lunch; and about two dozen states were considering total bans or limits on vending machine products.

One example: The Texas Agriculture Department started revamping the rules on what food the state's public schools can serve to their 4.2 million students. Among the new rules: Canned fruits had to be packed only in natural juices or light syrups; milk had to be reduced-fat or non-fat; potato or corn chips had to be reduced-fat or baked. Deep fat frying was banned entirely. Texas school districts had to follow limits of how much fat and sugar a meal could have.

Noting that some 38 percent of Texas fourth-graders were overweight, Agriculture Commissioner Susan Combs also banned "foods of minimal nutritional value"—including sodas, hard candy and gum—during the primary school day and at middle-school lunches.

CLASHING POLITICAL AGENDAS

Diet and nutrition aren't the only places that the school bureaucracy can fail kids. The conflicting political agendas of teachers, administrators and parents often make important matters "dead issues" that can't be discussed rationally. As a result, public health and security policies in public schools sometimes end up tripping over basic medical needs of individual kids.

Iowa public schools experienced exactly this sort of problem in the early 2000s, when they banned asthma inhalers from school grounds as part of an ill-conceived "zero tolerance" policy to drugs at school. Pretty quickly, parent groups complained that the school policy actually put kids who suffered from asthma at risk for serious attacks—if they

tried to bring their medicine inhalers to school (the devices were often confiscated by administrators).

In the spring of 2004, a group of state legislators drafted a bill that would require Iowa schools to allow students to carry and take their asthma or breathing medication with a parent's written approval—and as long as a school liability waiver was also signed by the student's parent or guardian.

The same public health advocates who'd championed the "zero tolerance" policy quickly realized that the asthma inhaler ban had gone too far. They agreed with the new bill, admitting that allowing kids to carry their medicine would encourage "acceptance of adult responsibility." That public policy aim was well and good—but the real point was to help asthmatics breathe.

Public health remains a mixed-bag of government efforts and results.

In California, some counties used settlement money from the state's lawsuit against tobacco manufacturers to develop what they called Perinatal Outreach and Education (POE) programs. The programs were instituted to enhance the health of Los Angeles county infants and their mothers and to lower several barriers to health care, including barriers to:

- prenatal care among low-income pregnant women;

- health care insurance coverage among low-income women and their children;

- health education among low-income women; and

- care coordination/case management among pregnant and post-partum women and female adolescents.

That last item caused some controversy.

In some cases, POE staffers worked with school health care providers to deliver child-bearing information to junior high- and high school-aged girls. While the intent may have been good, the effect— lessons on family planning, pregnancy nutrition, breastfeeding, etc.—seemed to condone young, unmarried girls having children. If nothing else, these sorts of programs ignite political tensions that make the news...but don't do much for kids' health care.

A SIMPLE FOCUS WORKS BEST

School health care programs tend to do better when they focus on basic, clinic-like services.

A growing number of school administrators, principals and public health officials conclude that the best way to reach uninsured children and teenagers is to offer free medical care at school. Education professionals see the matter simply as a necessary tool for making sure that kids are well enough to focus on their studies.

In 2003, at least 44 of the 50 states in the U.S. supported in-school medical care. But the tool isn't cheap—and remains controversial in many places.

First, the cost issues: In most cases, school-based "mini-clinics" will require a registered nurse or nurse-practitioner, a mental-health counselor and at least a part-time doctor. This can mean $100,000 in personnel costs before the first exam takes place. In most states, the state government makes money available to school districts (which usually operate at the county level) to set up the programs. But this money is tight.

Nationwide, there are an estimated 1,500 school-based health centers at the middle-school to high-school levels. Most of these—as many as four out of five—don't qualify for federal money because they don't have governing boards or other oversight structures.

So, many school districts partner with local hospitals or health care systems to arrange medical professionals on a part-time basis. In some cases, these MDs and nurses volunteer their time; in other cases, state education grants or public health grants pay them (or the hospitals where they normally work).

Beyond these arrangements, many schools and school districts solicit private donations to keep their clinics open, equipped and staffed.

One principal in a mid-western state says, "We have enough kids who need medical care that we could keep the clinic busy 24/7. The key to keeping to open even for school hours is finding grant money. Luckily, our district has a grant-writer on staff who looks for money and helps file the applications. And I've got a few parents who volunteer their time for grant-writing."

In many school districts, one clinic at a high school or junior high will serve several schools in a geographic region. Many of these clinics offer an impressive list of services—from physical exams to immunizations, blood tests to counseling.

In most cases, no insurance is necessary. Students only need to make an appointment and have parental permission.

Therein lies the second big issue: the controversy of parental permission.

In many school districts, both the students who use school clinics and their families are worried about privacy issues. School districts set clinic policies to reflect local preferences but privacy—especially with regard to sex, drinking and drug use—is an issue everywhere. Kids worry that clinic staffers will report their behavior to parents...and parents worry that the clinic staffers will co-opt their parental authority.

At the high-school level, sex is an unavoidable reality. Clinics usually make information about pregnancy, contraception, sexually-transmitted disease and sexual abuse available to any student who asks; in many cases, though, the school clinic will not be allowed to hand out contraceptives or do more than refer students to other facilities for treatment.

And most medical professionals are bound by confidentiality standards—regardless of where they're

seeing patients. The exceptions to these standards usually aren't related to reporting to parents: They are related to matters of sexual or physical abuse. If the providers see evidence of such abuse, they're obligated to report to state health authorities.

MENTAL HEALTH CARE IS IMPORTANT

Just as health care in general pays dividends when given to young people, mental health care—so often not covered by managed care plans—is cost-effective for kids.

According to a report in the March 2004 issue of the *American Journal of Public Health*, suicide attempts declined by 40 percent among high school students exposed to mental health programs.

The study looked at one such program—the SOS High School Suicide Prevention Program, created by the nonprofit organization Screening for Mental Health, Inc. It was the first school-based suicide prevention program to show a reduction in suicidal behavior in a randomized, controlled study.

The study included 2,100 students at five schools in Connecticut and Georgia.

As well as a reduction in attempted suicides, students enrolled in the program showed a greater knowledge of, and more adaptive attitudes about, depression and suicide.

SOS combines two suicide prevention strategies—depression screening and education about suicide

and mental illness—into a single, quick and inex-
pensive program.

CONCLUSION

Because of the political debates over sex education
(let alone treatments) and reporting requirements,
some states swing back and forth on funding the
clinics. In Massachusetts, for example, the state
closed its 70 school-based health centers in 2003
because politicians in Boston were bickering over
their funding. The state legislators later restored
enough funding to allow 45 of them to reopen, but
that money was only budgeted for one year...so
the politics were likely to come into play again.

Despite this politicking, expanded school clinics
are likely to become more common. Community
health clinics—of which school clinics are a par-
ticular subset—use a combination of public and
private funding to provide affordable or free health
care to local residents. Conceptually, they're a fa-
vored health care alternative for policy makers of all
political stripes.

George W. Bush has generally encouraged these
clinics as a cost-effective alternative to federal health
bureaucracy. In 2003, he called for increased fund-
ing for clinics—up to $2 billion a year by 2006.
Some of this money will filter down to schools.

Fittingly, one of the biggest benefits of school-based
health clinics may be educational. Public health
experts argue that one side effect of having a large
number of uninsured families is that their kids never
learn how to use medical services...how to see a

doctor before a health issue becomes acute or life-threatening. In this sense, the school clinics teach older kids how to think of medicine as a preventive measure.

And that's certainly a valuable lesson.

CHAPTER 8

WHEN YOUR CHILD NEEDS SPECIAL CARE

Some of the most disturbing news that any parent or guardian can get is the solemn words from a doctor, "I have bad news about your child."

A child's serious illness or injury seems like life's worst unfairness. Because kids have so much more of their lives in front of them, the impact of health problems is even greater than it is for an adult. (This is a concept even insurance actuaries understand.) However, for this very reason, your role becomes even more important when your child has a special health care need.

Your first response to finding out that your child has a medical condition will probably be emotional—fear of the consequences or anger over the harsh randomness of fate. This is natural and usually eases with time. But, until it does, seeking out support from others who've experienced what you are often helps. Your doctor or hospital should have some information about groups of parents in your area who have children with the same condition.

The other thing to do is educate yourself about your child's condition. Start by asking your child's doc-

tors lots of questions; and keep a written record of the answers. Many parents who've lived through children's health crises recommend keeping a binder—filled with pages of the questions you've had and the answers you've been given by whom. And keep information from the money-side people as well as the health care providers. Knowing who said what to you and when can be useful for settling disputes with insurance companies, managed care plans, state agencies, etc.

Also, ask for second opinions...again, from both providers and payers. One of the great secrets of health care is that it's more negotiable than lay people think. This applies to the treatments or prescriptions a doctor suggests to the settlements a claims manager is willing to make. People who don't work in the business sometimes accept first offers because they'd rather have an easy answer than the right one. As your child's primary advocate, you can—you must—demand more.

Once the initial emotion of learning about a child's health problem recedes, you'll find out pretty quickly that administrative issues...and paperwork...will be an even bigger part of your life. And this is true whether your child has traditional health care or is enrolled in a state program. You'll probably also find out that kids are resilient, both physically and psychologically.

As time goes on, you may find yourself serving as the main contact point among various care providers and business-end people. You'll know more about your child and his or her condition than some professionals...and you may have to get used to

bringing care-givers up to speed. Some people find it frustrating to be in this position; but you can turn it into an advantage. By playing an active role in your child's care—and letting everyone know that you're going to—you can improve the quality of care he or she gets.

> The silver lining to childhood health problems is that many conditions that were fatal even a decade ago (cancer, especially, comes to mind) can be managed as chronic conditions, if not cured, today.

In fact, for children—just as for adults—medical advances have given most Americans the luxury of turning their health care attention from fatal conditions to chronic ones. This is one of the several reasons that many kids are treated for conditions like Attention Deficit/Hyperactivity Disorder and food allergies. The resources are generally available for handling any special medical needs your child may have. You just need to know how to get them and, once you've got them, how to manage them.

In this chapter, we'll take a quick look at several common diseases and conditions that affect children—and how the U.S. health care industry deals with each.

LEUKEMIA

The term *leukemia* actually refers to several distinct cancers of the white blood cells (also called *leukocytes* or *WBCs*). Leukemia is worth considering because

it's the most common type of cancer among people under 18 years of age. When a child has leukemia, large numbers of defective white blood cells are produced in the bone marrow. These abnormal white cells crowd the bone marrow and flood the bloodstream, but they can't perform their proper role of protecting the body against disease.

As leukemia progresses, it interferes with the body's production of other types of blood cells, including red blood cells and platelets. Initially, leukemia cells may appear only in the bone marrow and blood, but later they may spread elsewhere, including the lymph nodes, spleen, liver and brain.

Cases of leukemia are classified as either acute (rapidly developing) or chronic (slowly developing); almost all cases of childhood leukemia are acute. Childhood leukemias are further divided into acute lymphocytic leukemia (ALL) or acute nonlymphocytic leukemia (ANLL), depending on whether they involve specific white cells called lymphocytes.

ALL generally occurs in younger children ages 2 to 8, with a peak incidence at age 4; AML may be seen in infants during the first month of life, but then it becomes relatively rare until the teen years.

Children who have inherited certain genetic problems—such as Down's syndrome, Kleinfelter syndrome and neurofibromatosis—have a higher risk of developing leukemia, as do children who are receiving drugs to suppress their immune systems after organ transplants.

Most leukemias arise from noninherited mutations in the genes of growing blood cells. Because these errors occur randomly and unpredictably, there is no effective way to prevent most types of leukemia.

The most common medical treatment for leukemia is radiation therapy combined with bone-marrow transplant; in some cases, a doctor may opt for chemotherapy instead. The good news is that cancer specialists have gotten very good at treating leukemia with radiation.

The main side effect of the radiation therapy is that, in addition to wiping out the cancer, it almost always wipes out all of the patient's bone marrow. This is the reason that the bone marrow transplant becomes necessary. In some cases, bone marrow will be "harvested" from the patient in advance of the radiation therapy and replaced afterwards; in other cases, it will be harvested from a family member or other donor when it's needed.

The bone marrow transplant can be painful, time-consuming and expensive—more so than the radiation itself. Until the mid-1990s, many managed care plans and some insurance companies refused coverage for radiation therapy and bone-marrow transplants because, they claimed, the procedures were "experimental." A series of high-profile lawsuits gutted this argument. Now, just about all plans cover radiation (or chemotherapy) for kids.

While cancer experts warn against looking for "cures," the prospects for a child with leukemia have improved dramatically in the last 20 years. By one estimate, 80 percent of children diagnosed with leukemia can expect to survive.

CYSTIC FIBROSIS

While leukemia is the most-common acute cancer that strikes children, *cystic fibrosis (CF)* is perhaps the best-known chronic disease. CF is an inherited condition that affects tissues that produce mucus secretions; these include the tissues that line the airways in the lungs, the gastrointestinal tract, the ducts of the pancreas and the ducts of the liver.

In short, CF changes the chemical properties of mucus, causing thicker mucus that can lead to obstructions in the respiratory and digestive systems. In the respiratory system, this means obstructed airways and conditions that lead to repeated infections in the lungs; in the digestive system, it means obstructed ducts in organs involved in digestion.

CF can interfere with the normal processes of the liver, the pancreas (the organ that secretes the hormone insulin, which the body uses to break down sugar and that produces digestive enzymes) as well as other organs that are part of the digestive process. This makes it difficult for persons with cystic fibrosis to digest food and absorb nutrients.

Frequent and prolonged inflammation in the lungs eventually results in cardio-respiratory failure, the primary cause of death in people with CF. This often comes when the person is in his or her late 20s or early 30s.

Cystic fibrosis is an inherited genetic disorder. The gene that causes cystic fibrosis is recessive, which means in order to get the disease a child must inherit the gene from both of his or her parents.

If you only inherit the gene from one parent, you become a carrier (you will not get the disease, but you can pass the gene on to your children). If you are a carrier and you and another person who is a carrier have a baby together, each child will have a 25 percent chance of having the disease and a 50 percent chance of being a carrier.

There is no single therapy that cures CF. If the disease is identified early enough, a combination of treatments can reduce its effects and lengthen—and improve the quality of—a child's life. These treatments include the regular use of:

- antibiotics for lung infections;

- decongestants, bronchodilators (drugs that open airways congested with mucus) and anti-inflammatory drugs;

- chest or back clapping (to loosen mucus from lungs) and postural drainage (to drain mucus from lungs);

- pancreatic enzymes (to aid digestion);

- a diet rich in proteins and calories; and

- vitamins and other dietary supplements (to add more nutrients to the diet).

A lot of genetic research is focused on finding chemical "gene therapies" that could eliminate CF and its effects. But these treatments truly are experimental and may be decades away from reliable use.

In the meantime, from the financial perspective, CF means a steady, regular use of moderately expensive prescription drugs. Most managed care pro-

grams and insurance policies cover these drugs—though the effect of out-of-pocket copayments and deductibles could take a major toll after several years. If your child is going to be on a steady schedule of prescription drugs, it will be important to find out about the maximums on your coverage—both the maximum that you have to pay in any given period and the maximum (if any) that the plan will pay over the course of your child's life.

STEM CELLS AND CORD BLOOD

Both the bone-marrow transplants related to leukemia treatments and the gene therapies being tested for conditions like CF bring us to a controversial topic—stem cells.

Leaving politics aside, the reason that stem cells are useful is that they can be used to replace bone marrow and for the gene therapy that's considered the best prospect for curing genetic conditions like CF.

Controversy surrounds stem cell use because the cells are usually harvested from aborted fetuses; and any large-scale effort to harvest them not only would rely on abortions...but might lead some families to use pregnancy to sow the stem cells for later harvest. Even if you support government-funded stem cell research some people believe there is an undeniably troubling quality to the prospect of conceiving merely to generate stem cells.

There are some options to consider—especially if you're pregnant and you know there's some chance that your baby might have a genetic condition like CF. When your child is born, you can choose to bank his or her "cord blood."

During the 1970s, medical researchers discovered that umbilical cord blood is a rich source of blood-forming (hematopoietic) stem cells. This particular kind of stem cell is found primarily in the bone marrow; and it's capable of developing into any of the three types of mature blood cells—red blood cells, white blood cells and platelets. (This type of stem cell may also develop into other cell types, though research on that question is still pending.)

Umbilical cord blood can be collected easily and stored...somewhat easily. In many cases, hospitals already do this—sometimes without making the practice clear to the women having babies. The cord blood is frozen in liquid nitrogen and kept in a collection facility, also known as a cord-blood bank.

The blood-forming stem cells can be thawed later and used in either autologous procedures (when a person receives his own umbilical cord blood in a transplant) or allogeneic procedures (when a person receives umbilical cord blood donated from someone else—a sibling, close relative or donor).

You can request that cord blood be collected when you have a baby. Collection takes place shortly after birth (whether you have the baby traditionally or by cesarean); it's done using a specific kit that your OB/GYN can order from a cord-blood bank.

How long can blood-forming stem cells last when properly stored? The maximum time for storage and use is still being determined; but blood-forming

stem cells stored up to 14 years have been used successfully in transplants.

The cost of storing core blood—and who will bear this cost—is less clear. In most cases, an insurance company or managed care plan will not cover storage unless it's medically necessary. In some cases, if you have a family history of conditions like leukemia or CF, your OB/GYN or primary care physician may be able to make the case that storing the blood is necessary and cost-effective.

If you have to pay for blood storage yourself, the market for storing blood (and semen and other bodily fluids) has become fairly consumer-friendly. As in any market-responsive industry segment, prices for storage can vary dramatically. Make some calls *before* the baby is due and get quotes for long-term (more than six months) storage. In most cases, after you pay a set-up fee, the monthly charge should be less than a dinner out.

OBESITY

CF is a chronic disease that hurts and kills children. Obesity is a chronic condition that does the same—though not as quickly.

Through the 2000s, the U.S. health care industry has turned a collective blind eye to the fattening of Americans and, especially, American kids. But the health effects of heaviness are starting to take a measurable toll on U.S. medical expenditures; so, insurance companies, managed care plans and other financing entities have started paying more attention to obesity.

Some of this attention has taken the form of dietary and nutritional education programs for plan members (and this is especially true for families participating in state CHIPs). But, despite their best efforts, insurance companies aren't as good at consumer education as they are at discouraging risky behavior by raising premiums. That's a trend that many risk experts predict for the 21st Century: Closer insurance underwriting attention to weight—and higher insurance costs for fat people.

The actuarial evidence backs up the predictions.

The best measure of obesity is the body mass index (BMI), which is the ratio of weight in kilograms to the square of height in meters. Standard pediatric growth charts for the U.S. population include BMI for age and gender; these are readily available online, including at the Centers for Disease Control and Prevention's Web site (*www.cdc.gov/growthcharts*).

BMI between 85th and 95th percentile for age and sex is considered at risk for overweight; BMI at or above the 95th percentile is considered overweight or obese.

The incidence rate of obesity among children and adolescents doubled between the 1980s and 2000s.

In the early 2000s, 15.3 percent of 6- to 11-year-olds and 15.5 percent of 12- to 19-year-olds were at or above the 95th percentile for BMI, with even higher rates among subpopulations of minority and economically disadvantaged children.

The U.S. Surgeon General's Office has predicted that morbidity and mortality associated with obesity may exceed those associated with smoking.

Fat children are more likely to have high blood pressure and high cholesterol. They're more likely to develop diabetes, have pulmonary problems (asthma, sleep apnea, etc.), orthopedic problems and gastrointestinal trouble. And, adding insult to injury—literally, they're more likely to have psychological problems.

Obesity lingers. The probability of childhood obesity persisting into adulthood ranges from about 20 percent at age 4 to 80 percent by adolescence.

It's long been recognized that obesity "runs in families"—high birth weight, maternal diabetes and obesity in family members all are factors—but it's also true that interaction between genetics and environment affects weight. Some examples:

- The extent and duration of breastfeeding have been found to be inversely associated with risk of obesity in later childhood. Why does mother's milk keep kids from getting too heavy? The chemistry of the milk may encourage healthy development; more likely, breastfeeding correlates with other parenting patterns that head to a healthier lifestyle.

- Adolescence is another critical period for development of obesity. The nor-

mal tendency for hormonal changes during early puberty creates spikes in body chemistry that are natural cofactors for excessive weight gain. Girls who start menstruation early are up to twice as likely to be obese at some point in their lives than girls who start later.

- The brace of psychological issues that health care experts cautiously call "food insecurity" also lead to obesity. These issues can include excessive parent/child conflict, overcontrolling parents, family instability, the child's socio-economic status and unhealthy eating habits learned from parents—even if they don't fight too much.

But even if they don't have food insecurity, kids in the U.S. are less active in the early 21st Century than earlier times. Leisure activity is increasingly sedentary, with wide availability of entertainment such as television, videos and computer games. In addition, with increasing urbanization, there has been a decrease in frequency and duration of physical activities of daily living for children, such as walking to school and doing household chores. Changes in availability and requirements of school physical education programs have also generally decreased children's routine physical activity.

All of these factors play a potential part in the epidemic of obesity—but the sedentary lifestyle is perhaps most important. Kids who watched four or more hours of TV per day had significantly greater BMI, compared with those watching fewer than two hours per day. Having a TV in the bedroom has

been reported to be a strong predictor of obesity, even in preschool-aged children.

The best way you can avoid obesity in your kids is to breastfeed them, maintain a stable home, teach them good eating habits (without being overcontrolling) and—most important—keep them active. Don't let them plug into MTV or their Gameboys.

These efforts will pay dividends over time. Health insurance underwriting will focus on weight issues increasingly in the 21st Century; companies may ask for BMI numbers as commonly as they ask for blood samples. And overweight people—including kids—will pay more for coverage.

ATTENTION DEFICIT DISORDER

Perhaps the biggest chronic condition facing kids in the U.S. is Attention Deficit/Hyperactivity Disorder (known as ADHD, more commonly, ADD).

ADD is controversial for several reasons, but two stand out. First, the drugs that are prescribed to help kids manage the disorder may have serious side effects; second, the disorder itself may be overdiagnosed by doctors eager to give "medical" explanations—which insurance companies will accept—for a child's erratic or destructive behavior.

We'll consider the second issue first.

Pediatricians and pediatric psychiatrists are diagnosing mental illness in children at increasingly young ages. The diagnoses include conditions (including manic depression and schizophrenia) once

thought to appear exclusively in adults and older adolescents. But some doctors insist that children are still just developing emotionally and psychologically—and that they're too young to suffer from advanced psychiatric disorders. So, ADD remains the most frequently diagnosed head case among children.

Why so many cases? Some doctors claim that they're just becoming aware of mental illness among kids. That claim is dubious. More candid MDs say the trend is the result of managed care plans—and the effects of managed care on traditional insurance and government programs. Managed care plans prefer clear diagnoses that can be treated by approved prescription drugs to psychiatry's more complex conditions and open-ended, talking-therapy cures.

HMOs insist drugs work. They point to various studies, including one that concluded drug treatment helps about 70 percent of children with ADD—as opposed to counseling, which only improved symptoms in about half of them. This is a twist on the traditional managed care approach to debated medical conditions; instead of denying any coverage because of expert dispute, the plans encourage drug therapy. As one Texas MD notes ruefully, "The only thing HMOs hate worse than drug bills is years of therapy sessions."

But the pressure for easy, prescription cures leads to some bad results. In early 2004, the U.S. Food and Drug Administration warned doctors not to prescribe the popular antidepressant Paxil to children for depression, citing evidence that the drug could increase the risk of suicide.

The growing wariness about drug therapies is partly due to suspicions about the diagnosis of ADD. There's no single test for the condition, and doctors don't always agree on a diagnosis. Not even medical experts understand exactly how one standard prescription drug treatment—Ritalin, a powerful stimulant—calms kids and improves mental focus.

Amidst all of this disagreement, what can you do if your doctor says your child has ADD? Many parents prefer behavior management to prescription drugs. Common alternatives include:

- *Detailed time management.* Kids with attention problems sometimes do better when their days are strictly scheduled. This means setting schedules—in writing and posted—of each hour or half-hour of each day. It also means scheduling time to discuss or reiterate goals for the day, the week and the month or year. Some studies have found that the intensive use of goal setting and time management can help 30 to 50 percent of children with attention problems do better in school and at home. The downside: It's time-consuming for parents and other family members.

- *Restrictive diet.* The notion that food dyes, preservatives and other ingredients can cause mental problems in kids goes back several generations. There is some evidence that kids on so-called "elimination diets" become more focused and settled. Such diets exclude processed foods that may cause allergic or other problematic reactions. A typi-

cal diet might include lamb, chicken, potatoes, rice and simple fruits and vegetables. In one widely cited study, researchers at the University of Alberta found that an elimination diet improved behavior in 12 of 24 hyperactive preschool-age boys. The improvements were noticeable within the first month. Of course, imposing a strict diet on a child who's already distracted or temperamental can add to family tension.

- *Supplementation.* Researchers have examined blood samples of children diagnosed with attention or learning problems, looking for deficiencies in vitamins, minerals or other nutrients. Their theory: Distracted children don't absorb nutrients properly or get sufficient nutrition in their diets. Some studies have picked up low levels of fatty acids, such as omega-3 and omega-6; others have discovered deficiencies in minerals, such as iron or zinc. Some children who take supplements to make up for a specific nutritional shortfall become noticeably more settled in school and at home. But the medical research on supplementation remains scientifically inconclusive.

- *Biofeedback.* The idea behind biofeedback is that people can train themselves to focus more deeply and continuously by controlling the electrical activity in their own brain. A handful of studies have concluded that people with ADD tend to have a distinct, lower-frequency wave pattern in their frontal cortexes.

By concentrating on patterns and mazes while receiving mild electric "signals" (okay, shocks) from a device called an electroencephalogram, some people can alter their brain activity and focus more, generally. The problem: There aren't any standards to evaluate the effectiveness of biofeedback treatments—or the devices used. And many doctors consider the whole process sheer quackery.

CONCLUSION

If you get the news that your child has an acute or chronic health problem, some sadness—and even some anger—is natural. But, once those emotions pass, you and your family will be left with the challenge to become the child's advocates.

If you're millionaires, this might mean hiring lots of nursing and caregivers to tend to the child. And insurance won't pay for that. Usually.

But you don't have to be millionaires to get good coverage. You just have to be willing to be aggressive—to learn all you can about the disease or condition; to record every exam and treatment; to act as an official historian when necessary...even if that means educating some doctors and providers.

This much work...this much aggressiveness...may be tiring. But it's the surest way to make sure that a sick child gets the best and most timely medical care available. And, truth told, in the U.S. medical system even millionaires have to do the same thing.

DENTAL, VISION &
PRESCRIPTION DRUG
PLANS

Our discussions of traditional insurance and man-
aged care plans both talked about how dental, vi-
sion and prescription drug coverage are often ex-
cluded from coverage. When we discussed COBRA
and state-subsidized plans, we suggested that you
consider dropping coverage for dental, vision and
prescription drug coverage if money is tight and
you're having trouble making monthly premiums.
Whenever anyone talks about economizing on
health care expenses, they'll make some mention of
cutting these coverages back.

But where does that leave you when your kid needs
dental work, vision care or prescription drugs?

Most risk management experts point out that den-
tal and vision problems are usually not life-threat-
ening—and that's the reason why they suggest
people opt out of coverage when it gets too expen-
sive. This works as corporate advice (companies
buying group health coverage can more easily pass
on specific coverages); but it doesn't work so well as
advice to someone whose five-year-old needs glasses.

In this chapter, we'll take a look at the nuts and bolts of dental, vision and prescription drug coverages. And we'll look at what you can do when you don't have insurance for these types of care—but you have a child who needs them.

DENTAL INSURANCE AND CARE

Most managed care plans and standard health insurance policies do not cover dental care. (Some used to; but, starting in the 1990s, they pared back the coverage—which was usually subcontracted out to specialist insurance groups, anyway.)

In some cases, standard health plans will pay for reconstructive oral surgery and dental work that's the result of damage from an illness or accident. But they're tight about even this kind of coverage, so be prepared to have several doctors state in writing that the dental work is medically necessary.

Generally, insurance companies consider dental care a "budgetable expense"—something that ordinary families should be able to pay for out-of-pocket.

As a result, dental insurance is fairly common as a stand-alone form of coverage. In many cases, this insurance is marketed by regional dental associations and operates like a managed care health plan. In exchange for your monthly premium, you're covered for dental care (after you make a copayment) from any member dentist.

Dental coverage usually includes payment for preventive care, such as regular checkups, x-rays and cleanings. It also pays for the things most people

hate about dental work: fillings, tooth removal, in-
lays, bridgework, oral surgery and—ugh—root ca-
nals. This insurance also will help you in a more
limited way—50 percent is a common figure—with
expenses for dentures and braces.

> **Typically, dental insurance will not pay at all for
> cosmetic work on your kids' teeth.**

However, dental insurance plans are not as univer-
sally-accepted as quality health insurance plans are.
If you already have a dentist you like, there's a good
chance that he or she won't be on a given dental
insurance plan. In these cases, you'll have to decide
to find a dentist on the plan that you like—or skip
the plan and just pay cash to the dentist you like.

As a result of this common dilemma, dentists are
more accustomed to offering credit terms to patients
than MDs are. So, you can often make payment
arrangements with a dentist—especially if you're
bringing your kids in for treatment. Terms will vary
with each dentist, but a common arrangement in-
cludes a third of the fee paid at the time of treat-
ment, a third in 30 days and the final third in 60 to
90 days.

Larger employers will sometimes include dental
insurance as an option, if they offer a menu of health
benefits. But—following the risk management ad-
vice that dental care is budgetable—many choose
to self-insure the coverage. If you're covered by a
self-insured plan (sometimes call a *direct reimburse-*

ment plan), you take your kids to the dentist and either pay the bill or make arrangements to pay the bill. Then you take a copy of the paid receipt to your employer's benefits office and they cut a check to you for a percentage (often something in the range of 60 to 80 percent) of the dentist's fee.

In some cases, the dentist will accept payment directly from your employer. This is especially true if your employer is a big player in the local economy.

In all, because dental care tends not to involve catastrophic matters—or result in catastrophic expenses—the attitude of the insurance industry, human resources experts and many employers is that it can be paid for out of pocket. The question left is: Whose pocket? Your's or your employer's?

CHIPS AND TEETH

In early 2004, Florida Governor Jeb Bush made a budget-based proposal to change the amount of dental care provided by the state's CHIP. Under Bush's proposal, children on the plan would only receive preventative care—things like cleanings and x-rays. Fillings, root canals and pulling of teeth would not be covered.

According to Florida budget officials, the changes would save between $7 and $9 million in state funds, by cutting the monthly premium dental insurance companies would receive $9 per child, down from $17. (Even Bush's political opponents admitted the cuts were necessary—they just disagreed on the amount. The House Subcommittee on Health Appropriations proposed cutting the premium to $12 per child.)

The 2004 cuts would be the second in two years. In 2003, Florida lawmakers put a $750-a-year cap on dental benefits offered by Healthy Kids (the public name of the best-known part of the state's CHIP).

Dentists in Florida warned that, if the state cut the benefits covered under its CHIP, most dentists would simply opt out of the program and not accept its payments—or its kids—at all.

At press time for this book, Bush was working out a deal to reduce the size of the cuts.

> **If you're getting health coverage for your children through a state-run Children's Health Insurance Program, your access to dental care is going to be more difficult.**

To start, many state CHIPs don't cover dental care at all. In the push-and-pull budget battles of the 1990s, a number of states decided that cutting dental coverage was a politically painless way to reduce spending related to the programs.

Social workers and program administrators will usually direct families using CHIPs to dental clinics in their areas. Like dentists generally, these clinics are accustomed to offering payment terms—especially to families with children. They often will have some sort of brief financial disclosure form that's attached to the patient information forms that you need to fill out when you arrive. (A few better-funded clin-

ics don't do this…but they are the exception.) Once the clinic has done a quick review of your information, it may ask you to pay a partial fee; in a few cases, it may ask you to pay more over time.

> **How much a dental clinic asks you to pay will be based on the type of work your kids need and your ability to pay.**

But—since you're often going to be offering financial information about yourself, anyway—it might be worth making a few phone calls to regular dentists in your area before you go to a clinic.

There are a number of telephone- and Internet-based dentist referral services in the U.S. that can put you in touch with local dentists who specialize in working with kids. The best known of these referral services is 1-800-DENTIST. And there are others.

One approach is to get a list of dentists from one of these referral services (the lists are usually free—the dentists pay to be included on them) and call each office to find out what sort of *credit, child-discounts* or *alternative payment arrangements* it offers. Even if they don't offer special terms, some dentists volunteer time at dental clinics…so, their offices may know the best clinics in your area.

PREVENTIVE DENTISTRY

Before you scoff at cost-cutting measures like Jeb Bush's, keep in mind that preventive dentistry is

more dentistry than most children from poorer families get.

A June 2003 report published by the Child Health Insurance Research Initiative (CHIRI) examined children's access to dental care in the Alabama and Georgia CHIP and Medicaid programs—and found it so lacking that simple tooth decay looms a major problem for children in those states.

The CHIRI researchers found that less than 40 percent of the Medicaid-enrolled children they studied received dental care of any sort (and they concluded that these numbers were typical of other states during the same time period). This was true, even though the state CHIPs studied did offer at least preventive dental care to kids in the programs.

The report reached some disturbing—and familiar—conclusions. For dental care, as for general medical care, kids who don't get preventive check-ups end up in the emergency room. Of the kids in the CHIRI study who *did* get some form of dental care, nearly none used intensive dental services (the dental equivalent of the emergency room).

While broader dentist participation in the state CHIPs had some effect on improving dental care access, the CHIRI report concluded that other factors have more influence on dental care use in public insurance programs. Summing up, it noted, "Medicaid-enrolled children are far more likely to receive medical care than dental care. If every child who had a medical visit also had a dental visit, many Medicaid-enrolled children would have received dental care."

Like Jeb Bush, many politicians look at state CHIPs for ways to cut costs. The CHIRI report was designed to help social program managers make the case for keeping enough money in the systems to make dental care available. It emphasized the importance of:

- early access to dental care and the use of preventive dental services;

- comprehensive dental benefits in public insurance programs for children; and

- multi-pronged strategies for improving access to dental care that capitalize on where kids and their families seek care.

WITH TEETH, PATIENCE IS KEY

Another important thing to remember, when it comes to dental care: Picking a good orthodontist can be as hard—if not harder—than picking a good pediatrician. There are many opposing treatment theories among orthodontists, and you'll want to have the doctor who can best handle the oral problems your child has...if he or she has them at all.

Some parents get caught up in the fact that, during the 1990s and 2000s, orthodontists have encouraged serious dental work on younger and younger children. Through the 1980s, most children weren't even considered for braces and other corrective measures until they were in their teens. Twenty years later, kids as young as 7 or 8 had them.

Driving the trend are orthodontists who say that starting treatment earlier can prevent more complicated problems. Others, however, recommend delaying or withholding care until most, if not all, of the permanent teeth are in place.

Some experts suspect the trend of earlier orthodontia is driven, in part, by financial gain. Starting early is a good way to lock patients in—and doctors who elect to postpone treatment may lose patients to more aggressive colleagues who suggest doing something dramatic sooner.

But sometimes it's the parents who push for the early braces. Around age 7 or 8, children go through what dentists often call the "ugly-duckling" stage of dental development. Not all of the permanent teeth have come in yet—and those that have come in are often crooked. Driven by the child's awkward appearance, and fearful of future problems, some parents become impatient.

Orthodontists who advocate early intervention believe that treatment can influence development of the dental arch and prevent more serious problems when the permanent teeth come in. For example: In a child whose teeth are misaligned because they're too crowded, an "expander" can create space and prevent more severe crowding; or, for a child with an overbite, a headgear can slow the outward growth of the upper jaw.

These types of early interventions can sometimes eliminate the need for later orthodontic treatment but, in most cases, a second, brief phase of treatment is required.

Opponents of early intervention argue that it's being over-utilized—suggesting that some children are receiving unnecessary treatment. Some problems will correct themselves if left alone. For example: A space between the two front teeth may close after the surrounding teeth fall out and larger permanent ones grow in; or crooked teeth might straighten as the mouth grows, increasing in width.

The choice to have your child treated early or later is a personal one. The challenge is to find an orthodontist you can trust to give you good and truthful advice. You will have to rely on that person to tell you what's necessary and what's not.

Don't take a passive attitude when it comes to your kids' orthodontist. Make sure you understand exactly what's going on and why, and that your kids' orthodontist explains everything in simple terms to both you and your kids. In other words, educate yourself as to the treatment plan and goals...every step of the way. When in doubt, get second opinions.

There are plenty of unscrupulous orthodontists who will treat children for years and years...and by the time they reach early adulthood their teeth don't look any better, and they have to start back at square one with a new orthodontist. Don't let this happen to your kid.

To this end, choose an orthodontist as carefully as you would a pediatrician.

VISION CARE

In terms of insurance and financial matters, vision coverage is similar to dental—it's rarely life-threatening or catastrophically expensive, so it's considered something that you should pay for yourself.

Vision care is typically covered on a scheduled basis that pays a fixed dollar amount for examinations, lenses and frames. In short, vision care is a classic "fringe benefit."

Your kids' eyes should be checked at least once a year so you'll know when they need corrective lenses. If your child can't see well, he or she will have a hard time concentrating, responding in school and doing homework. Schools often provide vision tests, but you should check to make sure they are being done regularly. If not, ask your child's doctor to conduct an exam during the annual wellness checkup. If you find your child squinting a lot or complaining of headaches, it's time to get an eye exam.

As with dental coverage, vision care is frequently offered as an optional coverage under group plans and benefits packages at larger companies. This vision care usually focuses on periodic eye exams and—most importantly—coverage of eye-glasses, contact lenses and other corrective hardware.

As with dental care, employers will often set up vision care on a self-insured or direct reimbursement model. And, as with dental care, if your employer doesn't offer vision care, you'll end up paying for eye exams and glasses out of your pocket.

The good news here is that vision care usually requires less professional service than dental care does. Vision problems are—in most cases—well categorized and can be diagnosed, based on standard tests. Also, the question of whether a prescription works or not can be answered easily: The person wearing glasses or contacts can say whether they make a difference, even if that person is a child.

As a result, the providers of vision care are different than doctors and even dentists. Ophthalmologists (eye doctors) and certainly optometrists (glasses and contact lens makers) tend to be more service-oriented than their colleagues in other fields. This may have something to do with the fact that there's more competition in their category.

In some cases, vision plans are just membership groups that negotiate volume-based discounts from larger vision-care providers. For a fee—as low as $20 and as much as $100 a year—you get a membership card that entitles you to discounts on eye exams, glasses and contacts. These discounts (usually in the 50 percent range for eyewear) often are good at a wide variety of stores, including most of the major chains.

> **Some plans offer contact lenses at a discount if you buy them through the mail.**

If you have children who need glasses, these plans are usually cost-effective.

CORRECTIVE EYE SURGERIES

Vision plans may also cover laser eye procedures (commonly called *lasik procedures*) and other corrective surgeries...but these treatments are sometimes a hot potato, tossed back and forth between vision plans and standard medical insurance plans.

Vision care programs can concentrate on eye exams and glasses because most standard health plans provide coverage for medical care related to eye injury or disease. So, if your child has any kind of serious eye injury or even really bad eyesight, start with your basic health insurance first.

Many eye specialists discourage laser corrective procedures for children. They point out that kids' eyes can change—literally, their shape can change—through puberty and other periods of rapid growth. In some cases, bad eyesight can correct itself.

But, in most cases, it doesn't.

Still, managed care plans and CHIPs can be stingy about approving corrective vision procedures for children. They'll sometimes use specific standards for vision problems that effectively mean no corrective procedures unless the child is legally blind.

If your child has really bad eyesight, and you think a lasik procedure or other corrective surgery will solve the problem, his or her school can be a help in justifying the surgery. Get a note from your child's teacher or principal stating that the kid's poor vision is interfering with school work. Even stingy

HMOs and CHIPs will usually have some sort of loophole in their eye-treatment coverage that allows for corrective procedures if a problem is "interfering with [the child's] ordinary development" (or some variation on that statement). A letter from the school saying the vision problems are affecting the kid's learning may satisfy that loophole.

PRESCRIPTION DRUGS

Getting your kids to the doctor or dentist is part of the health care equation. Taking them to the emergency room or hospital is another. Getting them the right medicine is yet another.

Prescription drugs are a huge deal for senior citizens, who often need a battery of drugs on an ongoing basis to maintain fragile health. Kids tend to need prescription drugs for shorter periods of time, to accomplish more specific results. But that doesn't relieve parents of the essential question: Who pays for your kids' prescription drugs?

The basic types of prescription drug plan include: *open panel*, *closed panel*, *mail order* and *prescription drug card* plans.

As we've noted before, if you have traditional indemnity insurance, the policy will usually cover prescription drugs generously. Indemnity plans usually offer open panel plans—which allow you to fill any legitimate prescription at any pharmacy. It won't require that the pharmacy give you generic drugs if they're available; it will give the widest discretion to the doctor's judgment.

Most managed care plans cover prescription drugs—with certain restrictions related to the type of drug and specific pharmacy that fills it. These are often called closed panel plans: They leave fewer options to the doctor's judgment and your preference.

In some cases, managed care plans will require that members place prescription drug orders through mail order pharmacies. These plans are the best cost control for the managed care company, in part because they channel many orders through a single location (or a few). In some cases, the managed care company actually owns the mail order pharmacy; in others, it simply makes a good contract in exchange for a lot of business.

Open panel and closed panel drug plans usually require some form of copayment or deductible. An open panel plan may require more of you, out of pocket—sometimes 20 percent of the total. A closed panel or mail order plan will usually require less, a fixed amount of $5 or $10 per prescription.

> Medicaid and state CHIPs usually cover drug costs in the same way that managed care plans do.

The main restrictions that these plans put on prescription drugs don't really apply to kids. (They limit drug coverage to prescriptions that are for treatment of an illness or injury covered by the plan—they don't cover things like contraceptive prescriptions or the nicotine chewing gum that helps you quit smoking.)

A few insurance plans for kids don't cover prescription drugs. If you have one of these (or you don't have any insurance—even a state CHIP), you can join a *prescription buying plan*.

Prescription drug buying plans are like vision plans. When you join, you get discounts on prescriptions when you buy from participating pharmacies. The plans usually include most major drug store chains. Discounts range from 5 percent to 50 percent on most drugs. (And they may be even higher if you order drugs through affiliated mail-order programs.)

One added plus: Prescription drug buying plans usually also have discounts for non-prescription, over-the-counter drugs.

Still, the discounts offered by drug buying plans aren't as good for the buyer as the open or closed panel plans. Most people who have health insurance don't need prescription drug plans—unless they have an extremely high deductible on a catastrophic coverage plan or MSA. In some cases, if your child has a chronic disease or permanent disability and you spend a lot of money on non-prescription drugs, the drug plans may also make sense.

CONCLUSION

In this chapter, we've looked at the mechanics of dental, vision and prescription drugs plans. For kids, these health care services are not usually as pressing

as they are for adults and—especially—for senior citizens. Insurance professionals call risks like this "budgetable expenses."

While it may seem harsh at first, this perspective makes sense financially—even if your finances are tight. You can pass on insurance for your kids' dental and vision care. Just be ready to pay out of pocket for the occasional eye exam or abscessed tooth.

IF YOU HAVE TROUBLE MAKING A CLAIM...

The 1990s saw increasing insurance litigation—fueled by more aggressive attempts by insurance companies to challenge or reject claims and a public backlash against the industry, especially managed care plans. In 1999, U.S. health care consumers made more than 35,000 complaints to state insurance departments about managed care plans and other health care insurance companies, according to the National Association of Insurance Commissioners. The most frequent complaints involved claim denials, disputed claims and slow payments by insurance companies.

The work that you put into getting health insurance for your family comes to a point when it's time to make a claim for your child's medical care. Even with the best coverage, getting claims paid can be difficult. Problems don't surface until you make a claim that is denied or underpaid; then, many of the same issues that influence how much the coverage costs also influence how the plan pays claims.

This chapter will point out ways that you can make a claim effectively.

Insurance is a process. It's a business built on contracts. Making a claim is like any other contractual transaction; it often takes more time than you expect.

The main contract—the insurance policy—states how claims will be paid. But beyond this simple start, within the parameters set by the contract, there's room for negotiation and compromise. Often, the insurance company or managed care group is counting on that room to work to its advantage; it employs people who spend their days reading and enforcing insurance contracts.

But there's room in the contract for you, the policyholder, too. If you don't like the fact...or the manner in which...a claim was denied, you can press your issue. Your pressure will usually need to start within the insurance company's own appeals process. If that doesn't accomplish anything, you can press on to regulatory agencies.

The most common mistake people make when they have trouble getting a claim paid is assuming that the insurance company or managed care group has more authority than it really does. Insurance companies don't have any special power over policyholders—both sides are simply parties to a contract.

Lawsuits or regulatory complaints relating to delays or denials usually allege bad faith on the part of the insurance company. This is one of the heaviest clubs a policyholder can wield to strike back at an insurance company.

One way in which an insurance company can act in bad faith is by not investigating a claim with an eye toward providing coverage.

And remember: Insurance companies are in business to make a profit. But their business is a regulated one; they generally don't want bad publicity. This will usually—despite how their employees act—settle disputes that they can't avoid. If your position is well-reasoned and consistently made, you may get more satisfaction than you might expect at first.

THE MECHANICS OF A CLAIM

It is always good to understand how your claim will be paid.

For example, if you assigned benefits to the provider, the check will be sent to the provider. You will pay any deductibles and co-insurance. But if you did not assign benefits, the check will come to you and you will pay your providers the entire amount.

If your claim is denied, don't panic. Any company that denies a claim must submit an "explanation of benefits" letter to you. Read that letter carefully to find out the reason for the denial.

With traditional indemnity insurance, benefits are payable directly to you; generally, medical insurance policies provide reimbursement for covered

expenses. This means the insurance company wants you to pay your bills first and then it will pay you.

There are other complicating issues.

After the insurance company receives notice of your claim—either from you or from a doctor or hospital, it will usually furnish claims forms within a specified number of days. Most states require insurance companies to either process a claim, or at least tell you why it hasn't been processed, within 60 or 90 days. If it fails to do so, you may submit a written proof of the occurrence, character and extent of the loss either in the form of an official accident report or an affidavit.

So, whenever you submit a health insurance claim, you should do the following:

- Find out if your provider submits the claim or if you need to.

- If you need to do it, review the information to be sure it is complete and correct.

- File the claim as soon as you are billed by the provider.

- Send the claim to the correct address.

- Keep a copy of all documents for your records.

Since your health insurance policy is a legal contract, the insurance company is obligated to pay the described benefits for all covered expenses. If your insurer doesn't live up to its obligations, you have the right to sue. However—in most states— no legal action may be taken against the company

prior to 60 days after proof of loss has been furnished, or more than three years after the date proof of loss is required to be furnished.

Of course, assuming that you'll sue your insurance company is a bad way to start the claim process. You shouldn't want this; it's not a cost-effective strategy, especially not for your kids. Despite the impressions you may have from John Grisham's legal fairy tales, lawsuits against insurance companies aren't dramatic windfalls; they're slow, grinding procedures. What you should want is to get your kids' medical expenses paid.

It's safe to assume that insurance companies will delay payments as long as they can without inviting lawsuits. But there are various things you can do to counter-balance this slow tendency:

- Don't accept a first offer—or even a first denial—by an insurance company as the final, unequivocal word.

- If the company doesn't respond quickly (within 60 days), ask for a formal explanation about its delay or denial.

- Reread your policy handbook or master policy (a master policy usually stays in the possession of benefits administrators for group plans; but anyone covered by a policy is allowed to see it—or a copy—on request).

- Check the policy's exclusions section. Exclusions identify types of losses that are not covered by the policy; they are the most common grounds on which insurance companies deny claims.

Exclusions are generally included to accomplish four broad purposes:

- to clarify intent of coverage;

- to remove coverages for losses that should be covered by other insurance;

- to remove coverage for losses that result from above-average risk factors that are not anticipated in rates and premiums (usually this coverage is available at an additional charge); and

- to remove coverage for catastrophic losses that are generally not insurable (although coverage may be available through special insurance pools or government programs).

Even if denial isn't your insurance company's ultimate goal, by playing the denial game it can achieve something almost as valuable to it—a lengthy delay in paying the claim. The longer an insurance company can hold on to money, the better off it is.

But the law and, more importantly, the courts don't give insurance companies free rein to delay fair settlements as they please.

PRE-EXISTING CONDITIONS

As we've mentioned throughout the book, pre-existing conditions are an important issue in health insurance. Technically, pre-existing conditions are a type of exclusion—a big type. They are usually the most common issue in insurance coverage disputes.

> Most plans don't cover pre-existing conditions during the six months following the effective date of coverage, or any disease or physical condition named or specifically described as excluded in any endorsement attached to the policy.

Pay attention to any specific or custom exclusions on any policy. This is especially true if your kids have had any notable illness or disability within the last 10 years—even if it's healed or in remission.

For example: When you applied for insurance, you disclosed that your 13-year-old daughter had been diagnosed with leukemia when she was eight. She went through radiation therapy, had a bone-marrow transplant and—happily—the disease has been in remission for almost five years. If the insurance company doesn't attach a specific exclusion, your daughter would be covered (after the waiting period ends) if the leukemia recurs. If the leukemia is excluded, she will never have coverage for that condition, regardless of how long the policy is in effect.

WHEN A CLAIM'S BEEN DENIED

Resolving claims disputes starts by contacting your insurance company, which must follow the dispute procedures outlined in your policy (also why it's important to hang on to your insurance documents).

If the dispute is not resolved by the insurance company, you may appeal to the proper state or federal

agency—the state Insurance Department; the state Department of Health for managed care plans; the federal Health Care Financing Agency for Medicare—managed care plans; and the state Department of Public Welfare for Medicaid—managed care plans.

But start with the company. If it has denied your claim, ask why the claim was rejected. Ask in writing...and ask that the response be in writing. Written correspondence marks the chronology of your dispute and establishes exactly who said what at which point along the way.

If the company's answer involves a service that isn't covered under your policy (and you believe it is covered), check all relevant claim forms. It could be that the provider entered an incorrect diagnosis or procedure code. That's relatively easy to fix.

Check that your deductible was correctly calculated and that you didn't skip an essential part of the process. Some people choose a high deductible when they're shopping for coverage because it makes the coverage less expensive; later, when they have trouble with a claim, they forget their earlier thriftiness.

If everything still seems to be in order, you can then ask your insurance company to review the claim.

For cases like these, it often helps to keep written records of the following:

- All correspondence with the plan.
- Claims forms and copies of bills.

- Phone conversations—the date and time, the people you speak with and the nature of each call.

If the insurance company still denies your claim or insists you take it to court for your money, don't be intimidated. And don't stop corresponding. Ask the company for the specific language in your policy or in state law that allows it to deny your claim.

In your exchanges with a health insurer, ask many questions—but try to say as little about your own opinions as possible. An insurance company determined to "manage cash-flow" by delaying claims isn't likely to be swayed by any of your arguments. It doesn't want to be convinced.

What you're trying to develop is an argument—supported by a paper trail—that will convince an arbitrator or regulator that your child's claim should be paid.

Most health plans have some sort of appeals process that you and your doctor may use if you disagree with the health plan's decisions. Doctors and hospitals know this. If you're having trouble getting a medical expense paid, let the provider know that you're challenging a decision. The provider isn't usually a formal party to the dispute; but many will allow some flexibility with their bills while you work the review process.

While state insurance commissioners usually have no legal authority to force an insurance company to pay an individual claim, the commissioner can fine

a company or take other punitive actions if an insurance company makes a practice of unfairly underpaying or denying claims.

DISPUTING DECISIONS

Most HMO disputes are handled—at least initially—by arbitration. The arbitration body is paid a daily rate that typically ranges from $750 to $1,200, with the process itself usually lasting from one to three days. All parties agree to abide by the decision instead of litigating.

But patients-rights advocates contend that many times, consumers don't even realize that they've locked themselves into arbitration. And increasingly, the courts have shown that they, too, are concerned about the fairness of forced arbitration in managed care contracts.

Unlike HMOs (which usually have to respond within six months), traditional indemnity plans don't have to respond to your complaints within a set time frame or have provisions for a formal hearing or appeals process. But if you are not satisfied with your insurer's willingness to pay a claim, you can ask for a reconsideration of the decision.

If you have problems getting paid, an indemnity plan allows you to choose your method of recourse, i.e., the court system or mediation. In addition, you have the option to appeal any decision by your insurance company to pay or deny a claim.

You can also file a complaint with your state's Department of Commerce or Department of Insurance—and you don't have to tell your insurance company first. You will have to fill out a complaint form and supply any information needed to support your position to the state agency.

State investigators will then contact your insurance company; and, if the problem cannot be resolved within 10 days, they will investigate whether the company followed the terms of your policy.

In most states, the company's review of your denial includes two steps—an informal review followed by a formal review if you remain dissatisfied after the informal review.

If you appeal to a state or federal agency, include your name, address and daytime phone number with any complaint.

It might be good to use the Insurance Department complaint form. To obtain a copy of the form call your state's Insurance Department's hotline number. (You can usually find these numbers in the opening pages of your phone book, or look online.)

State your case briefly, giving a full explanation of the problem. Include the name of your insurance company, policy number and the name of the agent or adjustor involved. Also supply any documentation you have to support your case, including phone notes (who you talked to and what was discussed).

Another tactic used by insurance companies: Delay in payment of claims. Despite laws requiring insur-

ance companies to pay unquestioned medical claims within 15 working days, some companies take up to six months or longer to compensate patients.

In 1998, three Florida-based physician organizations—a prominent 30-member OB/GYN group in Jacksonville, the 4,000-member Florida Physicians Association and the 16,000-member Florida Medical Association—filed a class action lawsuit against Prudential Health Care Plan, Inc., accusing the company of systematically denying and delaying payment on large claims and losing others. The MDs wanted to stop the alleged practices and recover interest on the claims and damages that they say exceeded $10 million.

The organizations had internal documents that proved Prudential made a policy of automatically rejecting claims once the insured person submitted more than $1,000 in medical bills on the basis that the covered person had other insurance, even though the plan had no knowledge of such co-insurance.

In fact, Prudential officials acknowledged that only 5 percent of its members had such dual coverage arrangements as those that exist when a husband and wife are covered by separate health plans, according to the physician organizations.

The groups also charged Prudential with knowingly losing claims that were filed electronically.

Prudential had little to say about the suit. Since 1998, this lawsuit—alongside others against other HMOs—were consilidated into one large case

against managed care. Some of the class-certified dependents (like Aetna and Cigna) decided to settle. The remaining class-certified dependents—including Prudential—were set to go to trial in June 2004.

THREE STATES DEAL WITH CLAIMS DISPUTES

Since health insurance is usually regulated at the state level, it's useful to consider how several larger states deal with claims disputes.

Pennsylvania's Act 68 is a state law that spells out how the claims process will work for managed care plans. Act 68 distinguishes between complaints (issues not related to a medical necessity) and grievances (issues of medical necessity).

The complaint procedure still begins with a two-step review at the company level. The grievance process includes the two-step review but adds an expedited review for urgent situations. And, the new law allows providers to pursue grievances.

For example, a physician could file a grievance if he or she wanted to provide treatment that the consumer's plan would not cover.

At the Pennsylvania state Health Department level, grievance appeals are assigned on a rotating basis to a certified physician, licensed psychologist or group of physicians or psychologists for a decision. (The Health Department makes sure none has any conflicts of interest.)

In June 2002, the New York Department of Insurance—citing a litany of bungled claims, improper treatment denials, unlicensed health insurance agents and poorly performing claims processors using out-of-date software—fined Aetna/US Healthcare and United Healthcare $2.5 million.

The NY DOI described poorly processed claims and violations of the state's insurance code in two recently released market conduct exams. The results of the exams forced both insurers to create an appeals process for claims that had been partially or fully denied during certain time periods. Aetna agreed to review claims it partially or fully denied between July 1994 and September 2001; United Healthcare agreed to review claims it partially or fully denied between July 1994 and December 2001. (New York law requires insurers to keep all paperwork associated with a claim for six years after the claim is resolved.)

In its June 1997 decision of a case involving managed-care giant Kaiser Permanente, the California state Supreme Court ruled that HMO members can file lawsuits if they demonstrate that their health plan's arbitration system is unfair. The court admonished Kaiser for intentionally delaying the selection of arbitrators and otherwise manipulating the process for its benefit.

Among other things, the court pointed to one of Kaiser's own surveys, which showed that in the mid-1980s an arbitrator wasn't appointed for nearly 674 days—almost two years after the enrollee had asked for one. Kaiser had promised to name an arbitrator within 60 days of a patient's demand.

In response to the ruling, Kaiser earlier this year announced an overhaul of its arbitration system. The company, which for more than two decades had operated an in-house arbitration process, began using an independent system like those used by competing health plans.

OUTPATIENT AND INPATIENT COVERAGES

When you're using medical services, remember that most insurance plans make a distinction between inpatient (someone who's been admitted to a hospital for at least 24 hours) coverage and outpatient (someone who plans to go home within a few hours of any treatment or procedure) coverage. This distinction can definitely affect which claims are paid.

> If you have coverage for outpatient services under your plan, the plan will usually pay for 80 percent of covered outpatient services and supplies, subject to the maximum benefit amount. You must pay the other 20 percent of the charges or copayment.

Here's a list of outpatient services and supplies that health plans typically cover:

- x-ray and fluoroscopic examinations;
- radium and other radioactive substance;
- electrocardiograms, microscopic and laboratory tests;

- drugs/medicines that may be purchased only on the attending physician's written prescription and that are dispensed by a licensed pharmacist;

- casts, splints, braces, crutches and artificial limbs; and

- oxygen and equipment used for its administration.

Outpatient services are covered only when rendered due to injury or sickness, while coverage is in force for an insured, and as the direction of a physician or surgeon. Outpatient benefits do not include benefits for the services of a radiologist, pathologist, anesthesiologist, physician or surgeon.

Hospital inpatient care provides you with benefits for charges a hospital makes on its own behalf (i.e., room and board, nursing care, etc.). Most plans limit room and board to a semi-private room rate, a maximum dollar amount per day and a maximum number of days. Miscellaneous services are also limited to a maximum dollar amount.

Say you have inpatient coverage with benefits of $300 a day for a maximum of 365 days. Your son is confined for 10 days in a private room. The hospital charges $325 a day for a private room and only $250 a day for a semi-private room. Your policy will only pay $2,500—the semi-private room rate for 10 days. You end up paying the difference.

Inpatient benefits can provide coverage for confinement for mental, emotional or nervous disorders, alcoholism and drug dependency—but usually not for more than 30 days in any one policy year.

ADDING INSUREDS TO A POLICY

If you're about to have a baby, look over your policy carefully and be extremely cautious about changing your insurance.

Under some plans, a new child will be automatically covered for 31 days after the date of birth. However, in order for coverage to continue beyond that time, you must notify the insurance company to request coverage and pay an additional premium for the child within the 31-day period.

Coverage for a newborn child includes coverage for:

- congenital defects;
- birth abnormalities; and
- injury or sickness.

A caveat: Benefits aren't usually provided for premature birth (where no defects or abnormalities are involved) or well-baby care. Ask about this.

If you want to add someone other than a newborn, such as, a new spouse or adopted child, you must make an application for coverage, submit proof of insurability and pay an additional premium.

TERMINATION OF A POLICY

Your insurance company can terminate your child's health coverage if you fail to pay a premium before

the end of a grace period. It won't affect any claims that you incurred before your coverage ended, but it will terminate your coverage on the original due date of your premium. Any claims that you make during the grace period will not be covered.

For example, you failed to pay your premium due February 15. On March 15, your child's coverage terminated for nonpayment of premium. The child was hospitalized in January; you submitted a timely notice of claim and furnished proof of loss on April 1 (within the required number of days). The claim for the hospital expenses is covered.

CONCLUSION

There are several important steps you can take to improve the chances that your health insurance claims will go smoothly:

- Never rely on what you think is true about benefits or providers covered under your plan—even if they are stated in your most recent benefits handbook. Check whether the benefits, services or providers you need are covered under your plan before you receive treatment.

- Call your plan's customer service department, and remember to take notes. Get the representative's name and write it down, along with the date, time and general substance of your conversation.

- If a claim problem arises and you need to file a grievance, these notes will come in handy. Most insurers' customer-

service phone calls are recorded. So, having the date and time of your call will make locating your call history with the representative much easier.

- Should you have a problem with a claim, call the insurer and ask for an explanation. Again, remember to take detailed notes.

- If the explanation is not consistent with your understanding of your health benefits, call or visit the person in your company responsible for benefits administration. Because of their position, they might be able to quickly resolve your problem.

- If you have a claim problem that's unresolved, file a grievance with your health plan. If you get a denial, don't give up. In many states, the complaint eventually goes before a grievance committee that's outside the plan. There's always a chance the denial might be reversed. You might also want to complain to the officials who regulate your health plan.

Remember: If your health plan is self-funded by your employer, it is regulated by the U.S. Department of Labor. Otherwise, your health plan is regulated by your state's insurance department. Your state has a complaint procedure that will trigger an investigation into your problem.

- If you discover your plan providers or benefits have changed, and you have not been notified, bring it to the attention of the person in your company responsible for benefits administration. Ask if this situation is covered under the company's contract with your health plan.

When it comes to solving health insurance disputes, you are your child's best advocate. But standing up for your rights requires understanding your policy, keeping careful records and following procedures, including appeals to the proper state and federal agencies.

CHAPTER 11

CHOOSING THE RIGHT DOCTOR... AND PLAN

Good pediatricians are always hard to find. If you join a managed care plan, tackle finding the best children's doctor like a research project. Scour the list of participating pediatricians. Ask friends or co-workers for suggestions. Call and visit as many participating pediatricians as time allows. Even if a doctor is busy, you can tell a lot about him or her by the condition and temperament of office staff.

Choosing the right doctor is as personal—and sub-jective—a matter as any choice you can make. Some people like stern, serious clinicians; some prefer warmer humanists. As they get older, your kids will have preferences of their own—but, when they're little, you're going to have to choose for them.

In this chapter, we'll take a look at the various factors to consider when choosing a physician. We'll consider the choice particularly from the perspective of matching the right provider with the right plan. The right combination improves the whole experience.

Cast a wide net by consulting standard reference resources that offer "Yellow Page" style lists of practicing physicians. The best known of these are:

- *AMA Physician Select*, the American Medical Association's free service on the Internet for information about physicians (*www.ama-assn.org*); and

- *Directory of Medical Specialists*, a book available at your local library; lists up-to-date professional and biographic information on about 400,000 practicing physicians—including a section on pediatricians. If you have trouble finding a copy, call the American Board of Medical Specialties at (800) 776-2378 for more information.

Also, there are a number of for-profit medical information Internet sites that offer information on doctors by geographic region. The best-known of these include *WebMD.com* and the AMA's search function called AMA Physician Select at *www.ama-assn.org*. Another site, *Hypocrates.com* also offers many useful links. But beware, when you use these sites: Many of the listings on them are paying for their placement.

Once you have the names of plan doctors who interest you, follow as many of these steps as you can:

- Ask plans and medical offices for information on their doctors' training and experience.

- Find out whether the doctor is board certified. Although all doctors must be licensed to practice medicine, some go

a step further to become board certi-
fied in a particular specialty.

- Ask if any complaints have been regis-
tered or disciplinary actions taken
against the doctor. To find out, call
your State Medical Licensing Board or
state insurance department. (Not all
departments accept complaints.)

- Set up a "get acquainted" appointment
with the doctor. Ask if there is a charge
for these visits. Such appointments al-
low you to interview the doctor.

- Even if the doctor isn't available for a
meeting, ask office staff about whether
the doctor has any special focus within
pediatrics, if the practice includes sev-
eral doctors and—critically—which
health plans the doctor accepts.

The kind of health care plan that you choose also
will influence the doctor you choose—and this goes
beyond the simple fact that you'll need a pediatri-
cian for your kids.

If you are in a managed care plan, ask your plan for
a list or directory of its providers. And call the mem-
ber services staff for tips on which pediatricians are
their most popular; sometimes, these administra-
tive employees can help you find a good doctor.

And sometimes the best doctor for a family with
children may not be a pediatrician. The growth of
managed care has encouraged a growing number

of "family medicine" specialists. These doctors have training and experience in children's medicine (in fact, many have started their careers as pediatricians); but they also see adults. Their training may also include OB/GYN work and some psychiatry. The net result: A specialist with general experience in the various medical fields related to families.

Family medicine specialists work especially well as primary physicians in managed care programs— your entire family can have the same "doctor," who's usually able and inclined to make smart referrals when the various family members need special care.

A key question to ask any doctor: Will he or she enroll in your health plan? Some will, especially if you have several children. (And, frankly, the answer to this question may have as much to do with how adept the doctor's office staff is at handling health plan paperwork.)

Managed care plans aren't the only ones that use primary gatekeeper physicians. Increasingly, even indemnity insurance plans ask members to choose a primary physician—if only to have a recognizable name to use when reviewing medical bills. But this choice is much less important than the choice of a primary physician in a managed care plan.

A BOOMING SUPPLY OF PEDIATRICIANS

Occasionally, parents will hear horror stories about how changes in U.S. health care are discouraging doctors from focusing on pediatrics and children's health. Doctors around the U.S. do have a lot to

complain about today—including stagnant or lower incomes and rocketing malpractice insurance costs—but there's little evidence that these trends are affecting pediatrics particularly.

In fact, the evidence that does exist suggests there will be more pediatricians in the coming years. You might find them forming groups to better manage their patients, control costs and handle claims.

A March 2004 study in the medical journal *Pediatrics* predicted that the number of pediatricians in the U.S. would increase by almost 60 percent during the next 20 years, while the number of children would increase by less than 10 percent.

The researchers used the current number of working pediatricians in the U.S. and the child population in 2000 as a baseline. They then created a statistical model that included several factors that may influence the number of pediatricians in the future.

These factors included:

- current supply of pediatricians;
- age and gender of new pediatricians entering the workforce;
- new pediatricians from other countries who trained in the U.S.;
- the U.S. population;
- deaths of and retirement ages for pediatricians; and
- the number of children who may see a primary care doctor other than a pediatrician.

The results predict that by 2020 there will be one pediatrician for every 1,400 children in the U.S., compared to the current level of one pediatrician for every 2,040 children. At first blush, this sounds like a boon for kids—but the trend really reflects the growing specialization in the medical profession. The cost-control mechanisms of managed care health plans makes many aspiring doctors move toward specialized fields. Instead of working for an HMO, they can specialize in pediatrics and form a corporation with other pediatricians.

CHOOSING THE RIGHT PLAN

Look for a good pediatrician first, then work on how to make your health insurance fit your doctor. But, for some people, that strategy requires too much work and too much time. They prefer to choose a health plan first—and then pick a pediatrician from those already enrolled.

Fair enough.

If you're going to choose a plan first and then look for a doctor, you need to consider some of the kinds of service and coverage your family will need. And this is especially important if someone in your family has a chronic or serious health condition.

Indemnity and managed care plans differ in their choice of providers, out-of-pocket costs for covered services and how bills are paid. Refer to Chapters 3 and 4 for more information on these two types of plans.

> The plan that is "best" for your neighbor may not be the "best" plan for you and your family.

In addition to basic benefits, you might want to find out if the plan you are considering covers:

- physical exams and health screenings;

- care by specialists;

- hospitalization and emergency care;

- prescription drugs;

- vision care; and

- dental services.

The Department of Health and Human Services Agency for Health Care Policy and Research (AHCPR) also recommends looking into how a plan handles the following:

- care and counseling for mental health;

- services for drug and alcohol abuse;

- OB/GYN care and family planning services;

- care for chronic (long-term) diseases, conditions or disabilities;

- physical therapy and other rehabilitative care;

- home health, nursing home and hospice care;

- chiropractic or alternative health care, such as acupuncture; and

- experimental treatments.

If health education and preventive care benefits are important to you and your family, you might want to ask about services such as, shots for children, breast exams, Pap smears or other programs to counsel kids who need it.

In order to get a true idea of what your costs will be under each plan, you need to look at how much you will pay for your premium and other costs. You can't possibly know what your health care needs for the coming year will be, but you can guess what services you and your family might need. To figure out what the total costs to you and your family would be for services under each plan, it makes sense to ask the following questions:

- *Are there deductibles you pay before the insurance begins to cover your costs?*

- *After you have met your deductible, what portion of your costs are paid by the plan?*

- *Does this amount vary by the type of service, doctor or health facility used?*

- *Are there copayments you must pay for certain services, such as doctor visits?*

- *If you use doctors outside a plan's network, how much more will you pay?*

- *If a plan does not cover certain services or care that you think you will need, how much will you have to pay?*

- *Are there any limits to how much you must pay in case of major illness?*

- *Is there a limit on how much the plan will pay for your care in a year or over a lifetime?*

Some people choose a deductible in the thousands of dollars—making their coverage, in essence, a catastrophic insurance policy. In this case, you'd absorb all the everyday costs of medical care, from doctor visits to prescriptions. But, if you got seriously ill, you'd be covered. If you are single and healthy, this could wind up saving you money.

For most people, a deductible in the $100 to $250 range is easiest to live with. But look into other deductibles, too. If your family has been healthy for a number of years, you may want to switch to a deductible of $500 or $1,000. You'll notice a sizable reduction in premiums. (Just remember that you'll have to pay your own way until you satisfy the deductible.)

Investigate what the insurance company considers usual, reasonable and customary charges, if at all possible. The charges a company considers normal for a particular medical procedure in a specific geographic area are the maximum it will pay. If the charges are higher, you'll be stuck paying the difference.

Another way you can save money on your premiums is by paying them annually. Find out how much

the service fee is for monthly payments and ask whether there's a discount for prepayment.

Even if you don't get to choose the health plan yourself (for example, your employer may select the plan for your company), you still need to understand what kind of protection your health plan provides.

The more you learn, the easier it will be to decide what fits your personal needs and budget.

IF YOU'RE PREGNANT

Many people choose their kid's first pediatrician based on the advice of the doctors on hand (or close by) when the baby is born. While there's nothing wrong with this strategy, it doesn't allow you to cast the widest net in the search for a pediatrician. It's better to start looking before the baby is born.

Of course, pregnancy is a hard time for many things, including changing health plans—should you decide that's necessary to get the best care for your child.

But pregnant women don't have to lose any sleep...at least not for this reason. Even they have some flexibility in dealing with health insurance. In some situations, pregnancy can be considered a pre-existing condition that limits your ability to change insurance; but there are some loopholes here.

Federal law bars group health insurance plans that cover maternity from considering pregnancy a pre-existing condition. This means that if you change group health plans while you're pregnant, your new group health insurer (as long as it covers maternity)

can't deny claims related to your pregnancy. But a variety of loopholes means pregnant women could still lack insurance coverage for their prenatal care if they don't do some careful planning.

Under the Kennedy-Kassebaum Act (which, as we noted in Chapters 1 and 4 also goes by the acronym HIPAA), group health plans cannot consider pregnancy a pre-existing condition and cannot exclude coverage for prenatal care or your baby's delivery, regardless of your employment or health insurance history, but only if the plan already includes maternity coverage. This holds true whether you are the primary insured or a dependent. So, health plans can't deny you coverage when you switch jobs and switch employer-sponsored group health plans.

According to the HIPAA:

> EXCLUSION NOT APPLICABLE TO PREGNANCY. A group health plan, and health insurance issuer offering group health insurance coverage, may not impose any pre-existing condition exclusion relating to pregnancy as a pre-existing condition.

Unfortunately, HIPAA applies mainly to group health plans. So, if you move from one individual health plan to another individual health plan or from a group plan to an individual plan, you might not get pregnancy coverage at all, you might have to sit out a waiting period, or, if you are offered insurance that covers your pregnancy, you might find it's very expensive.

> While HIPAA is really the only protection women have against pregnancy being treated as a pre-existing condition, the law doesn't apply to everyone.

Unmarried pregnant women take note: Despite the movement afoot in some communities and businesses to offer coverage to "domestic partners," chances are you won't be added to your boyfriend's group health plan simply because you're having his baby; there's no legal requirement to do so, and it's at the discretion of the employer.

Once the baby is born, however, the unmarried father should be able to easily add the baby to his group health plan, although he might have to own up to his paternity in writing first. And a woman with individual health coverage should have little problem adding her baby to her plan.

CONCLUSION

Choosing the right doctor is critical to the overall health of your children. Hopefully this chapter gave you some tips to making that decision. Insurance company representatives might be able to assist you as well...assuming you've found a plan.

Remember to check with your state's insurance department to see if there have been a lot of complaints about the insurance companies you're considering.

There are agents and companies whose lack of professionalism and ethics can cost consumers dearly. But there are also ways for you to protect yourself. If someone calls you claiming to have been authorized by the government to review your existing insurance program, don't agree to an appointment.

Anyone who tells you that he or she is a counselor or adviser for any association, may in fact just be a licensed insurance agent trying to sell you a supplement insurance policy. Ask for credentials, the licenses they hold, and what kinds of products they are authorized to sell. A business card is not a license. To the extent an insurance rep can offer advice about doctors, make sure you've done your own homework and considered other sources for doctor referrals. You don't want to end up with a doctor only your insurance company likes. This can mean poor care.

Never let an agent talk you into signing any form, application or document in blank. When you are buying a policy, never pay your policy premium in cash or make out a check to the agent's personal account. The agent should make it clear that you have the option of paying your premiums directly to the insurance company.

As with all insurance policies, it pays to compare the costs of similar policies available from different insurers.

KIDS, HEALTH &
DIET

Perhaps the biggest influence that every parent or guardian has on his or her children's health is what—and how—the kids eat. Teaching them to eat wisely may not have the immediate affect that finding and paying for a good doctor has; but good dietary habits will affect their lives for a long time.

A March 2004 report from the Centers for Disease Control and Prevention showed that poor diet and physical inactivity caused 400,000 deaths, or 16.6 percent of the total—up from 300,000, or 14 percent of deaths, in 1990.

More than 30 percent of U.S. adults are obese, according to the CDC. That's about 59 million people. If Americans continue to get fatter at current rates, by 2020 about one in five health care dollars spent on people aged 50 to 69 could be due to obesity—50 percent more than now—according to a separate study by the Rand Corporation.

Pediatricians say too much weight is now the most common medical condition of childhood. The problem doubled between the early 1980s and early

2000s; by 2003, about 15 percent of American kids were considered overweight or obese. (As late as the early 1990s, the rate of high blood pressure among children was estimated at about 1 percent.)

In this chapter, we'll consider the diet issues that parents and children face—and what you can do to make sure your kids eat healthily.

CONSTANT DILIGENCE

The first thing you need to realize about your kids' diet is that you have to be thinking about them from the time they're born until they're 18.

A March 2004 study of infant and toddler eating habits concluded that parents feed their babies better than in the past. Unfortunately, many parents then let toddlers adopt the family's poor eating habits at an early age.

The Feeding Infants and Toddlers Study selected a random group of more than 3,000 children aged four months to two years and looked at the food the children ate during an ordinary day. Parents appear to know the importance of good nutrition for babies: Compared to past findings, more babies were breastfed—and were breastfed for longer periods. And virtually all who were fed formula received the recommended iron-fortified type.

But, as babies grow into toddlers, parents often let their dietary guard down.

Most toddlers did not receive the recommended five servings of fruits and vegetables a day. Among tod-

dlers aged one to two years, fruit was absent for about half at breakfast, for half at lunch and for about 60 percent at dinner. In the same group, about half had no vegetables at lunch and about one-third had none at dinner—even when french fries were counted as vegetables.

French fries turned up as one of the three most common vegetables eaten by those aged nine to 11 months. This fatty, high-calorie choice was the most common vegetable from 15 months onward.

Experts say parents should include one or two fruits or vegetables at each meal. Ideally, everyone would eat at least as many—if not more—servings.

The most common snacks for toddlers were cookies, crackers, chips, milk, water and fruit drink (not fruit juice). And the majority of toddlers had at least one dessert or sweetened drink every day.

Snacks play a major role in the nutrition of young kids, since their stomach capacity limits the amount of food they can eat at meals. Parents should limit high-calorie, low-nutrient snacks. Better choices include fruit, cheese, yogurt and low-sugar cereals.

The study pointed out that fruit drinks and carbonated drinks often replace milk in toddlers' diets. This is not a good trade-off. The American Academy of Pediatrics recommends that juice be held from babies until they are six months old. From ages one to six years, children should be limited to a four to six-ounce portion of juice a day. The AAP also stresses that whole milk should be served until age two.

The study also concluded that parents gave up too easily when offering new foods to toddlers. It referred to other studies that showed a new food usually needs to be served eight to 15 times before a young child will grow accustomed to it. But the diet study found that less than 10 percent of parents offered their kids a new food even six times. On the other hand, about 25 percent gave up after serving a new food only once or twice; and 38 to 55 percent threw in the towel after three to five tries.

When it comes to your kids' diet, sodas are particularly bad. According to the American Academy of Pediatrics, kids can't afford to consume empty calories found in soda. The group opposes providing sodas in schools and released a statement that cited research results that supported its position:

- Drinking one sugared soft drink a day increases the risk of obesity in a child by 60 percent.

- Average soda serving sizes grew from 6.5 ounces in the 1950s to 20 ounces by the late 1990s.

- Between 56 percent and 85 percent of school-aged children consume at least one soft drink daily.

- Teenage males drink the most soda, with 20 percent consuming four or more servings per day.

In the face of deep budget cuts for education, school districts are making exclusive contracts with beverage companies. The soda dollars help pay for items such as band uniforms, field trips and computers.

But a lifetime of obesity is a heavy price to pay for some new epaulets.

MILK AND DAIRY ARE OKAY

Milk is certainly better for toddlers than soda. But some parents worry that too much milk and dairy products will make their kids fat. This worry is generally mistaken.

At a March 2004 meeting of the American Heart Association, researchers from the Boston University School of Medicine reported that two servings of dairy food a day through childhood was linked to a substantial reduction in adolescent fatness.

Childhood dairy intake fell during the 1980s and 1990s, in part as kids' preferences shifted from milk to soft drinks. (During the same period, average annual soda consumption among young kids rose 300 percent.) But the shift also was caused by the impression that dairy products were fattening. "Adolescent girls in particular are concerned about eating dairy because they think it will make them fat," the Boston University group reported. But the group's research, based on the Framingham Children's Study, found just the opposite is true.

The researchers did frequent dietary surveys on 106 families with children and followed them an average of 12 years. They judged body fat by measuring the skin thickness on four parts of their bodies and found that kids who consumed less than two

servings a day averaged about an extra inch of fat in a fold of skin, a surprisingly large amount. The average skin fold thickness was 75 millimeters; those who ate little dairy were 33 percent thicker.

Among other findings that the Boston University group reported: Kids who ate moderate amounts of fat—between 30 percent and 35 percent of total calories—weighed less than those who ate either more or less.

A good statistician would point out that moderate dairy intake might not *cause* better health. It might indicate a generally well-balanced diet…which itself might indicate a more stable or supportive home life. Any of these factors might be the real reason for the healthier weight at adolescence.

Specific findings come and go, but the general conclusion that studies share is that kids' diets need to be more balanced than they are. A child shouldn't drink a soda every day—and certainly not more than one. And he or she should eat some kind of fruit and some kind of vegetable with each meal.

FOOD/ALLERGY LINK IS WEAK

People—especially expecting and new parents—often worry a lot about allergies and other chronic conditions in their children. Various theories about how to prevent or reduce the effects of these conditions have bounced around medicine and alternative-medicine circles for generations.

A report delivered at a March 2004 meeting of the American Academy of Allergy, Asthma & Immunology by a group of researchers from the Univer-

sity of Manitoba suggested that some of these theories are more fiction than fact.

The Manitoba researchers had a group of ob/gyn's ask their patients—pregnant and breastfeeding women—to avoid various foods supposedly associated with allergies. These foods included milk, eggs and nuts. The women were selected from a larger Canadian study of asthma and allergies, so their children were all considered *high risk* (defined as having either one first-degree relative with asthma or two first-degree relatives with some allergic condition) for allergic conditions.

The researchers counseled the mothers to avoid peanuts, nuts, fish and decrease milk and egg consumption in the third trimester and during the first year of breastfeeding. The women were also asked to delay the introduction of solids for six months and only introduce milk after one year, eggs after two years and nuts after three years. The researchers then tracked the allergy histories of the children every two months for several years. Their conclusion: Skipping the suspect foods didn't do anything.

Specifically, when the kids were one, there was no statistically significant difference between the kids whose mothers had skipped the suspect foods and a control group (taken from the same larger asthma study) whose mothers had unrestricted diets. About 4 percent of the children in each group were allergic to milk; a few more of the kids in the test group than in the control group were allergic to eggs— but that difference wasn't significant.

At age two, there was a significant difference between the two groups in allergy to eggs. Responses

to the other foods were about the same. By age seven, the difference had shifted to nuts; the test kids were slightly more sensitive. And, across the board, the rates of sensitivity dropped as the kids got older.

Avoiding the suspect foods—which was supposed to prevent allergies—actually made sensitivities worse. This result was surprising. The researchers agreed...but noted that the sample was small, so their conclusions might not apply to everyone.

BALANCE IS IMPORTANT

Time and again, when it comes to diet issues, balance is the key point.

For example: One study suggested that, although calcium usually gets top billing when it comes to bone health, fruits and vegetables may also promote stronger bones in girls. The study of 56 girls ages eight to 13 found that those who ate at least three servings of fruits and vegetables each day had bigger bones than their peers.

The researchers suspected that a produce-rich diet helps limit the body's excretion of calcium from the bones. They recorded the subjects' food intake on three different days over a two-year period.

During the study, the researchers used x-rays to measure the girls' bone size; they also took urine and blood samples. They found that, compared with girls who ate fewer than three servings of fruits and vegetables per day, those who ate more had greater bone area overall.

The higher levels of fruits and vegetables didn't add any calcium to the girls' bones; but they did help keep the calcium from leaching out.

Since peak bone mass begins to decline after about age 30, it's important to build strong bones early in life—especially for young girls. Women have fragile bone problems more often than men. This means girls need an adequate intake of calcium and vitamin D during childhood and through teen years.

Children with abnormally low bone mineral density (a condition called *osteopenia*) may be at greater risk for osteoporosis later in life when bone mass begins to decline. In severe cases, patients may even experience bone fractures during childhood.

> **Why do some kids have osteopenia? Sometimes, it's a side-effect of other diseases. It can even result from an especially bad bone break. But the most common cause of osteopenia is poor nutrition.**

Poor nutrition (especially low intake of calcium and vitamin D) may limit the body's ability to form new bone. And the replacement of milk with cola really hurts here. Cola beverages contain phosphoric acid and caffeine, which may interfere with bone mineralization and increase the risk of bone fractures.

But the news isn't all bad here. Nutritional deficiencies can often be treated with diet and exercise. Children who are anorexic may need extensive counseling to overcome their poor eating patterns. Some

children may need calcium supplementation. Several medications have been approved to treat low bone mass in adults, but these medications haven't been fully tested in children.

TRENDY "DIET SCIENCE"

Generally, parents should treat any diet research they see or hear skeptically.

Some of these numbers are based on aggressive extrapolation from standard dietary impact charts, which lose their effectiveness the farther they move from empirical numbers. Infamously, for a report on the heart risks related to eating butter, the American Heart Association cobbled together different reports on daily fat intake over a lifetime...and forced some specific, short-term conclusions. To extrapolate such detailed, small numbers out of broad measures makes meaningless results.

Other statistics are based on animal tests, which have an important flaw: animal experiments necessarily involve large doses on sample populations. To measure a risk of one in a million precisely, you'd have to perform a million tests involving as many as 1,000 animals each. The cost would be prohibitive. The best scientists can do is experiment with large doses, adjust for the weight and metabolic activity of the animals compared with humans...and project the possible results of small doses on people.

A lot of guesswork is involved.

Through the early 1990s, an intense debate took place in scientific circles over whether some nutri-

ents, such as vitamins C and E, calcium, coenzyme Q10 and zinc—taken at levels well above the federal government's recommended daily allowance (RDA)—provide benefits beyond their traditionally-defined essential functions. The theory that they would, called "super-nutrition" in dietary circles, was fashionable at the time.

The use of foods for medical purposes dates back many centuries. But advocates of super-nutrition base their position on modern science—specifically, anecdotal evidence that certain nutrients, taken in huge doses, can reverse things like early-stage cancer tumors.

Scientists argue that cancer is not an on-off switch. It's more like a gradual deterioration with built-in stops. These stops are biological mechanisms: DNA repairs, cell-to-cell communications and other mechanisms in the body that repair cell damage.

Super-nutrition holds that you can boost these stops so that the body can participate more effectively in the recovery and illness protection process.

Nutrition and exercise ought to be protective factors. Unfortunately, for most, they are not. On any given day, only 18 percent of Americans eat cruciferous vegetables (i.e., broccoli, radishes, watercress and brussels sprouts) and only 16 percent eat whole grains. The rest of us are eating junk food.

FAT AND SALT = OBESITY

The U.S. Surgeon General's Office has noted that, in the 2000s, some 61 percent of Americans are

overweight—up from 46 percent in the 1970s. More than ever, Americans eat cheap and convenient food...from McDonald's, KFC and Pizza Hut. But along with this convenience come empty calories, refined sugars and artery-clogging fats. This isn't good. And it's especially not good for kids.

Obesity leads to diabetes, heart disease and other health problems. It causes or contributes to 300,000 deaths in America each year...and costs $117 billion in health care. And both of those numbers are going up.

American Heart Association dietary guidelines emphasize reducing total fat (not just cholesterol) and keeping a balanced diet. In 1995, the AHA reduced its recommendation of no more than 30 percent of fat in the daily diet to no more than 20 to 25 percent. Less than 10 percent of the fat in the daily diet should come from saturated-fat (animal) sources. AHA dietitians insist that simple adjustments to the average balanced diet can achieve these goals.

Lowering fat intake can also reduce your risk of getting colon cancer. This is especially important if your child is a boy. Colon cancer is the second leading cause of cancer deaths in men in the U.S.

And then there's salt. Reducing sodium intake actually can prevent hypertension from developing. About 80 percent of consumed sodium comes from processed foods; 20 percent is added during preparation or at the table. So, you can cut out most of this problem when choosing food at the grocery store. Avoid processed foods. If the ingredient list on a product includes "salt" or any compound term

that includes "sodium," don't let your kids eat it out of the container.

Why is this problem getting worse? Part of the problem is that America seems institutionally insecure about how fat it's getting. In the 1990s, the Department of Agriculture and the Department of Health and Human Services adjusted their guidelines for what a person's normal weight should be. The feds said that a "normal" 5-foot-6-inch woman under age 34 could weigh 118 to 155 pounds; over 35, she could weigh 130 to 167.

This upward adjustment is a dietary version of the phenomenon economists call bracket creep (when inflation raises the incomes of middle-class people into upper-class tax brackets). In this case, overweight people are reclassified as not overweight. It's a national version of indulgent parents telling their fat child that he's just "big-boned."

WHAT FAT KIDS FACE

A simple truth is that overweight children face a far greater risk of high blood pressure—and various other health problems—than their leaner peers do.

A health study of students in Houston public schools published in the March 2004 issue of the journal *Pediatrics* proved this point in scientific detail. The study of 5,102 students between age 10 and 19 found that 4.5 percent had high blood pressure and that blood pressure rose in tandem with body mass index (or BMI). Among overweight children, 11 percent already had high blood pressure— and the oldest of them were just 19.

Overall, 20 percent of the students in the study had a BMI at or above the 95th percentile—the definition of "overweight" for children. And the obesity rates in the Houston schools had an ethnic component; rates were highest among Hispanic kids, at a shocking 31 percent. Twenty percent of the black kids were overweight; so were 15 percent of the white kids and 11 percent of the Asian kids.

Hispanic children also more frequently had high blood pressure, a finding the researchers tied back to their disproportionately high BMIs.

High blood pressure is one of a number of cardiovascular conditions, including type 2 diabetes and high cholesterol, increasingly being seen in children as their rates of overweight and obesity climb.

Lead author Ronald Portman of the University of Texas Health Science Center argued that the responsibility for reacting is on parents and guardians— because their children are largely powerless over the food that's in the house. But Portman and his colleagues did admit that their study emphasized the importance of schools not adding to the problem by offering junk food meals in their cafeterias and soda machines in their hallways.

Bad diet comes at kids from all angles. A February 2004 report from the Center for Science in the Public Interest pointed out that—while the servings may be smaller for chain restaurant children's menu items—the food was loaded with fat.

CSPI researchers analyzed food choices for children available at 20 of the top sit-down chain restau-

rants in the U.S. They found little variety in the children's menus, which are heavily tilted toward fattening foods—hamburgers, breaded chicken, pizza and french fries. Many of the kids' meals equaled or exceeded the U.S. government's daily recommended totals for children of 17 grams of fat and 1,500 calories.

YOU CAN LEAD BY EXAMPLE

A report published in the journal *Public Health Nutrition* in early 2004 blamed parents of children who don't eat the recommended five portions of fruits and vegetables a day for setting a bad example. Although kids can be stubborn about what they will and won't eat, parental eating habit has a major influence.

"Parental consumption was the strongest predictor of children's consumption," said Lucy Cooke, the report's lead author and a psychologist at University College London. "Setting an example is tremendously influential."

Cooke sent questionnaires to parents of children in 22 nursery schools in Northern England to get an idea of what influences the eating habits of two- to six-year-olds.

What the parents consumed was the biggest influence on kids' diets. But eating together as a family, breastfeeding and introducing a variety of fruits and vegetables early were also important factors.

Cooke stressed that kids will not automatically eat the same foods as their parents but it helps if they

see adults and siblings eating nutritious meals. "Eating together as a family is a really good thing," and parents should be vocal about how much they like healthy foods because kids are programmed to imitate their parents in many ways, she added.

CONCLUSION

Being overweight increases a child's risk of diabetes, cardiovascular problems and several kinds of cancer. So, it's good not to be overweight.

Losing weight and lowering your cholesterol will not make you healthy. These things will simply make you less unhealthy. Being lean and in-shape doesn't make you healthy per se, but it makes you healthier as compared to being overweight and lethargic.

Diet is a long-term, gradual protection. Your best bet is to shave at mortality and life-span odds by eating a balanced, low-fat diet—including lots of mineral-rich fruits and vegetables...and engage in some form of physical activity to increase your heart rate...and pass these good habits on to your children.

Bottom line: It's no mystery that a good diet will improve your chances for living a longer, healthier life. But a good diet is significant largely because it reflects a balanced, generally healthy approach to living. In this way, it's the opposite of fad diets designed to help someone look good by means of drugs or strange eating habits.

CHAPTER **13**

COMMON
CHILDHOOD
MEDICAL ISSUES

A basic fact of having kids is that they get sick and hurt…a lot. Usually, their injuries and illnesses are not life-threatening—but are experiences that prepare them for living long lives as adults.

Still, as a parent or guardian, you are going to spend more time in doctors' offices and emergency rooms than people who don't have kids. And, if you have more than one, the health issues often seem to increase geometrically.

In this chapter, we'll take a quick look at some of the most common health issues that kids face—and some simple things you can do to manage them well. The best advice boils down to knowing a little about how doctors and health plans deal with common kids' problems, which in turn, can help you make informed decisions.

EAR INFECTIONS

Younger children get ear infections. Sometimes, the infections are related to drinking from baby bottles— they occur a lot in toddlers who are still drinking

bottles at night. In other cases, the ear infections are related to rapid growth and the intricate tubing that's part of the inner ear.

Whatever the cause, ear infections are the most common reason that pediatricians prescribe antibiotics for children. There were an estimated 16 million office visits and more than 13 million antibiotic prescriptions written for ear infections in 2000. Those antibiotics can break a fever fast...but they're not necessarily the best response for the child.

In March 2004, two influential doctors' groups published guidelines aimed at limiting use of antibiotics for ear infections in children. The guidelines stated that about 80 percent of children with ear infections get better without antibiotics—and that pain relief should be the top priority.

The guidelines encouraged doctors to try pain relief and observation in otherwise healthy children with relatively mild ear infections, if they could be assured of adequate follow-up. In such cases, antibiotics could be started if symptoms didn't improve in two or three days.

The rationale behind addressing pain first is that about 60 percent of kids feel better after a day, and antibiotics don't relieve pain in the first 24 hours anyway. This wait-and-see approach requires patience and may lead to a second office visit that may be inconvenient and expensive.

Because some ear infections can lead to complications, the guidelines say antibiotics should be prescribed to children younger than sixth months who

have diagnosed or suspected middle ear infections; kids six months to two years with suspected or confirmed infections and severe symptoms; and kids two to 12 with confirmed infections and symptoms.

If antibiotics *are* used, the guidelines—a joint effort of the American Academy of Pediatrics and the American Academy of Family Physicians—say amoxicillin should be prescribed for most children.

The guidelines focused on a specific type of ear infection known as *acute otitis media*. It's the most common infection for which antibiotics are prescribed. And the doctors' groups acknowledged that initial treatment with antibiotics may be appropriate for children younger than two and those who are very sick or have a high fever with their ear infections.

While use of antibiotics for childhood ear infections has long been routine in the U.S., in European countries common practice is observation and pain relief first—which may help stop the rise in antibiotic-resistant germs created by overuse of the drugs.

Why do American doctors prescribe—and American children consume—more antibiotics than their European counterparts? Some experts point out that the doctors are so frightened by potential malpractice claims that they medicate just about any illness or discomfort that they see. Patients are satisfied and feel justified when a doctor prescribes drugs; the doctors can show they took the patient's complaints seriously...if anyone questions their actions later.

Some doctors suggest surgery for children with chronic otitis media. This kind of surgery involves the insertion of tubes into the eardrum and is one of the most common operations performed on children. It is usually performed in an outpatient clinic. Tubes are usually placed in both ears. They ventilate the middle ear and help equalize air pressure.

Tubes also drain fluid from the middle ear and improve hearing. Hearing loss is common in children who have built-up fluid behind their eardrums. Children who have ear infections often develop fluid behind their eardrum and hearing loss. Hearing loss is of greatest concern in children age 2 and younger because normal hearing at this age is critical in developing basic speech and language skills.

The decision to resort to surgery is made on a case-by-case basis and has been a debated topic among doctors for decades. Surgery to remove the adenoids (adenoidectomy) or to remove the adenoids and tonsils (adenotonsillectomy), are also controversial operations, which may be done if swelling of this tissue is thought to be blocking the eustachian tube. A large study over a 14-year period found only limited and short-term benefits from either surgery. For this reason, the experts recommend adenoidectomy or adenotonsillectomy only after tubes have failed to prevent recurrent ear infections. If you're considering these kinds of operations for your children, it's a good idea to get a few opinions from various doctors first.

FEVERS

The question of how to treat a young infant with a high fever has been debated for decades. The Ameri-

can Medical Association has tended toward the invasive extreme—issuing guidelines that encouraged hospitalization and many lab and blood tests, sometimes including a spinal tap. This conservative approach reflects the institutional fear that doctors who do less might miss a case of serious illness such as bacteria in the blood or bacterial meningitis. It has resulted in relatively healthy babies spending unnecessary days in the hospital.

But the early 2000s saw a series of published studies that questioned this response. One study, conducted by pediatrics researchers at the University of California at San Francisco, concluded that doctors in private practices and HMOs could choose not to follow the AMA guidelines without compromising their patients' health.

The UCSF researchers evaluated data from 3,066 infants aged 3 months or younger seen by 573 practitioners from all parts of the U.S. The babies all had body temperatures of at least 100.4 degrees Fahrenheit. The researchers tracked what tests were ordered and whether the children were hospitalized. Their conclusion: Following AMA guidelines strictly didn't do anything to improve the diagnoses—but it did result in the hospitalization of 40 percent more of the babies, which cost more, of course, than following the infants via regular office visits; and it caused a lot more stress for parents.

Of the 3,066 babies, 14 had bacterial meningitis. Another 49 had bacteria, E. coli or group B strep in the blood. In two cases, doctors missed one of these serious problems—but both babies were examined again within a few days and treated correctly.

So, why the aggressive guidelines? Cynics might snort that the guidelines assure lots of full beds in pediatrics wards. But pediatricians say that the guidelines were based on experiences in inner-city emergency departments. In those settings, doctors say, there's often no follow-up—and a pediatrician may not see a sick baby for weeks or months after an emergency room visit.

But that situation isn't true everywhere. In the UCSF study, only 4 percent of the cases involved one-time visits.

CHICKEN POX

Chicken pox is a common disease caused by the varicella-zoster virus (VZV), which is part of the herpes virus family.

Don't get upset by the name; the herpes virus family is made up of nearly 100 viruses. The group does include herpes simplex—the "herpes" that most adults know of—but it also includes Epstein-Barr virus (which causes infectious mononucleosis) and others.

Chicken pox includes flu-like symptoms—fever, headache, runny nose, muscle and joint soreness. But its most distinctive symptom comes a day or two after the others: blister-like legions that give the illness its name. The blisters usually appear on the chest, back or face first; but they eventually appear over the entire body. In two to four days, the blisters burst and harden into small scabs. The scabs fall off a few days after that.

Although chicken pox is most common in kids under the age of 15, anyone can get it. In the 1990s, an antiviral vaccine was developed that can prevent chicken pox in children and adults. While the vaccine isn't 100 percent effective, it does tend to reduce the effects of chicken pox in the cases where a vaccinated person contracts the illness.

While most people consider chicken pox a relatively minor rite of passage through childhood, it can cause some serious health problems. In a few cases, it causes serious inflammation of the nervous system and brain swelling; these problems can leave long-term damage. Slightly more often, a chicken pox legion will erupt in a child's stomach, intestines, eyes or a mucus membrane lining and cause serious infection. And chicken pox is a serious risk during pregnancy—it can cause major problems for the fetus, including deafness and nervous system problems.

A person usually has only one episode of chicken pox in his or her life, though there are some exceptions to this rule. The virus can lie dormant within the body and can cause a different type of skin eruption later in life, called shingles (also known as *herpes-zoster*). Shingles is notoriously painful and poses a greater risk of lasting nervous-system damage.

The chicken pox virus is very contagious. It spreads in the air through coughs or sneezes or through contact with fluid from inside the chicken pox blisters. If exposed to an infected family member, 80 to 90 percent of those in a household who haven't had chicken pox will get it.

If your kids get chicken pox, your best course of action will be to do all that you can to keep them from scratching. Good steps for doing this:

- frequent baths in lukewarm water mixed with baking soda (four or five baths a day aren't too many);

- apply calamine lotion as needed to the skin—be prepared to apply a lot of it;

- give them an antihistamine like Benadryl or an equivalent brand for itching;

- give them acetaminophen for fevers above 102 degrees;

- if they get blisters in their mouths, have them rinse with warm water mixed with baking soda or a light hydrogen peroxide solution—make sure they don't swallow either;

- if blisters look infected, wash them well and apply an antiviral ointment like Neosporin or Bacitracin.

You may feel tempted to take an uncomfortable child to the emergency room for help with the chicken pox. In most cases, the staff there will focus on the child's temperature—and usually won't take much action unless the fever is over 102 degrees. But it is a good idea to speak with your pediatrician's office about your child's chicken pox; they will probably want the child to come in, for a checkup to make sure none of the more serious nervous-system problems are afoot.

A child with chicken pox should usually stay out of school or daycare for five to seven days—or until the blisters have all scabbed over. When the scabs appear, the contagious stage is largely over.

INFLUENZA

Flu, or influenza, is caused by viruses that infect the nose, throat and lungs. The flu is not the same condition as the "common cold," which is caused by other types of viruses (typically rhinoviruses). Unlike the common cold, the flu causes severe illness and can be life threatening. Each year, more than 100,000 Americans are hospitalized because of the flu, and more than 36,000 die from complications from it.

The flu usually spreads through the air from person to person when an infected person coughs, sneezes or talks.

Influenza and its complications are the sixth-leading cause of death among children ages 4 and younger, according to the Centers for Disease Control and Prevention. So, it is a serious matter for young kids.

Some children—particularly those who already have a weakened auto-immune systems—are at high risk of having complications from the flu. Flu could make them very sick or even kill them.

Anti-viral "flu shots" can greatly reduce the chances that your young children will contract influenza. These shots are widely available—often for no charge at schools, public daycare centers and free clinics. If you hear that cases of influenza have been diagnosed in

your area, contact your pediatrician about getting the anti-viral shots for your children; if you don't have a pediatrician, contact your county health department or a local free clinic for information.

Flu shots are available in the fall, anywhere between September and December. During some years when the flu is predicted to be bad, it's smart to call your doctor in advance and reserve a shot for you and/or your children. Only so many flu shots get made every year, and they often run out. Your local pharmacy or even supermarket might have special "get your flu shot" day, too.

Babies younger than six months are usually not allowed to receive the anti-viral shots. But all young children from six months to three years should have the shots. And children over three should have the shots if they have any of the following conditions:

- asthma or other problems of the lungs;
- immune suppression;
- chronic kidney disease;
- heart disease;
- HIV/AIDS;
- diabetes; or
- sickle cell anemia.

Also any child who's receiving long-term aspirin therapy should get a flu shot.

The best way to protect babies under six months old from influenza is to make sure that you, their family members and their caregivers are vaccinated.

TONSILLITIS

The tonsils are fleshy clusters of tissue that lie in bands on both sides of the back of the throat. *Tonsillitis* is an inflammation of the tonsils caused by an infection. In tonsillitis, the tonsils are enlarged, red and often coated (either partly or entirely) by a substance that is yellow, gray or white. Tonsillitis usually occurs as part of a *pharyngitis* (throat infection). In older children, the illness usually begins with sudden sore throat and painful swallowing. A child may also experience loss of appetite, chills and high fever. Glands in the neck and at the angle of the jaw may be swollen and tender.

In infants, tonsillitis may include symptoms that appear to be less focused on the throat, such as poor feeding, runny nose and a slight fever.

As with many children's health issues, pediatricians used to use surgery a lot more quickly...and frequently...than they do today. As recently as the 1980s, doctors would remove infected tonsils more than two-thirds of the time. More current statistics suggest they cut on fewer than half of the cases.

Tonsillitis is caused by viruses or bacteria; the symptoms are often the same no matter what sort of germ is causing the infection. *Bacterial* tonsillitis can be treated with antibiotics, but *viral* tonsillitis cannot. Doctors differentiate between the two by taking a throat culture (a painless swab of the back of the throat) or a quick strep test. In about 15 percent of throat cultures, streptococci are found, and the infection is presumed to be a strep infection; in the other 85 percent

of throat cultures that are negative for strep, the cause of the throat infection is usually a virus.

To prevent tonsillitis, avoid exposure to anyone who already has tonsillitis or a sore throat. At home, when someone is infected with tonsillitis, be sure to keep drinking glasses and eating utensils separate, and wash dishes in hot, soapy water. All family members should wash their hands frequently.

All forms of tonsillitis, whether caused by bacteria or viruses, are contagious illnesses. Tonsillitis usually spreads from person to person by contact with the throat or nasal fluids of someone who is already in-fected. This is why parents who care for a child with tonsillitis should keep the child's drinking glass and eating utensils separate from those of other family members. They should also wash their hands frequently as they care for a child who is sick with tonsillitis, especially if they are also caring for younger children who are not ill.

Infections caused by streptococci cause special prob-lems. Estimates are that in a home where someone already has strep, about one out of every four family members will get it, too. Some children can be carri-ers of strep bacteria without having any symptoms. Among school-age children, one in five may be as-ymptomatic carriers of strep bacteria.

Call the doctor if your child has symptoms of tonsil-litis, including sore throat, painful swallowing, headache, fever, chills or swollen neck glands.

If your child is already being treated for tonsillitis, call your child's doctor immediately for any of the following symptoms: fever that returns after several days of normal temperature; skin rash; earache; nasal discharge that's discolored or bloody; cough, especially if it produces mucus; chest pain, shortness of breath or extreme tiredness; convulsions; painful, red or swollen joints; nausea or vomiting.

MONONUCLEOSIS

When your child reaches his or her teens, different kinds of communicable illnesses can become concerns. One example: Infectious mononucleosis.

Mononucleosis is an illness caused by the Epstein-Barr virus (EBV), a member of the herpes virus family. Similar symptoms and illness are sometimes caused by cytomegalovirus, which is also a member of this family of viruses. EBV is transmitted through the saliva. Young children can be infected from the saliva of playmates or family members. Adolescents with the virus can spread EBV through kissing (hence its once popular name, "the kissing disease").

Blood tests usually show an increase in the overall number of white blood cells. Blood can also be examined under a microscope to determine whether there is an increased number of particular white blood cells called *lymphocytes*. These white blood cells help fight viral infections, and an increased number of "atypical" lymphocytes usually indicates current infection with mononucleosis.

Studies show that most people have been infected with EBV at some point in their lives, and most have few or no symptoms of viral infection.

When people think of "mono," they often think of extreme exhaustion as one of the major symptoms. Other typical symptoms of infectious mononucleosis in older children include:

- fever;

- sore throat;

- enlargement of lymph nodes (in the neck, armpit and throat);

- sore muscles; and

- enlarged spleen (located under the rib cage on the left side and functioning as a blood filter and antibody producer).

Loss of appetite and generalized weakness also may be present, especially in adolescents. Nausea, hepatitis, jaundice, severe headache, stiffness, chest pain and difficulty breathing can occur in some cases. A pink rash can occur all over the body in children who have been treated with certain antibiotics.

Younger children may have few or none of these symptoms; instead they may have nonspecific symptoms like fever, slight malaise and loss of appetite. Adolescents are more likely to exhibit the classic symptoms. Some may experience extreme fatigue, staying in bed for more than a week because they feel too weak even to walk around the house.

Some pediatricians will prescribe antibiotics to counter the Epstein-Barr virus. But infectious mononucleosis is generally a self-limiting disease, which means it goes away on its own in most cases.

LICE

Lice are parasitic insects that can cause itching and scratching, especially on areas of the body that are covered with hair—typically the scalp, neck and behind the ears. Six to 12 million people are infested with lice each year.

The common head louse, *Pediculus humanus capitus*, is very small (less than 4 millimeters long) but you can see it if you look carefully. It lives among human hairs, draws blood from the skin (although the amount drawn is almost too little to measure) and lays its eggs (also called "nits") on hair shafts, close to the skin surface, where the temperature is good for incubation. A louse has tiny claws on its legs that are well-adapted for clinging on to strands of hair or clothing. Its bites may cause inflammation and itching; and they can become infected.

If your child's hair is infested, you might be able to see the nits, which look like white grains of sand attached to the hair shafts. It is more common to see nits in a child's hair than it is to see live lice crawling on the scalp.

Head lice are sometimes considered a sign of poor personal hygiene—but, in fact, infestations have little to do with cleanliness. Lice are highly contagious. Although they don't fly in the air or walk on the ground, they can pass from person to person on clothing, bed linens, combs, brushes and hats. Children and young teens are most prone to catching lice because they are most likely to share such personal items and because they are often in close physical contact with other infected children.

Most schools and daycare centers have a standard notice on-hand and circulate it among parents when teachers or staff discover a lice infestation.

Medicated shampoos, creams and lotions—available without prescription—can end a lice infestation right away, but it may take about 5 days for the itching to stop. And most skin doctors suggest repeating the medicated treatment about a week after the first treatment—just to be sure you've killed all of the bugs.

Your children (and you) can minimize the chances of being infested by head lice by taking the following common-sense precautions:

- avoid physical contact with a person who has lice;

- do not share combs, brushes, hats, scarves, ribbons or other personal items;

- examine and treat members of your household who've had close contact with a person infected with lice;

- buy a fine-toothed comb (specially designed ones are often sold in combination with lice-killing shampoo) and comb your kids' hair, looking for nits;

- if your kids' school or daycare center sends home a note about lice, have some medicated shampoo at home—just in case your kids start scratching.

Although not usually necessary, washing clothing and bed linens in very hot water putting them in airtight bags for 10 days can help kill the lice and

their eggs. Hair-care items, like combs and brushes, can either be soaked in hot water or medicated shampoo or thrown away. Because lice infestations are easily passed from person to person in the same house, your family members may need treatment for lice infestation to prevent lice from coming back. Lice are not dangerous, but they can be annoying.

STRESS

Stress can affect anyone, even a child, who feels overwhelmed. A two-year-old may be anxious because the person—usually, her parent—she needs to help her feel good isn't there enough to satisfy her. In preschoolers, separation from parents is the greatest cause of anxiety.

As children get older, academic and social pressures can create stress. In addition, well-meaning parents sometimes unwittingly add to the stress in their children's lives; ambitious parents often have great expectations for their children, who may lack their parents' motivation or capabilities. Parents who push their children to excel in sports or who enroll their children in too many activities may also cause unnecessary stress and frustration if their children don't share their goals.

Simply said, stress is a function of the demands placed on people and their ability (or inability) to meet them. These demands often come from outside sources (such as family, friends or school); but they can also come from within.

Some kids internalize all kinds of outside pressures: fights their parents have, petty social rituals at schools,

their appearance, violence on television, family member's happiness or sadness, world events.... Sometimes it shocks parents to find out what things make kids feel stressed.

Usually, kids—like adults—will function with their stress well enough until some sort of triggering event happens that makes the stress unbearable. For children, these triggers can be an illness or death in the family, a divorce or a dramatic change in family circumstances.

How can you identify serious stress? It's difficult. Abrupt changes in behavior—things like mood swings, self-destructive actions, changes in sleep patterns or bed-wetting—can be indicators. Some children experience physical effects, including stomachaches and headaches. Others have trouble concentrating or completing schoolwork; others become withdrawn or spend a lot of time alone.

This range of responses is a big part of the reason that insurance and health plans put strict limits on how much mental health care they will cover. Stress takes many forms and can involve many cures.

If you think your kids are feeling stress, there may be non-insurance steps that you can take to make the situation better.

Proper rest and good nutrition can help increase your child's resistance to stress—make sure they're getting these. Time with parents can help, too; whether your

child needs to talk...or just to be in the same room...with you, make yourself available. It's often hard after a day of work, to play with your kids or talk to them about their day; but, by showing interest in your child's life, you underscore the family that he or she can rely on.

Children like routine. If times are particularly stressful, it can help to set daily schedules—school, doctors' appointments, sports—with extra detail.

And remember that some level of stress is normal; let your child know that it's normal to feel angry, scared, lonely or anxious. Let him or her know that other people feel the same things.

SHORTNESS

In 2003, the U.S. Food and Drug Administration approved use of a synthetic human growth hormone—specifically, Eli Lilly and Co.'s Humatrope—for children with "idiopathic short stature." That means kids who are just short, not because of any underlying disease. Humatrope had been proved to help short children grow into slightly less-short adults.

The decision meant that as many as 400,000 children could get medication for a problem that wasn't quite an illness...but something closer to a personal obstacle or point of social prejudice.

Extreme short stature—defined as 4' 1" for a boy or girl age 10 and less than 4' 11" for an adult woman or 5' 3" for an adult man—is not a disease. But it is often one symptom of an underlying medical disorder, such as Turner's syndrome (which affects girls

and women), chronic kidney failure, malnutrition or any of several genetic development disorders. In 1997, the FDA added "growth hormone deficiency" to the list of medical conditions that can cause extreme short stature, and for which the use of Humatrope was government approved.

Like the FDA's handling of drugs that treat shyness, impotence or depression, the growth hormone decision took the agency into some dicey political and ethical grounds. Drug companies had made the business decision in the 1990s to pursue lifestyle drugs, which modify conditions that aren't necessarily life-threatening. In order to get these drugs approved by the Feds, the drug companies spent heavily to arrange the testimony of people who either had been (in pre-approval testing) or would be helped by the drugs.

This changed the dynamic of the drug approval process, which had traditionally been very clinical. With drugs like Humatrope, it was hard to show— scientifically—that the benefits were significant; the actual inches that it added to most people's height weren't so many. Instead, the review process became more like a congressional hearing—with emotional testimony from people about how much the drugs had improved their lives.

The decision to use a drug like Humatrope is yet another example of something that must be done on a case-by-case basis. The FDA's decision was important because it meant, in most cases, insurance companies would pay for hormone therapy for short kids. Parents should realize that it's not a miracle pill to produce super tall kids. And years of treat-

ment might draw them just inside the range of "normal height" but you have to consider all the costs and potential side-effects. Another reason to get multiple opinions from doctors beforehand.

CONJUNCTIVITIS

If you get through childhood without a bout of conjunctivitis, consider yourself lucky. It's a very common infection...especially in children. The conjunctiva is a thin, transparent membrane that lines your eyeball and your eyelid. When it becomes inflamed for various reasons, the result—conjunctivitis—is a painful infection that usually clears up in a few days.

It's caused by a bacterial or viral infection, chemical exposure, or by an allergic reaction to pollen, smoke or other material that irritates the eyes. Children sometimes contract conjunctivitis after a cold or a sore throat.

And it can be highly contagious (known to spread rapidly in schools or daycare settings). But it's rarely serious and will not damage a child's vision if detected and treated promptly.

Ophthalmia neonatorum is an acute form of conjunctivitis in newborn babies. It must be treated immediately by a doctor to prevent permanent eye damage or blindness.

Generally, at-home remedies can alleviate conjunctivitis associated with uncomplicated colds, minor infections or allergies. Treatment consists primarily of cleansing the eyes and preventing the condition from spreading. If your child has a severe bacterial infection, antibiotics for the eyes—prescribed by an ophthalmologist—will clear up the conjunctivitis within a few days.

Key to managing conjunctivitis is preventing its spread. The follow is a list of things to keep in mind:

- Wash your hands often and well. Make your children do the same.

- Keep your hands away from the infected eyes. This means telling your children to avoid contact with their eyes.

- Make sure your child does not share washcloths, towels, pillowcases or handkerchiefs with others.

- Wash your children's washcloths, towels, and pillowcases frequently (after each use).

- Keep children with pinkeye out of school for a few days.

APPENDICITIS

Diagnosing appendicitis is tricky. There are no definitive tests other than using a medical history, physical examination and laboratory tests that look at the white blood cell count. Appendicitis is most common in people ages 10 to 30, although it can occur at any age. It is unusual in children younger than 2.

The appendix is a three- to six-inch hollow sac attached to the large intestine (colon) where the large and small intestines join. It's located in the lower right area of the abdomen...and has no known function.

The first indicator of appendicitis is abdominal pain. It might be generalized pain or it might be localized in one area—typically the lower right quadrant. Moving, walking or coughing increases the pain. Other key symptoms are loss of appetite, slight fever, nausea and sometimes vomiting. If you think your child has appendicitis, best thing to do is take him or her to the doctor. If you delay, the appendix can rupture and lead to fatal consequences. (For more details, see Chapter 17.)

CONCLUSION

Illnesses and injuries are constant facts of childhood. Your child may not need invasive treatment just because he or she is sick. In most cases, old-fashioned common sense goes a long way. Treat their pain or discomfort, keep a close eye on their temperatures, push clear fluids so they don't get dehydrated. These basic tips can get your kid through many childhood illnesses.

And, bear in mind that some childhood illnesses prepare their young immune systems for a robust adulthood.

In 2003, medical researchers from Henry Ford Health System in Detroit reviewed the medical

records of 835 children enrolled at birth in the Childhood Allergy Study and noted any illnesses with documented fevers—defined as a temperature of at least 101 degrees Fahrenheit—in their first year of life. When the children were 6 or 7, researchers tested about half of them for reactions to dust mites, cats, dogs, bluegrass and ragweed. (The results were published in the *Journal of Allergy and Clinical Immunology*.)

Among children who had no fevers in their first year, 50 percent showed allergies or skin sensitivity to at least one of the allergens. Having at least one fever dropped the percentage to 46.7, while having two or more fevers in infancy dropped it to 31.3 percent.

The findings added some weight to the controversial "hygiene hypothesis." This theory—which many pediatricians dispute—holds that children who are exposed to dirt, bacteria and animals early in life are less prone to allergies and asthma later on.

The key to ensuring your children's health is by being vigilant to their pains and ailments...but knowing when it's necessary to visit the doctor and not. This is a challenge—one that's perhaps best mastered the longer you're a parent and the more children you have.

CHAPTER 14

PREVENTIVE
MEDICINE

As we've noted, one major difference between an indemnity insurance plan and a managed care plan is the approach to preventive medicine. Under an indemnity plan, there's usually no coverage for ordinary checkups, so-called "wellness programs" or preventive treatments and therapies. Under a managed care plan, all of these preventive measures—as well as some farther-out therapies like chiropractic treatments, acupuncture and alternative medicine—may be covered and even encouraged.

This emphasis on preventive care is a major reason that we say managed care plans make sense for families with kids. Regular checkups are a good idea.

And, if your child has a chronic or long-term medical condition, a managed care plan will cover more of the educational components of wellness programs, so that you and your child can learn about the condition...and how to live with it.

In this chapter, we'll look at the various mechanics of preventive medicine and wellness programs—and how they can be particularly useful for kids.

WHAT IS PREVENTIVE MEDICINE?

To some people, the term *preventive medicine* means so much that it ends up meaning nothing. According to various sources, it can involve everything from early psychiatric therapy or family counseling to parental education.

The National Research Council and Institute of Medicine issued a voluminous report, *From Neurons to Neighborhoods*, that presents scientific evidence showing the importance of early childhood development and early intervention services. It finds that the brain and nervous system undergo their most dramatic development during the first few years of life. From birth to age five, children develop foundational linguistic, cognitive, emotional, social and moral capabilities upon which subsequent development builds.

The differences among what kids know and can do are obvious by kindergarten. These differences are keenly associated with social and economic circumstances and can predict later academic performance.

For the purposes of this book, we'll describe the difference between responsive and preventive medicine as the difference between the ER and the doctor's office. Responsive medicine treats illnesses, injuries and health issues once they've become problems; preventive medicine measures a child's development from infancy—and focuses on eliminating potential health issues before they become problems.

Preventive medicine is harder to quantify and categorize—but it does save money over the long term.

The effectiveness of preventive medicine has been documented in a variety of studies. For example:

- Breastfeeding is recommended by pediatricians to help infants grow and to anchor mother-infant interactions. A survey by The Commonwealth Fund found that mothers are more likely to breastfeed when educated and encouraged to do so by their doctor or nurse.

- Consistent reading times and daily home-life routines have been shown to influence healthy brain development in young kids.

- Educating parents about infant communication has resulted in significant differences in sensitivity to communication cues and social/emotional growth-fostering behaviors.

- Guidance from the pediatrician during office-based visits has resulted in infants showing advanced vocal imitation.

- Education and assistance provided to mothers in an intensive care unit nursery had a significant effect on the cognitive development of low birth weight infants, to the point where their development approximated that of normal birth weight infants.

VERY YOUNG KIDS

When your child was first born, you may remember the preventive or "well-baby" visits that you

made to the pediatrician maybe once a week for the first few weeks and once a month or every other month for the first six months.

In these early appointments, there is a lot of measuring and simple testing. The most common elements of these checkups are:

- Measurement of the baby's length, weight and head circumference. Growth is usually plotted on an individual growth chart—and compared to the population generally.

- A physical examination to check for normal function of the eyes, ears, heart, lungs, abdomen, arms and legs, etc. Examination of the baby's soft spot (the *fontanel*) at the top of the head—and the baby's mouth for signs of teething.

- A review of your baby's physical and emotional development through both observation and your report of his progress. Can he hold up his head? Is he rolling over? Is he attempting to sit up after six months? Is he trying to use his hands more and more? How does he react to strangers?

- A discussion of the baby's nursing and eating habits, including suggested schedules for moving to solid foods and away from breastfeeding.

In short, the doctor is checking for problems—and eliminating as many common ones as he or she can from simple testing, direct examination and speaking with you.

This process-of-elimination approach to caring for a child is much different than the work-backward-from-problem approach that doctors and nurses in emergency rooms use. It's less invasive, less expensive...and better for the child, in the long-run. Preventive medicine is important because it recognizes potential problems early and can act before problems manifest themselves.

Unfortunately, many parents and doctors move away from regular checkups when a child gets older than about three years. After that, the child will often see a doctor once a year—or when something's wrong. Whichever is less often. That's bad. The regular-checkup model from early childhood should continue through all of childhood (and, for that matter, through life). Many pediatricians think a child should have a general checkup twice a year.

And, if you have a managed care plan, the cost of those checkups is usually not a factor.

EARLY RECOGNITION

More regular, preventive checkups would do a lot for battling the growing phenomenon of childhood obesity in the U.S and other developed countries.

An excessive rate of weight gain relative to linear growth—that is, height—is sometimes an indicator of obesity; sometimes, though, it's just a side-effect of growth spurts. If a pediatrician sees a patient two to four times a year, he or she will have enough information to distinguish between a growth spurt and a burgeoning weight problem.

If the doctor only sees the child every other year, or less, there's not usually enough data to make useful conclusions.

Most pediatricians and public health experts believe that the high rates of obesity among American kids is partly due to social trends and partly due to the basic health ignorance of many parents.

> **As we've seen elsewhere, the social pronouncements of public health professionals are often influenced by trends among welfare-recipients. Research funding is often tied to assistance programs, so the experts' world view can become skewed by welfare.**

One likely benefit of preventive medicine is that it involves an educational component for both children and their parents. Looking at a Body Mass Index (BMI) percentile or a height/weight chart a couple of times a year makes it hard to plead ignorance about your child's weight issues.

The American Association of Pediatrics has spent a lot of time generating talking points for how its members can broach sensitive topics with parents. For example:

> Discussions to raise parental awareness should be conducted in a nonjudgmental, blame-free manner so that unintended negative impact on the child's self-concept is avoided. ...pediatricians are strongly encouraged to incorporate assessment and anticipatory guidance about diet, weight and

physical activity into routine clinical practice, being careful to discuss habits rather than focusing on habits to avoid stigmatizing the child, adolescent or family.

PREVENTION AND DIET

One reason that some health plans don't cover preventive medicine is that it often moves into areas like diet and hygiene—which aren't traditional fields with which the insurance companies are familiar.

But managed care plans have been savvy about recognizing that a nutritionist on staff can provide enough good advice that at least a few young people learn about the many bad health effects of being overweight.

Preventive medicine or wellness programs may include meetings with a nutritionist. But, even if they don't, they are more likely to include doctors who are inclined to offer nutritional advice to their patients. This is important, because various studies from the AAP and other pediatric groups indicate that children and parents take nutritional advice from doctors—when doctors offer it.

But, as one report noted in what passes for bureaucratic understatement: "Lack of reimbursement is a disincentive for physicians to develop prevention and treatment programs and presents a significant barrier to families seeking professional care."

This lack of reimbursement comes from indemnity insurance companies and—ironically—the CHIPs

and other state-funded health plans available to children from poor families. Both types of plans have made some progress in matching the focus that managed care plans give to preventive care. But an explicit focus on preventive medicine for children would accomplish a number of useful goals in the fight against childhood obesity:

- The news would get out. Parents who don't already know about the high rates of obesity and its significant side-effects among American children would learn.

- The change from response to prevention would be especially important in regard to obesity because there's little long-term data that suggests response works.

- Genetic, environmental or combinations of risk factors that predispose certain kids to obesity would be measured.

- Early recognition of excessive weight gain relative to height would become routine in pediatric settings.

- Generally, families would be educated to recognize the impact they have on the development of lifelong habits of physical activity and nutritious eating.

- Dietary practices that encourage moderation and emphasize healthful choices rather than restrictive eating patterns would be reinforced.

Moving from these general goals to more specific measures, the AAP has made the following preventive health recommendations:

- Identify and track patients at risk by virtue of family history, birth weight, or socioeconomic, ethnic, cultural or environmental factors.

- Calculate and plot BMI once a year in all children and adolescents. Use change in BMI to identify rate of excessive weight gain relative to linear growth.

- Encourage, support and protect breast-feeding.

- Encourage parents to promote healthy eating patterns by offering nutritious snacks, such as vegetables and fruits, low-fat dairy foods and whole grains, encouraging children's autonomy in self-regulation of food intake, setting appropriate limits on choices and mod-eling healthy food choices.

- Routinely promote physical activity, including unstructured play at home, in school, in childcare settings and throughout the community.

- Recommend limitation of television and video time to a maximum of two hours per day.

- Recognize and monitor changes in obe-sity-associated risk factors for adult chronic disease, such as hypertension, dyslipidemia, hyperinsulinemia, im-paired glucose tolerance and symptoms of obstructive sleep apnea syndrome.

MEDICAID'S PREVENTIVE EFFORTS

As we mentioned before, state CHIPs and other Medicaid programs have been surprisingly bad about encouraging preventive medicine. They tend to consider "early intervention" as an antagonistic process of invading a family's home and snatching some form of custody over a child with medical, cognitive, emotional or—sometimes—financial limitations that exist in the child's environment.

Clearly, state programs should find a better way to encourage preventive care.

And the politicians in Washington seem to realize this. Congress has provided for the coverage of early intervention services in a number of federal statutes: the Individuals with Disabilities Education Act provides federal funding for developmental and behavioral services for infants and children under age three who have developmental delays or are at risk of delays; the Maternal and Child Health Services Block Grant allows federal funding to ensure maternal and child access to quality health services and to increase the numbers of young children who receive checkups and needed follow-up care.

These services target the first few years of life and include health, education and social services. The health services include comprehensive diagnostic screenings, nutrition counseling, behavior therapy, physical and/or speech therapy, family support services and health education describing expected developmental milestones. This is a lot of ground— maybe too much, since CHIPs don't get the preventive medical care to kids consistently or often.

The most promising of Medicaid's various preventive tools is the Early and Periodic Screening, Diagnosis and Treatment (EPSDT) benefit—which even the federal government itself admits is an "underused" source of federal funding.

Medicaid-eligible children and youth under age 21 are entitled to receive EPSDT's comprehensive benefits. These benefits include: screening, diagnosis and treatment services and outreach. Four separate screening services—medical, vision, hearing and dental—must be offered at pre-determined, periodic intervals. From birth through age five, the American Academy of Pediatrics recommends 14 medical screening visits. For Medicaid-eligible children, the medical screen must include:

- a comprehensive health and intervention history that assesses both physical and mental health;

- a comprehensive, physical examination;

- appropriate immunizations;

- lab tests (including lead blood testing at 12 and 24 months and otherwise according to age and risk factors); and

- health education, including "anticipatory guidance to the child (or parent)."

The EPSDT screen is an essential early intervention service. Properly focused, this screen can be used to diagnose developmental problems and risks and to educate the child and family about expected developmental milestones and activities for maximizing the child's early growth. Therefore, it is critical for health care providers who are treating young children to know the full scope of EPSDT.

Many don't.

If an illness or condition·is diagnosed during a screen, EPSDT requires state Medicaid agencies to "arrange for (directly or through referral to appropriate agencies, organizations or individuals) corrective treatment."

EPSDT benefits include all of the services that the state can cover under the Medicaid Act, whether or not such services are covered for adults. In addition, the Medicaid Act says the service must be covered for a child if it is "necessary...to correct or ameliorate defects and physical and mental illnesses and conditions."

Unfortunately, the Medicaid Act doesn't list covered services using the terminology that health care providers use. As a result, the program has been used more as a social services tool than a medical care tool.

Health care practitioners need to be paid for the early intervention services they provide. Unfortunately, the provision of these services has been hampered by lack of knowledge of funding sources. The Medicaid EPSDT program exists to provide comprehensive and continuous care to America's poor children and children with special health care needs. EPSDT screening forms have been developed that cue providers to early intervention services that should be provided during the screening encounter and that identify children needing follow-up intervention services. As recently illustrated by a federal circuit court of appeals, EPSDT is also a significant source of funding for the provision of early

intervention treatment services that young children need.

CONCLUSION

The specific health promotion topics most likely to be addressed in collaborations between managed care and public health are immunizations, prenatal care, nutrition and injury prevention.

There needs to be more of these.

Preventive medicine remains something used by wealthier—and better-informed—people. For example, according to one 2003 study, Californians covered by commercial indemnity health insurance are the most likely to participate in some form of health promotion program—as compared to only 5 or 6 percent of the population insured through Medi-Cal or commercial HMOs or PPOs. This is true, even though indemnity plans usually don't cover preventive care.

An indemnity plan offers you the freedom of choice but usually requires you to pay more out-of-pocket expenses than you would with an HMO or PPO. The indemnity plan may not cover you for any routine care—annual checkups and other preventative treatments—either.

Some of these preventative treatments include:

- blood tests;
- prostate exams;
- genetic trait tests;

- hearing and sight loss;

- electro-cardiogram (stress tests);

- mammograms;

- Pap smears; and

- CAT scans (if you have a history of problems).

In an age of heavily-touted preventive medicine, the fact that these treatments aren't covered may seem strange.

Of course, you can get these services under an indemnity plan. You just have to be willing to absorb the related costs—at least large parts of them—by yourself.

As a consumer of medical services for children, you should make sure that any plan you use will cover preventive medicine—starting with regular check-ups for your kids and going as far as education programs for living with chronic or long-term conditions.

As a citizen of a developed country, you should support efficient preventive medicine programs for anyone—and particularly any child—using state-funded health coverage. State bureaucrats don't always like preventive medicine programs, because they're not as easy to categorize as lists of procedures...and they require the subjective judgment of doctors and other providers.

But that judgment is worth more than any bureaucracy. It's what the medical system should provide.

15

KIDS AND DRINKING AND DRUGS AND SEX

As your kids reach their teens, you may begin to worry about how they will respond to the drinking, drugs and sex that are a part of American culture—if not their specific social world. You may be worrying about these matters even before they are teens. The anecdotal evidence of problems is certainly out there, with constant media reports of ever-younger kids involved in abusive use of controlled substances or reckless sexual activity.

In this chapter, we'll take a quick look at the health issues posed by drinking, drugs and sex for teenagers and older children. And we'll consider how health insurance and health plans deal with these issues.

DRINKING AND DRUGS

There are so many statistics on alcohol and drug use among older children and teens that it's hard to make specific conclusions (that are reliable) from the volume of data.

The best conclusion that you can use is that something like three in 10 kids say they've tried drink-

ing alcohol or smoking marijuana by the time they're 13. And these reported "experiments" don't seem to change much as you look up and down the socio-economic scale. So, even kids from good homes and competitive schools are drinking or smoking.

Without sounding careless about these risks involved with alcohol and drugs, some experimentation with these things is a natural part of adolescence. That doesn't mean every kid does—or should—use; it just means that many do.

The challenge for parents is to educate their kids about the risks and health impacts of alcohol and drugs without either seeming to condone their use...or making that use so forbidden that it becomes attractive to a rebellious child.

The problem with young people's experimentation—especially with drinking—is that they don't do it in moderation. They do it to get drunk. One study showed the number of young people (this number included teenagers as well as young adults) who said they drink "to get drunk" climbed from 40 percent in 1993 to 48 percent in 2001.

This strategy can cause several problems.

The first: Drunk people do dumb things...including hurting themselves. A 2002 report by the National Institute on Alcohol Abuse and Alcoholism linked binge drinking to at least 1,400 student deaths and 500,000 injuries a year. Some of these were related to drinking and driving; but most were related to bad choices made at parties or smaller gatherings where the drinking takes place.

The second: Binge drinking is a major health risk. (Forget the "French paradox" and reports that alcohol can be good for your health—they all relate to moderate drinking. Occasional heavy drinking is clearly bad for you.) Consider these points:

- A light drinker (who quaffs one pint of beer a day) faces a one in 50,000 chance of getting usually fatal cirrhosis of the liver in any single year. Over a drinking lifetime of 50 years, the odds narrow to one in 1,000.

- Heavy drinkers obviously face starker odds. Their odds of dying from the habit are one in 100.

- And both of these projections only calculate disease. They don't count the even greater risk of accidents—in a car or on foot—when alcohol is involved.

For most kids, it's enough to emphasize to them that drinking is illegal for people under 18 years old—and drugs are illegal for almost everyone. The message that they can experiment with alcohol later, when it's legal, is often an effective deterrent.

RECOVERY PROGRAMS

Standard indemnity health insurance and even managed care plans will cover recovery programs for insured people—including kids—who are abusing alcohol or drugs.

In most cases, the plans will limit any individual's in-patient use of a recovery facility to one 30-day stay per year. A few, stingier programs limit this

benefit to once every three or five years; a few limit it to once, period.

But inpatient recovery isn't always what a child needs. In most cases, a young person who's using alcohol or drugs can get effective help from meeting with a counselor on an outpatient basis.

Most health care plans treat outpatient drug or alcohol counseling like they do psychotherapy: They will limit the number of visits available—to something like a total of 25 visits. And some plans will require a new referral from the primary doctor after every four or five visits. Usually, you'll have to pay a deductible or copay for each session. Assuming that your child meets with a counselor once a week, these benefits cover about six months of treatment.

After these limits are exhausted, you would have to pay out of pocket for continued treatment.

One thing that this system clearly encourages: Only kids who really have a problem with alcohol or drug use are likely to benefit from counseling. If your kid has been caught once experimenting with drugs or drinking, neither you nor he or she will find the bureaucratic aspects of getting counseling worth the benefits.

A silver lining to these cost controls: Most alcohol and drug counselors are well aware of the bureaucracy—and are experienced in dealing with it. They will usually coordinate with your doctor and even the claims office of the insurer or health plan.

Of course, there are low-cost or no-cost alternatives to private counseling. Many non-profit organiza-

tions—from the Salvation Army to Boy's Clubs/Girl's Clubs or your local city- or county-run recreation center—offer counseling in small groups for kids who've used alcohol or drugs at a young age. One big advantage of these programs is that they tend to take a more constructive approach—encouraging and offering alternative activities, rather than just dwelling on a kid's personal problems.

In many cases, a better outlet for activity is all a kid needs.

Managed care plans acknowledge that some people need personal counseling to deal with a variety of issues, including alcohol and drug use. But they don't pay for a person to use counseling or psychotherapy as an ongoing "lifestyle" choice.

This may seem harsh at first glance—but, on reflection, it's not such a bad strategy for dealing with a kid with personal problems. Six months of private counseling and then a move to some more outward-directed activity is a good mix in most cases.

SEXUAL ACTIVITY

Your great hope, as a parent, will probably be that if your child has used alcohol or drugs no other harm has followed. Drinking and driving is one worry, once the kid is old enough to drive. But the larger worry is probably that the child will act recklessly while drunk or high. And the riskiest kind of reckless behavior is sex.

While they represent just a quarter of sexually active people in the U.S., teenagers and young adults account for nearly half the cases of sexually trans-

mitted diseases, according to one study from the U.S. Centers for Disease Control and Prevention.

The report, which appeared in the journal *Perspectives on Sexual and Reproductive Health*, said that people aged 15 to 24 accounted for an estimated 9.1 million cases of eight kinds of STDs in the year 2000. There were 18.9 million new STD cases overall in the U.S. that year.

A separate CDC report estimated that those 9.1 million cases of STDs in teens and young adults have an estimated lifetime medical cost of $6.5 billion.

Three STDs—chlamydia, human papillomavirus and trichomoniasis—were responsible for 88 percent of the 9.1 million new STD cases in teens and young adults in the year 2000. (The other STDs tracked were HIV, genital herpes, syphilis, gonorrhea and hepatitis B.)

The "good" news here is that health plans are relatively generous about covering treatments and prescriptions for STDs. And many free clinics make a specialty of treating STDs cheaply—but effectively.

SEX EDUCATION AS A HEALTH FACTOR

Preventing STDs by encouraging sex education among older children has long been a staple of public health policy. It's also been a controversial topic among many PTAs, school boards and parents.

Two different studies released in early 2004 suggested that children weren't learning as much about preventing STDs as some may think.

One concluded that STDs were on the rise among teens and young adults; the second concluded that only improved sex education—including instruction on using condoms—would stem that tide.

The first study—published by the Alan Guttmacher Institute, a nonprofit group that advocates abortion and other reproductive rights—found the 15 to 24 age group accounted for nearly half of the cases of sexually transmitted diseases diagnosed in the U.S. in 2000, even though they constitute only a quarter of the nation's sexually active population.

The second study—performed by researchers at the University of North Carolina—said that only comprehensive sex education (teaching abstinence and instruction on condom use) could reduce the spread of STDs. Other approaches, especially programs advocating sexual abstinence, weren't effective.

Both reports pointed to other surveys, which suggested that, while most parents say they want their children to get information about sex from them, only a fraction actually provide that information. Most parents want to talk with their children about sex and sexuality, but are not sure how to begin.

Some tips for getting past awkwardness, from a pamphlet published by The Henry J. Kaiser Family Foundation:

- Communicate your values about sex. Kids who feel they can talk with their parents about sex are less likely to engage in high-risk behavior.

- Start early. Teaching your kids about sex demands a gentle, continuous flow

of information. If your child hasn't started asking questions about sex, look for a good opportunity to bring it up.

- Talk about more than the "birds and the bees." Explain that sexual relationships involve caring, concern and responsibility.

- Provide accurate, age-appropriate information and talk with your kids not only about their current stage of development but about the next stage, too.

- Don't worry about knowing all the answers. What you know is a lot less important than how you respond.

Some Web sites that contain information about STDs and how to talk to your children about sex:

- *www.iwannaknow.org*. A teen site operated by the American Social Health Organization.

- *www.goaskalice.columbia.edu*. Information about STDs from Columbia University.

- *www.talkingwithkids.org*. Tips on how to discuss tough subjects like sex, AIDS and STDs with youngsters.

ABSTINENCE ISN'T RELIABLE

While public health experts are cautious about advocating one sex education strategy over another, the one point they all seem to agree on is that abstinence programs—in which parents, teachers and

other authority figures ask kids to make pledges that they'll avoid sex until they're either adults or married—aren't reliable.

A 2004 study, funded by the National Institutes of Health, from researchers at Columbia University concluded that adolescents who pledged not to have sex until marriage had about the same rate of STDs as other teens—and often fail to keep their pledge.

The study of about 15,000 youths aged 12 to 18 found that 88 percent of teens who pledged to remain virgins until marriage ended up having sex before marriage. The study also found that the pledging teens were less likely to use condoms or other "safer-sex" practices when they did have sex. And, because of their ignorance about STDs, "pledgers" were also less likely to seek medical help if they contracted one of the diseases, said the study.

Only 40 percent of male pledgers had used a condom in the past year compared with 59 percent of those who did not promise to avoid sex. Among females, the gap was 47 percent to 55 percent.

The study found that pledging did succeed in delaying sex, reducing the number of partners and led to earlier marriages but it did not reduce the rate of sexually transmitted diseases.

Some parents' groups complained that the Columbia study was designed and executed with the specific goals of discrediting abstinence programs. And they claimed some of the authors had established records of intense criticism of abstinence programs.

CONCLUSION

When it comes to drinking, drugs and sex, all statistics and most advice come wrapped in political controversy. Parents' groups, family groups, scientists and political interest groups all battle over their various agendas.

For your own kids—as they reach adolescence and its pressures—the public health policy debate is irrelevant, anyway. Individual lives follow their own, often intense paths.

From an insurance and health coverage perspective, the news is generally good on these fronts. Plans will usually cover treatments for substance abuse recovery and sexual health issues. And, beyond this, various nonprofit group and public-sector agencies make sexual hygiene services and products available to anyone who needs them—including teens.

As a parent, you may find so many options troubling. And you may not like the idea that your teenager might be getting sex information—and contraceptives—without your knowledge.

All of these factors combine to suggest a candid approach to dealing with teens and drinking, drugs and sex. That doesn't mean you have to condone the illegal or ill-advised use of any of them. It just means that you should try to keep relations with your kids open enough that they feel comfortable letting you know if they're in any kind of trouble.

16

POLITICS & CHILDREN'S HEALTH COVERAGE

Health care remains a heavily regulated industry; so, the posturing pronouncements of windbag politicos matter. And, when it comes to keeping children healthy, the windbags generate a lot of hot air.

Texas serves a good, windy example. In early 2004, state legislators in Austin voted to make their state's CHIP more difficult to join. They enacted a so-called "$5,000 assets test." This financial qualification would apply to new or renewing CHIP applicants; it asked the following questions:

1) Does the family have a combined gross family income above 150 percent of the federal poverty level? (If no, the family qualified for the Texas CHIP; if yes, the program would ask more questions.)

2) Does the family own more than $5,000 in assets, which includes all of the following: cash balances in checking and savings accounts; investments or other financial service accounts not part of an IRA or 401(k) retirement plan; and vehicle values above $15,000 for the

first and $4,650 for each additional ve-
hicle.

Federal poverty level guidelines vary depending on
the size of the family; but for a family of four, the
income level for the cut-off of automatic qualifica-
tion was about $38,000 a year. Early estimates pre-
dicted that some 5,000 families would be pushed
out of the Texas CHIP by the new qualifications.

The implied message in the measure: Use your sav-
ings or sell your second car to buy commercial health
insurance for your kids, instead of using the CHIP.

Advocacy groups like the Children's Defense Fund
of Texas immediately leapt to criticize the assets test
as something that would penalize working families
for having two cars or saving for higher education.

According to U.S. Census data, Texas already had
the highest rate of uninsured children in the coun-
try before the $5,000 assets rule—with 22.6 per-
cent of children lacking coverage. (And about 90
percent of uninsured Texas children had at least one
parent who worked full-time.)

Doctors pointed out that the $5,000 assets rule
wasn't the only thing chasing kids out of the Texas
CHIP. An earlier change—which had removed den-
tal and vision coverage from the plan—had con-
fused many member families. They thought the cuts
meant *all* coverage was gone; so, they didn't renew
their participation. (In Texas, CHIP families have
to renew their participation every six months.)

Public health experts in Texas predicted that, if the
monthly decline in CHIP enrollment continued at

the same rate as it had in the first six months of fiscal year 2004 (an average of 4.7 percent every 30 days), enrollment would drop to about 300,000 by the end of fiscal 2004—less than the official budgeted enrollment average of 346,818.

But doctors on the Lone Star State noted ruefully that the CHIP reductions were simply rearranging the same expenses. Kids not covered by Texas CHIP can see a doctor at a clinic or go to the emergency room—and the costs would be shouldered by a separate state plan covering medical care for the indigent. "It's the same old story," said one Dallas-area M.D. Instead of coming to the doctor's office and eliminating problems early on, uninsured families wait until an appendix bursts or a cut gets infected before going to the emergency room. "And the state pays more, there. [The Texas CHIP] should be open to every kid who needs it. It's the 'ounce of prevention' factor."

RATIONAL CHOICES—AND OBLIGATIONS

For some people, adequate health care has become unaffordable. However, many of those who claim that health insurance is unaffordable really mean that they elect not to spend their money on health insurance because they do not consider it a reasonable spending choice—not necessarily that they don't have the money to pay for health care.

This can be a rational decision, especially if you are young and in good health. But it's not a rational decision if you have children.

The ranks of uninsured children are growing faster than rational decision-making would seem to support, though. In 2003, more than 46 million people—almost one in five non-elderly Americans—had no health insurance.

If Congress addresses the problem, it will probably take only a few small steps: make health insurance fully tax-deductible for the self-employed or set up a system that lets private organizations (like religious groups and labor unions) negotiate health insurance deals for members...as employers do now.

But political action may not be the answer. And that's probably a good thing. Politics and medicine are an unstable combination.

THE STANDARD OF POLITICAL IMPACT

HHS's Office of Inspector General releases an annual audit of Medicare payments each March. During the late 1990s, these reports triggered a regular pattern of response that people who deal with health care issues agree sums up the political farce.

The pattern goes something like this:

- Congress expresses shock and outrage at the volume of improper billings and reimbursements...and then moves on to the next outrage.

- Health care industry spokesmen attack the report's methodology and worry loudly that opportunistic politicians will blame doctors for gouging patients.

- Medicare's bureaucrats announce new efforts to discourage improper billing and prosecute outright fraud and abuse.

- A few high-profile arrests take place, while doctors and hospital groups look on anxiously.

- Business goes on as usual.

KIDS MEAN HARD CHOICES

Having children is one of the best things that a person can do in life. But—as you find out from the first moments you have children—it involves hard choices on a variety of levels. You'll rethink everything from what's for dinner to how—or whether—you practice religion.

If you're lucky enough to have healthy children, the mechanics of health coverage are more an annoyance than a front-and-center issue. But you still need to choose well to assure your kids have the best available coverage.

And, if you and your child are challenged with health issues, you can rest a little easy that the United States has the best health care system—and the best doctors—in the world. However flawed our system may be, it gets that part right.

This book has aimed to spell out how the U.S. health care system applies, especially, to kids. It gives you a basic understanding of the jargon, policy forms, government plans and public policy issues that

shape the kind of healthy coverage your kids—or any kids—can get. But the important choices will always settle back in your shoulders.

When you start a new job, you often have a choice of health insurance plans and group disability plans, as well as the option of participating in a cafeteria plan (which can include coverage for dental care, chiropractor's visits and vision care). If your company changes insurance carriers, you may be asked all these questions all over again.

You've probably also been offered insurance coverage by phone (say, from one of your credit card companies), via the mail and even over the Internet. This direct sales approach to marketing insurance of all sorts is becoming more and more common, as insurance companies try to cut costs by eliminating agents—and their commissions—from the sales process.

This new approach to insurance sales may make prices more affordable in the long-run (or at least keep them level). But it also means that you—as a consumer buying insurance directly from insurance companies—have to know more than ever about these policies.

The good news is: After reading this book, you know enough about the coverages that can work for your kids that you can ask the right questions to buy health insurance any way you see fit. This will be something that you find yourself doing more and more as the insurance industry completes its move to a self-service focus.

HELPFUL TIPS,
CHECKLISTS &
QUESTIONS TO ASK

This chapter is a collection of helpful tips, check-lists and questions to refer to when dealing with you and your children's health care. The health information in this chapter is meant to complement, not replace, any advice and care from your child's physician or health care provider. Every child is different, and as a parent, you know your own children best. Remember: Seek medical advice when you are concerned about your child's health; his or her doctor is usually in the best position to offer advice that is right for your child.

KEY QUESTIONS

Ask yourself the following questions now and think about your answers—they might urge you to re-evaluate your current health care plan for you and your family:

1) Does your employer offer you health insurance?
2) Do you have a choice between an HMO and a reimbursement-style policy?
3) Is your regular physician a provider for the HMO you're considering?
4) If you choose a medical expense policy, how much of a deductible are you considering? (It's worth-

while to compare premiums for a policy with several different deductibles.)

5) Would you consider purchasing catastrophic coverage by increasing your deductible substantially?

6) Do you belong to a group that offers discounts on health insurance (e.g., a trade association, an alumni association, a church)?

7) Have you asked your doctor or pharmacist to recommend a health insurance plan? What did he or she recommend?

8) If you have been unable to obtain insurance on your own, do you qualify for a state-sponsored health insurance pool?

9) Do you qualify for Medicaid?

10) Do you qualify for Medicare?

11) Have you considered a Medigap policy?

12) Do you need dental insurance?

13) Do you need a vision plan?

14) Do you need a prescription plan?

15) Does your employer offer a cafeteria plan?

16) How much money would you want to have withheld from your paycheck for a cafeteria plan? (Add up your regular monthly medical-related expenses, and also include an allotment for annual costs, such as copayments for doctors' visits and glasses.)

• Health insurance premiums _____

• Average monthly copayments _____

• Dental premiums/fees _____

• Alternate therapies, etc. _____

• Psychological counseling, etc. _____

• Child- and elder-care expenses _____

• Vision care expenses _____

• Medical equipment _____

• Other health-related expenses _____

• **Monthly Total** _____

17) If you're about to leave your job, have you investigated COBRA coverage?
18) If you do not have group health insurance through your job, have you considered a medical savings account?

ASTHMA: WHAT YOU DON'T KNOW CAN HURT YOUR CHILD

As we discussed in an earlier chapter, asthma is a chronic and potentially life-threatening lung disease in which airways become inflamed and/or swollen, making it hard to breathe. Nearly five million American children have asthma. The humidity and the polluted air contribute immensely to this miserable breathing disorder which is the number one chronic disorder in children and the number one reason for children's absence from school.[1]

The most common form of asthma is *allergic asthma,* which is triggered by allergens such as pet dander, pollen and mold, as opposed to irritants, viral or sinus infections, weather changes or exercise. Nearly 10 million—including 3 million kids—suffer specifically from allergic asthma.

How do you know if your child's asthma is allergic?

Many of the symptoms of allergic and non-allergic asthma are the same (coughing, wheezing, shortness of breath, rapid breathing and chest tightness). However, allergic asthma is triggered by inhaling

[1] *The Green Guide*, July 1998. (Published by The Green Guide Institute, an independent media service that provides news, information and educational material to consumers and others.)

allergens such as dust mites, pet dander, pollens, mold, etc. These allergens then cause the passages in the airways of the lungs to become inflamed and swollen, resulting in coughing, wheezing, etc.

Some kids are genetically predisposed to have asthma. However, you can reduce the risks associated with dangerous asthmatic attacks by ensuring sure that your child:

- avoids cigarette smoke;
- spends hot days in air-conditioned areas; and
- has a consultation with an asthma specialist, such as an allergist or immunologist about any allergies your child exhibits.

> **An asthma specialist can identify allergic triggers and develop a plan to help avoid these allergens or prescribe medication that prevents allergens from setting off an inflammatory response.**

The following is a list of questions provided by the Asthma and Allergy Foundation of America (AAFA) and American Academy of Allergy, Asthma and Immunology (AAAAI) to help you gauge whether your child has allergic asthma. Then, armed with this information, talk to your doctor or find a physician who specializes in treating asthma and allergies to find out how to manage your child's asthma.

1) Do/did either of the child's parents have asthma?
2) Do/did either parent suffer from allergies?
3) Has the child experienced any of the following symptoms: sudden or repeated coughing,

wheezing, shortness of breath, rapid breathing and/or tightness in the chest?

4) Does being near the following allergens trigger or worsen the symptoms: dust, pollen from trees or flowers, animal fur or dander, molds, certain foods or other allergens?

5) Do the symptoms seem to be worse during the spring and/or fall?

6) Does your child suffer, at any time of the year, from any of the following allergy symptoms: sneezing, itchy/watery eyes, stuffy nose/congestion lasting more than 10 days, runny nose lasting more than 10 days?

For more information, contact your health care provider, the AAAAI executive office at (414) 272-6071 or the American Lung Association at (800) 586-4872.

BROKEN BONES AND SPRAINS

If your child breaks a bone or twists an ankle, would you know what to do? If you think your child has a broken (fractured) bone, you should seek emergency care. But, how do you know if a bone is broken? Suspect a broken bone if:

- your child heard or felt a bone snap;
- your child has difficulty moving the injured part; or
- the injured part moves in an unnatural way or is very painful to the touch.

A *sprain* occurs when the ligaments that hold bones together are overstretched and partially torn. Over-stretching of musculature is called a *strain*. Sprains and strains generally cause swelling and pain, and

> there may be bruises around the injury. After proper medical help, most sprains can be treated at home.

SUSPECT A BROKEN BONE?

- If the injury involves the neck or back, never move a child unless he or she is in imminent danger. Movement can cause serious nerve damage. Call 911. If the child is moved, the neck and back must be completely immobilized first. When emergency care arrives, they'll know how to keep your child's head, neck and back in alignment.
- If the injury involves an open break (bone protrudes through the skin) and there is severe bleeding, apply pressure on the bleeding area with a gauze pad or a clean piece of cloth. Do not clean the wound or try to push back any part of the bone that may be sticking out.
- If the child must be moved (e.g., injury occurred in a high-traffic, public place), apply splints around the injured limb to prevent further injury. Leave the limb in the position you find it. Use boards, brooms, a stack of newspapers, cardboard or anything firm, and pad them with pillows, shirts, towels, etc. Splints must be long enough to extend beyond the joints above and below the fracture.
- Apply cold packs or a bag of ice wrapped in cloth on the injured area and keep the child lying down until medical help arrives.

INFECTIOUS DISEASES

Whenever kids are gathered together in groups their risk of sharing sicknesses increases. Though it is virtually impossible for toys and other shared items

to be in perfect sanitary condition, there are steps that can be taken to avoid the spread of infection.

Immunizations are a valuable weapon when it comes to protecting your child against illness. Make sure your child's immunizations are up to date and include the following:

- ☐ diphtheria;
- ☐ tetanus;
- ☐ pertussis;
- ☐ polio;
- ☐ measles;
- ☐ mumps;
- ☐ rubella;
- ☐ hepatitis B; and
- ☐ chicken pox.

Make sure your childcare facility requires up-to-date immunization records for each child, as well as for any caregiver.

Teach your child proper hygiene, including hand washing, at home. Children should be encouraged and monitored to make sure they wash their hands after using toilets, before eating and after blowing their noses or coughing or sneezing into their hands.

When your child is sick, sending them to a childcare facility or school will only spread the sickness. As a parent, you can help keep other children healthy by keeping your child home until their illness is no longer contagious.

> **Illnesses most common in childcare facilities include: colds, flu, diarrhea diseases and skin/eye infections.**

INSECT STINGS AND BITES

The two greatest risks to a child from most insect stings and bites are *allergic reaction* (which can be fatal) and *infection* (more likely and less serious).

If your child is stung by a bee, it will leave behind a stinger attached to a venom sac. Do not try to pull the stinger out, which may release more venom. Gently scrape it out with a blunt-edged object, such as a credit card or a dull knife. After doing so, or if your child was stung by a wasp, hornet or yellow jacket, take the following precautions:

- Wash the area with soap and water. Do this two to three times a day until the skin is healed.
- Apply a cold pack, an ice pack wrapped in a cloth, or a cold, wet washcloth for a few minutes.
- Apply a paste of baking soda and water and leave it on for 15 to 20 minutes.
- Give acetaminophen (such as Tylenol) for pain.
- Dab on a tiny bit of household ammonia. There are also over-the-counter products for insect stings that contain ammonia.
- Give an over-the-counter antihistamine, if your doctor says it's okay; follow dosage instructions for your child's age and weight.
- A sting in the mouth or nose warrants immediate medical attention because swelling may block airways.

You should also seek emergency care if you see any of the following symptoms, which may indicate an allergic reaction:

- large area of swelling;
- abnormal breathing;
- tightness in throat or chest;
- dizziness;
- hives or rash;
- fainting;
- nausea or vomiting; and
- persistent pain or swelling (more than 72 hours).

SPIDER BITES

Most spiders found in the United States are harmless, with the exception of the black widow and the brown recluse (or violin) spider. Typically found in warm climates, if your child receives a bite from one of these, take the following precautions:

- Wash the area carefully with soap and water. Do this two to three times a day until skin is healed.
- Apply a cold pack, an ice pack wrapped in a cloth, or a cold, wet washcloth.
- Apply a paste of baking soda and water and leave it on for 15 to 20 minutes.
- Give acetaminophen (such as Tylenol) for pain.
- To protect against infection, apply an antibiotic ointment and keep the child's hands washed.

If you suspect your child has been bitten by a black widow or brown recluse spider, seek help immediately. Symptoms include:

☐ a deep blue or purple area around the bite, with a whitish ring and a large outer red ring;

☐ body rash;

☐ muscle spasms, tightness and stiffness;

☐ abdominal pain;

☐ headache or fever;

☐ general feeling of sickness;

☐ lack of appetite;

☐ joint pain;

☐ signs of infection around the bite (swelling and redness); and

☐ pink or red urine.

In the southwestern United States, an unidentified bite may be caused by a scorpion. Take your child to the emergency room immediately. In addition, check your children and pets for ticks carefully after you've been in or around a wooded area. Common types of ticks include *dog ticks* and *deer ticks* (deer ticks may be carriers of Lyme disease).

THINGS LIKE LYCOPENE

New research from Harvard School of Public Health in Boston suggests that eating something tomato-ey—even ketchup on french fries—nearly every day may lower your risk for heart disease by up to 50 percent.

Diets rich in *lycopene*—a pigment in red fruits and veggies—can help lower heart disease and prevent skin cancer.

Researchers analyzed blood samples from more than 28,000 women and found that over a nearly 5-year time frame women with the highest blood levels of lycopene had up to a 50 percent lower risk for developing heart disease. Their blood levels of lycopene reflected their dietary intake.

Tomatoes are the richest source of lycopene, but other good sources to include in your child's diet include:

- watermelon;
- papaya;
- pink grapefruit; and
- guava.

Getting your kids used to eating a good array of fruits and vegetables at a young age is important. These products supply the body with the right tools for staving off all sorts of cancers, among other ailments. And the sooner your kids learn to enjoy these foods, the better.

Tomatoes pack a nutritious bang for each bite, but keep in mind that lycopene is only one of 12,000 phytochemicals in fruits and vegetables that help lower the risk for heart disease.

How much lycopene do kids need to lower their risk for heart disease? The numbers aren't out yet, but studies show that people who include anywhere from seven to 10 servings a week of lycopene-rich foods have the lowest risk for heart disease. It also

looks like blood levels of this heart-healthy compound decrease with age, so the older we are the more we need. What we do know is that the more fruits and vegetables you eat the better, and there is no evidence that lycopene-rich foods are harmful at any dose.

Lycopene is best absorbed and most helpful to the body when it comes from cooked and processed foods. But, fresh tomatoes are also a good source of lycopene. Deep-red tomatoes have more lycopene than pale ones or yellow or green tomatoes. Vine-ripened tomatoes have more than those picked green and allowed to ripen later. And, those grown outdoors in the summer have more lycopene than those grown in greenhouses.

LIMITING FISH INTAKE

In March 2004, two U.S. government agencies issued new joint guidelines on the consumption of mercury-tainted fish by women and young children. The recommendations were aimed, in part, to balance neurological risks to youngsters.

The new guidelines, issued by the U.S. Food and Drug Administration and Environmental Protection Agency, advise that pregnant women, women who may become pregnant, nursing mothers and young children should avoid eating meat from older, larger fish, including:

- shark;
- swordfish;
- king mackerel; or
- tilefish.

Albacore tuna, however, which activists say may have even higher levels of mercury per serving than other species on the "banned" list, was not included. In fact, the latest guidelines now encourage women and young children to eat six ounces, or one serving, of albacore tuna per week.

ACKNOWLEDGE OBESITY

Today's parents are so accustomed to seeing overweight youngsters that many fail to recognize whether their own kids fall into the obese category.

As we've illuminated in this book, being overweight and obese increases the risk of a variety of illnesses later in life. A lot of overweight or obese people have skewed perceptions of body size. They often rate themselves and others as "about right."

Prevention of childhood obesity is critical because long-term outcome data for successful treatment approaches is limited. But, how can you help prevent childhood obesity?

- Help your doctor to identify any genetic, environmental or combinations of risk factors predisposing your children to obesity.
- Assess your child's level of physical activity and recognize excessive weight gain relative to linear growth. Ask your doctor to calculate and plot your child's BMI (see *www.cdc.gov/growthcharts*).
- Be a good role model. Recognize the impact you have on your children's development of lifelong habits of physical activity and nutritious eating.
- Encourage moderation rather than over consumption, and emphasize healthy choices rather than restrictive eating patterns.

- Provide emotional support during childhood. Kids who receive a lot of support from their parents early in life tend to have higher self-esteem, better social relationships and a better sense of control when it comes to coping with stress and problem-solving without turning to problem behaviors (i.e., excessive eating, smoking and drinking).
- Write—or ask your doctor to write—your child a "physical activity prescription." This reinforces that physical activity is as important to their health as any medication that might be prescribed, allowing the child to participate in setting the physical activity goal.
- Create a social climate for physical activity. Physical activity should be fun and accessible. Help your kids choose an activity routine that is fun, developmentally appropriate and realistic given his or her individual, family and community resources.

PROMOTING PHYSICAL ACTIVITY

Several sets of recommendations and guidelines have been established that define the quantity and quality of activity needed to optimize physical fitness and to identify the health-related benefits of physical activity among kids. Use these to help monitor both your child's health and level of activity.

According to the 1993 International Consensus Conference on Physical Activity Guidelines for Adolescents, adolescents should:

1. be physically active daily, or nearly every day, as part of play, games, sports, work, transportation, recreation, physical education or planned exercise in the context of family, school and community activities; and

2. engage in three or more sessions per week of activities that last 20 minutes or more at a time and that require moderate to vigorous levels of exertion.

Kids have to be ready to make a change. If a child is not ready to change, provide brief reinforcement about healthy lifestyles and encourage him or her to engage in physical activity. Identifying the current barriers to activity and emphasizing current benefits also can be an important first step. Common barriers to physical activity may include:

- lack of time;
- lack of access to facilities;
- unsafe neighborhoods; and
- dislike of exercise.

Other suggestions for promoting physical activity:

- walking or bicycling for transportation;
- planning physically active rather than sedentary activities with friends (i.e., taking walks with friends rather than talking on the telephone, turning off the TV and putting the Gameboy down);
- planning active times or vacations with your kids;
- participating in dancing, skating and swimming classes;
- identifying activities that can be done indoors, such as exercise to videos, dancing to popular music or using a stationary bicycle;
- encouraging participation in after-school sports programs or club teams;
- allowing kids to utilize local rec centers, parks, and other public venues safe for kids to play; and
- identifying the exercise they already get (e.g., walking, using the stairs whenever possible).

> Remember: Organized sports is not the only type of exercise that "counts."

BREAK THE SODA HABIT

You can help your child break his soda habit with these tips from the Texas Department of Health:

- Save soda for a special treat.
- Stock your fridge with low-fat milk, fruit-flavored seltzers and low-sugar juices.
- Serve water with meals.
- Have a soda-free week once a month.
- Buy large-size containers for special occasions only.

BELLYACHES OR APPENDICITIS?

Bellyaches are one of the most common complaints in childhood, and among the most worrisome for parents. The causes range from simple stomach upset to appendicitis.

We mentioned appendicitis in Chapter 13 when we talked about common childhood ailments. Except for injuries, appendicitis is the most common cause for emergency surgery in children and adolescents. About 70,000 appendectomies are performed on children in the U.S. each year, and among children under 14 years old, as many as one child in 250 will require the operation each year.

Although appendicitis is common, it is frequently misdiagnosed in children. This is particularly true

if signs and symptoms are vague or if a child is not good at communicating the complaint. However, early diagnosis of appendicitis is important. If diagnosis is delayed, the appendix will rupture, leading to a longer hospitalization and increased likelihood of complications.

Diagnostic imaging—ultrasound and CT scans—can help physicians and surgeons make (or exclude) the diagnosis of appendicitis in children where appendicitis is suspected. Yet, as a parent, there are several signs of appendicitis that you can look for.

The first sign of appendicitis: pain that appears to be coming from the area around the navel (belly button). If your child has this symptom, look for:

- worsening abdominal pain that is, at first, colicky and intermittent, then continuous as it gradually worsens in intensity over a number of hours.
- pain that is different from anything that the child has experienced or you have witnessed before.
- the child's preference to remain curled up in bed (may also refuse to walk or walk with difficulty).
- loss of appetite and nausea and/or vomiting. (Vomiting typically begins after the belly pain, rather than before.)
- bowel movements, in which the volume of stool is not great, in contrast to the larger watery bowel movements typical of intestinal virus infections (gastroenteritis.)
- pain that may (but not always) move to the right lower corner of the abdomen.

Seek the advice of your child's physician as early as possible when you suspect appendicitis.

It is best to have the appendix removed before it ruptures and spills its bacteria and infected fluid into the abdominal cavity. This spread of infection to the abdominal cavity is called *peritonitis*. Peritonitis is much more serious. A ruptured appendix with peritonitis may even necessitate more than one operation before full recovery.

It is estimated that only 10 percent of appendices rupture in the first 24 hours of the illness but that the majority have ruptured by the end of the second day. The older your child, the more likely he or she will be diagnosed with appendicitis—and the appendix removed—before it has ruptured. In a younger child, despite the best efforts of parents and skilled physicians, it is often not possible to suspect and diagnose appendicitis before rupture.

CONCLUSION

Hopefully, by now you feel better equipped to take charge of your family's health care plans. It can be scary thinking about injury and illness...and the potential bills facing you when something happens to you or someone in your family. Children come with a whole new set of worries and require an entire different game plan. Rest assured that the best medical care is available in the U.S., but it often comes with a price.

Being educated about your options and knowing how to pursue the best ones is an important part of parenthood. If you can accomplish that task, then you can probably accomplish any task you face in the rearing of good, healthy children. Good luck.

A

APPENDIX

CONTACTS FOR
CONSUMERS

STATE INSURANCE DEPARTMENTS

Alabama
Commissioner of Insurance
135 South Union St., Montgomery, AL 36130
(205) 269-3591 or (205) 269-3595

Alaska Division of Insurance
P.O. Box 110805, Juneau, AK 99811
(907) 465-2515
E-mail: insurance@dced.state.ak.us

Arizona Department of Insurance
2910 N. 44th St., 2nd Floor, Phoenix, AZ 85018-7256
Phoenix Area: (602) 912-8444
Tucson Area: (520) 628-6371
Statewide: (800) 325-2548

Arkansas Insurance Department
1200 West Third St., Little Rock, AR 72201
(501) 371-2600 or (800) 282-9134

California Department of Insurance
300 South Spring St., Los Angeles, CA 90013
(800) 927-HELP

Colorado Division of Insurance
Commissioner of Insurance
1560 Broadway, Suite 850, Denver, CO 80202
(303) 894-7499 or (800) 930-3745

State of Connecticut Insurance Department
P.O. Box 816, Hartford, CT 06142-0816
(860) 297-3800 or (800) 203-3447
E-mail: ctinsdeptinformation@po.state.ct.us

Delaware Insurance Commissioner's Office
841 Silver Lake Blvd., Dover, DE 19904
(302) 739-4251 or (800) 282-8611
E-mail: consumer@deins.state.de.us

District of Columbia
Department of Insurance, Securities and Banking
810 1st St., Suite 701, Washington, DC 20002
(202) 727-8000

Florida Office of Insurance Regulation
200 E. Gaines St., Tallahassee, FL 32399-0300
(850) 413-3100 or (800) 342-2762

Georgia
Insurance Commissioner
2 Martin Luther King Jr. Dr., West Tower, Suite 704,
Atlanta, GA 30334
(404) 656-2070 or (800) 656-2298

Hawaii Division of Insurance
P.O. Box 3614, Honolulu, HI 96811
(808) 586-2790

Idaho Department of Insurance
700 W. State St., P.O. Box 83720, Boise, ID
(208) 334-4250

Illinois Department of Insurance
320 W. Washington St., Springfield, IL 62767-0001
(217) 782-4515 or (800) 207-6958
E-mail: director@ins.state.il.us

Indiana Department of Insurance
311 W. Washington St., Suite 300, Indianapolis, IN 46204
(317) 232-2385 or (800) 622-4461
E-mail: doi@state.in.us

Iowa Insurance Division
330 Maple St., Des Moines, IA 50319-0065
(515) 281-5705 or (877) 955-1212

Kansas Insurance Department
420 SW 9th St., Topeka, KS 66612-1678
(785) 296-3071 or (800) 432-2484

Kentucky Office of Insurance
P.O. Box 517, Frankfort, KY 40602
(800) 595-6053

Louisiana Department of Insurance
P.O. Box 94214, Baton Rouge, LA 70802
(504) 342-5900 or (800) 259-5300 or -5301

Maine Bureau of Insurance
34 State House Station, Augusta, ME 04333-0034
(207) 624-8475 or (800) 492-6116

Maryland Insurance Administration
525 St. Paul Pl., Baltimore, MD 21202-2272
(410) 468-2000 or (800) 492-6116

Commonwealth of Massachusetts Division of Insurance
One South Station, 5th Floor, Boston, MA 02110-2208
(617) 521-7794

Michigan Office of Financial and Insurance Services
611 W. Ottawa St., 3rd Floor, Lansing, MI 48933
(517) 373-0220 or (877) 999-6442
E-mail: ofis-info@michigan.gov

Insurance Division of the
Minnesota Department of Commerce
85 7th Pl., Suite 500, St. Paul, MN 55101
(651) 296-4976 or (651) 297-4288
E-mail: insurance.commerce@state.mn.us

Mississippi Department of Insurance
P.O. Box 79, Jackson, MS 39205
(601) 359-3569 or (800) 562-2957

Missouri Department of Insurance
P.O. Box 690, Jefferson City, MO 65102-0690
(573) 751-2562

Montana Insurance Division
840 Helena, Ave., Helena, MT 59601
(406) 444-2040 or (800) 332-6148

Nebraska Department of Insurance
941 O St., Suite 400, Lincoln, NE 68508-3639
(402) 471-2201

Nevada Division of Insurance
788 Fairview Dr., Suite 300, Carson City, NV 89701
(775) 687-4270 or (800) 992-0900, ext. 4270
E-mail: insinfo@doi.state.nv.us
Las Vegas Office:
2501 E. Sahara Ave., Suite 302, Las Vegas, NV 89158
(702) 486-4009

State of New Hampshire Insurance Department
56 Old Suncook Rd., Concord, NH 03301-7317
(603) 271-2261 or (800) 852-3416

New Jersey Department of Banking and Insurance
P.O. Box 325, Trenton, NJ 08625-0325
(609) 292-5360 or (800) 446-SHOP
Reporting Insurance Fraud: (800) 373-8568
Individual Health Coverage Program Info: (800) 838-0935
Small Employer Health Benefits Info: (800) 263-5912

New Mexico Insurance Division
P.O. Drawer 1269, Santa Fe, NM 87504-1269
(505) 827-4601 or (800) 947-4722

New York State Insurance Department
25 Beaver St., New York, NY 10004
(212) 480-6400
E-mail: consumers@ins.state.ny.us
Albany Office:
One Commerce Plaza, Albany, NY 12257
(518) 474-6600

North Carolina
1201 Mail Service Center, Raleigh, NC 27699-1201
(919) 733-2032 or (800) 662-7777
E-mail: consumer@ncdoi.net

North Dakota
State Capitol, 5th Floor, 600 East Blvd., Bismarck, ND 58505-0320
(701) 328-2440 or (800) 247-0560

Ohio Department of Insurance
2100 Stella Ct., Columbus, OH 43215
(614) 644-2658 or (800) 686-1526

Oklahoma Insurance Department
P.O. Box 53408, Oklahoma City, OK 71352-3408
(405) 521-2828 or (800) 522-0071

Oregon Insurance Division
P.O. Box 14480, Salem, OR 97309-0405
(503) 947-7980
E-mail: dcbs.insmail@state.or.us

Pennsylvania Insurance Department
1326 Strawberry Square, Harrisburg, PA 17120
(717) 783-0442 or (877) 881-6388

Rhode Island Division of Insurance
Associate Director and Superintendent of Insurance
233 Richmond St., #233, Providence, RI 02903-4233
(401) 222-2223

South Carolina Department of Insurance
P.O. Box 100105, Columbia, SC 29202-3105
(803) 737-6160

South Dakota Division of Insurance
445 East Capitol Ave., Pierre, SD 57501
(605) 773-3563

Tennessee Department of Commerce and Insurance
500 James Robertson Pkwy., Nashville, TN 37243-0565
(615) 741-2241 or (800) 252-3439

Texas Department of Insurance
P.O. Box 149104, Austin, TX 78714-9104
(512) 463-6169, (800) 252-3439 or (800) 578-4677

Utah Insurance Department
3110 State Office Building, Salt Lake City, UT 84114
(801) 538-3800, (800) 439-3805 or (801) 538-3805

State of Vermont Insurance Division
Commissioner of Banking, Insurance, Securities & Health
Care Administration
89 Main St., Drawer 20, Montpelier, VT 05620-3101
(802) 828-3301 or (802) 828-3302

Virginia Bureau of Insurance
P.O. Box 1157, Richmond, VA 23218
(804) 371-9741 or (800) 552-7945

Washington Office of the Insurance Commissioner
P.O. Box 40255, Olympia, WA 98504
(350) 725-7080 or (800) 562-6900

West Virginia Insurance Commission
1124 Smith St., Charleston, WV 25301
(304) 558-3354 or (800) 642-9004
E-mail: wvins@wvinsurance.gov

Wisconsin Office of the Commissioner of Insurance
125 South Webster St., Madison, WI 53702
(608) 266-3585 or (800) 236-8517
E-mail: information@oci..state.wi.us

Wyoming Insurance Department
Herschler Building, 122 W. 25th St., 3rd Floor, Cheyenne,
WY 82002
(307) 777-7401 or (800) 438-5768
E-mail: wyinsdep@state.wy.us

NATIONWIDE INFORMATION RESOURCES

Insurance Information Institute
110 William St., New York, NY 10038
(212) 346-5500 or (800) 942-4242

National Consumers League
1701 K St. NW, Suite 1200,, Washington, DC 20005
(202) 835-0747
E-mail: info@nclnet.org

National Insurance Consumer Organization
1701 K St., NW, Suite 1200, Alexandria, VA 22314
(703) 549-8050

INDEX